THE FOUR SEASONS OF FLOWER FRUIT MOUNTAIN

THE FOUR
SEASONS
OF
FLOWER
FRUIT
MOUNTAIN

An Immersive Exploration in
Bronze, Porcelain, Plaster, and Glass

Photography by Mark Hanauer

DAVID WISEMAN

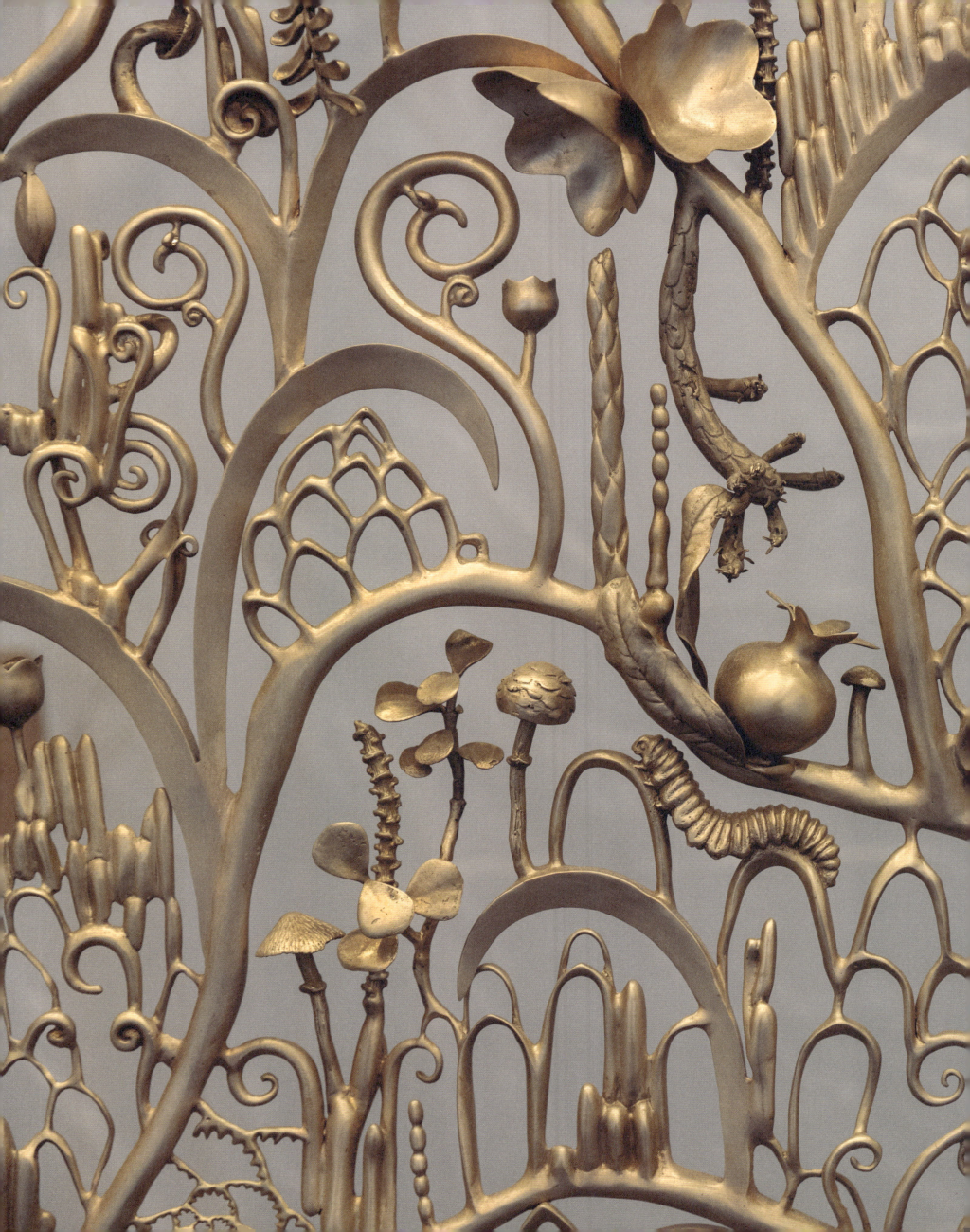

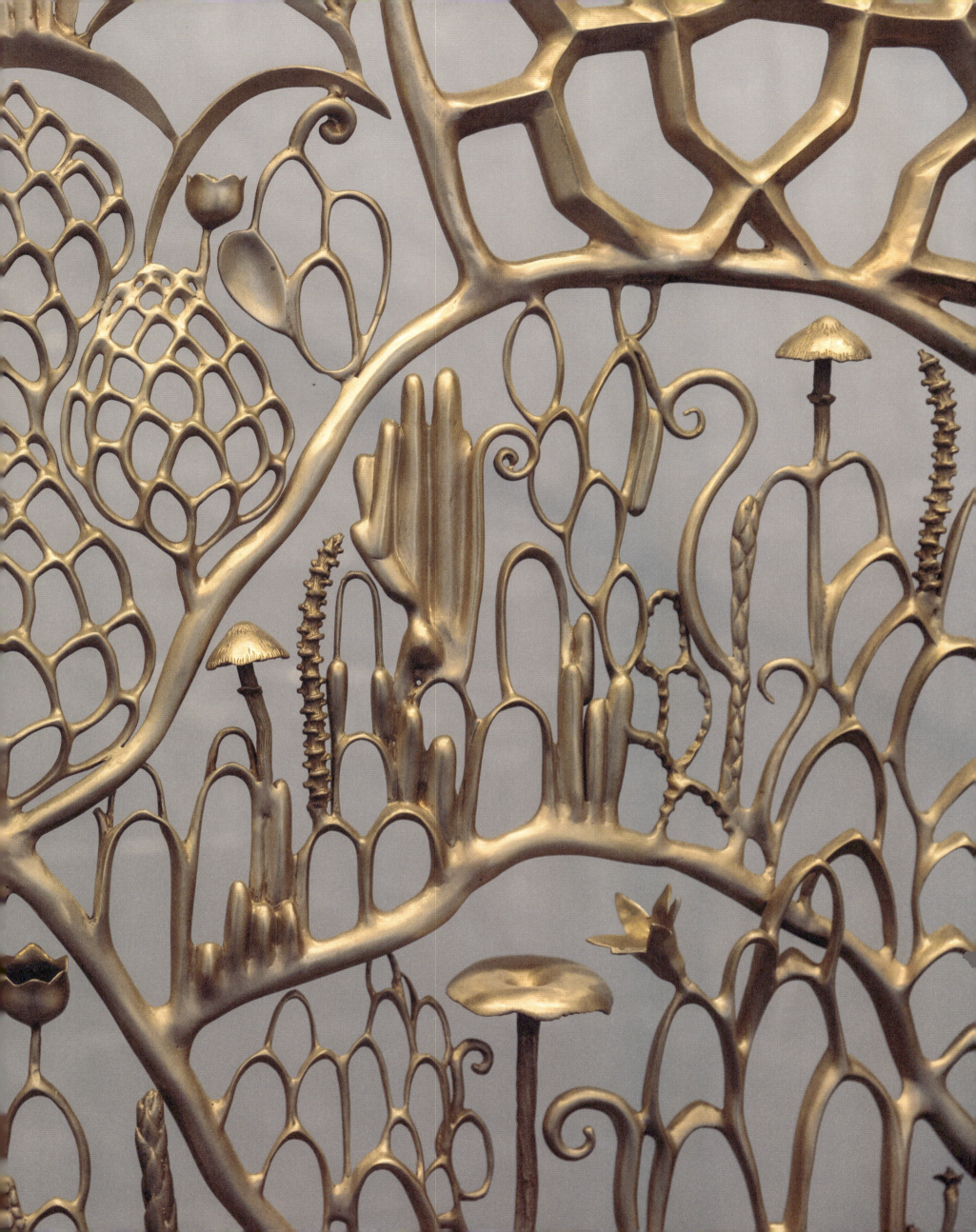

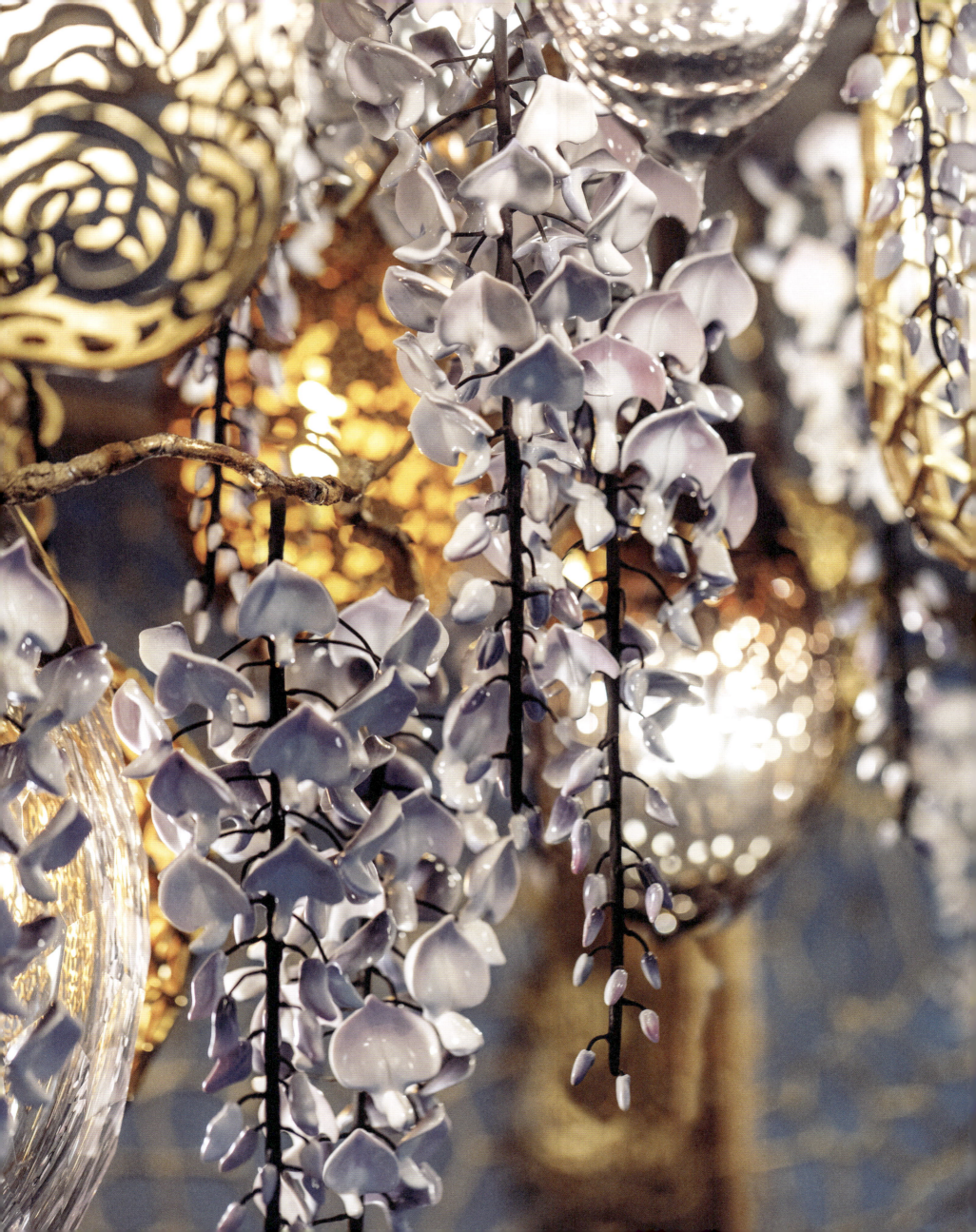

INTRO [6]
BRONZE CASTING [12]
PORCELAIN [38]
PLASTER [50]
INTERVIEW [68]
IN BLOOM [73]

INTRO- DUCTION

Bounded on either side by the Los Angeles River and picturesque Elysian Park, Wiseman Studio inhabits a 30,000-square-foot warehouse complete with all the components of an industrial facility: glowing kilns, workstations stacked high with wax molds, countless tools for wielding, and quiet spaces for drawing and sculpting. As the scene comes into focus, delicate baubles rendered in ancient materials, seemingly plucked from the surrounding urban oasis, are crafted into forms of organically-inspired furniture, screens, tableware, and lighting—to name just a few. At the center of this humming production, David Wiseman consults his detailed sketches as he examines the walls, ceiling, and floor of the 12-by-14-foot model room he and his team of 20 have spent the last three years bringing to life.

Within this careful composition of cast bronze, inlay terrazzo, porcelain slip cast, plasterwork, hand-knotted silk, and cut crystal, two paintings from Monet's quintessential *Water Lilies* series have been suspended in white bronze frames that evoke those lining the walls of the Musée de l'Orangerie in Paris. Here, the nineteenth-century artist consulted with architect Camille Lefèvre to choreograph a rotund, meandering procession around eight large-format *Water Lilies* compositions. Enveloping visitors in vignettes of the floating florals and weeping willows found at the prolific painter's garden in Giverny, the egg-shaped galleries elevate the artistic experience from a mere viewing to a full immersion. By melding his paintings with the architecture, Monet's jump from the flat canvas into the third dimension allows visitors to feel transported to the painter's beloved garden.

At the time of the construction of the Musée de l'Orangerie, the German concept of *Gesamtkunstwerk*, or "total work of art," had begun to take root. Nearly a century later, this manner of holistic and experiential design immersion continues to command the creative canon. In 2019, after working for two decades within a realm of ethereal and Edenic handcrafted sculpture, furniture, and site-specific installations, designer David Wiseman was granted the unprecedented opportunity to pursue his own *Gesamtkunstwerk*. Like Monet, Wiseman takes his cues from the bounty of nature, creating organically inspired works from bronze, porcelain, plaster, enamel, terrazzo, and glass. The charge was to design a system of such objects—screens, console tables, a chandelier, dining table, wall and floor treatments—in conversation with two *Water Lilies* paintings in order to elevate the dining space within a Hong Kong apartment. Aside from this loose framework, the designer was given carte blanche: a dream project, but nonetheless daunting. "Is there any artist from the last 100 years that defines Western art more than Monet?" Wiseman asked upon reflection of the project onset. "How does one even begin?"

In order to deliver a design simultaneously respectful of the iconic artwork and true to his own creativity, Wiseman conducted thorough assessments of his personal artistic process and that of the legendary painter during his *Water Lilies* period. "I wanted the room to be a dialogue between Monet's natural inspirations and my own," he noted. Upon studying a photograph of a long-bearded Monet standing before the Japanese-style bridge spanning his pond in Giverny, Wiseman noticed a picturesque convergence of nature and architecture upon the roof of the bridge, nearly swallowed by an entanglement of wisteria. "In that moment," Wiseman said, "I began to think of the space not as a series of interconnected, organic objects, but rather an architectural expression of my work." The cube-like space was then amended to include an arched ceiling, reflecting the form of the bridge and creating the sensation of a tree canopy.

As Wiseman continued to explore the motif of wisteria, he began to ponder the seasons. Familiar with the species due to its abundance in California, he knew its pendulous vines of violet bloomed only briefly each year. Was this room destined to portray a perpetual spring? Or could there be a way to include summer, winter, and fall? With four corners to address, Wiseman decided to assign a season to each, capturing within them the species in bloom that time of year. Climbing from the spring corner and across the ceiling, a stately cast-bronze vine cuts through the orthogonal entry with a cascading, slip-cast porcelain wisteria chandelier. Made of 4,000 hand-sculpted petals, the sinuous structure is also illuminated by Bohemian, amethyst cut crystal pendants and bronze lanterns.

Just as Monet had ensured that Giverny would be blooming with life to paint year-round, so too would Wiseman's room. Species that Monet planted—irises, hollyhocks, nasturtiums—became departure points for depictions in bronze and

porcelain. A marriage of nature and craft, each delicately detailed planting demonstrates Wiseman's mastery of lost-wax bronze casting and porcelain slip cast. Working with a combination of cast and handbuilding-ceramic techniques allowed Wiseman to capture delicate, organic forms. In the spring corner, he pays homage to the painter's favorite flower, the Japanese iris; ripe fruit trees appear in summer; hollyhock and snowdrops for the winter; and in fall, autumnal berries and toadstool mushrooms. "I wanted to represent an impression of every season, but also create a sense of place," noted Wiseman, "by positioning every piece and pattern as a part of the larger narrative."

Wiseman then looked beyond the Monet references to further develop the narrative. Tying the project to its regional context, motifs from Chinese mythology appear throughout the seasonal composition as figures cast in bronze. A dragon, which is celebrated every summer in the famed and ancient Dragon Boat Festival, descends from the clouds, bringing tempestuous torrential rain and lightning—a harbinger of the year's bountiful harvest to sustain the realm below. The dragon, also a central character in the sixteenth-century classic novel, *Journey to the West*, is angrily staring at his adversary, the Monkey King, who hangs from tree limbs in the autumnal corner of the room. Unconcerned, he contemplates the moon's reflection on a pond in his abundant realm of Flower Fruit Mountain. Celestial bodies represent the Mid-Autumn Festival, a lunar-based event celebrated with mooncakes and lanterns ascending to the heavenly realm above.

The white bronze treatment of various moments in this narrative—frozen waterfalls in winter, the moon and its reflection upon a pond below in mid-autumn, puddled water within a gnarled tree root console table in spring, and the Monkey King pausing to inquisitively admire its reflection—points to their significance while also linking them directly to the two Monet paintings framed in the same material. Over the course of their history, the paintings had received different frame treatments. To address this discrepancy, Wiseman looked to the frames Monet had specified for l'Orangerie and replicated them in a solid cast white bronze.

The immersive composition continues above and below the paintings, echoing through the fantastical rug across the floor of the room and throughout the freestanding furniture that sits atop it. The organic bronze latticework along the walls coalesces at the center of the space as an open-framed base for a glass tabletop. This transparency provides unhindered views of the bronze details as well as the brilliant greens, blues, and purples of the graphic, hand-knotted wool rug below. Overhead, illuminated, crystalline glacier pendants emanate from winter's frozen bronze mountain ranges, co-mingling with autumn's bronze lanterns and the wisteria blooms of the spring and summer to form a cascading chandelier above.

Over the course of this three year commission, Wiseman and his team worked entirely within a full-scale replica of the Hong Kong dining room to design, test, iterate, and create this formally and metaphorically layered experience. Accurate down to the millimeter, the replica simulated the exact conditions of the apartment, going as far as to fill Wiseman's white bronze frames with facsimiles of the *Water Lilies* paintings. Upon completion, the room was disassembled and packaged for shipment to Hong Kong. Carefully pieced back together over the course of weeks, David Wiseman's total work of art was completed, at last, in December 2023. Fittingly titled *The Four Seasons of Flower Fruit Mountain*, this room is the most comprehensive exercise of Wiseman's imagination thus far. A profound articulation of his organic inspirations executed through masterful craftsmanship, it will live on in perpetual bloom as a testament to the boundless art that is nature.

—Sophie Aliece Hollis

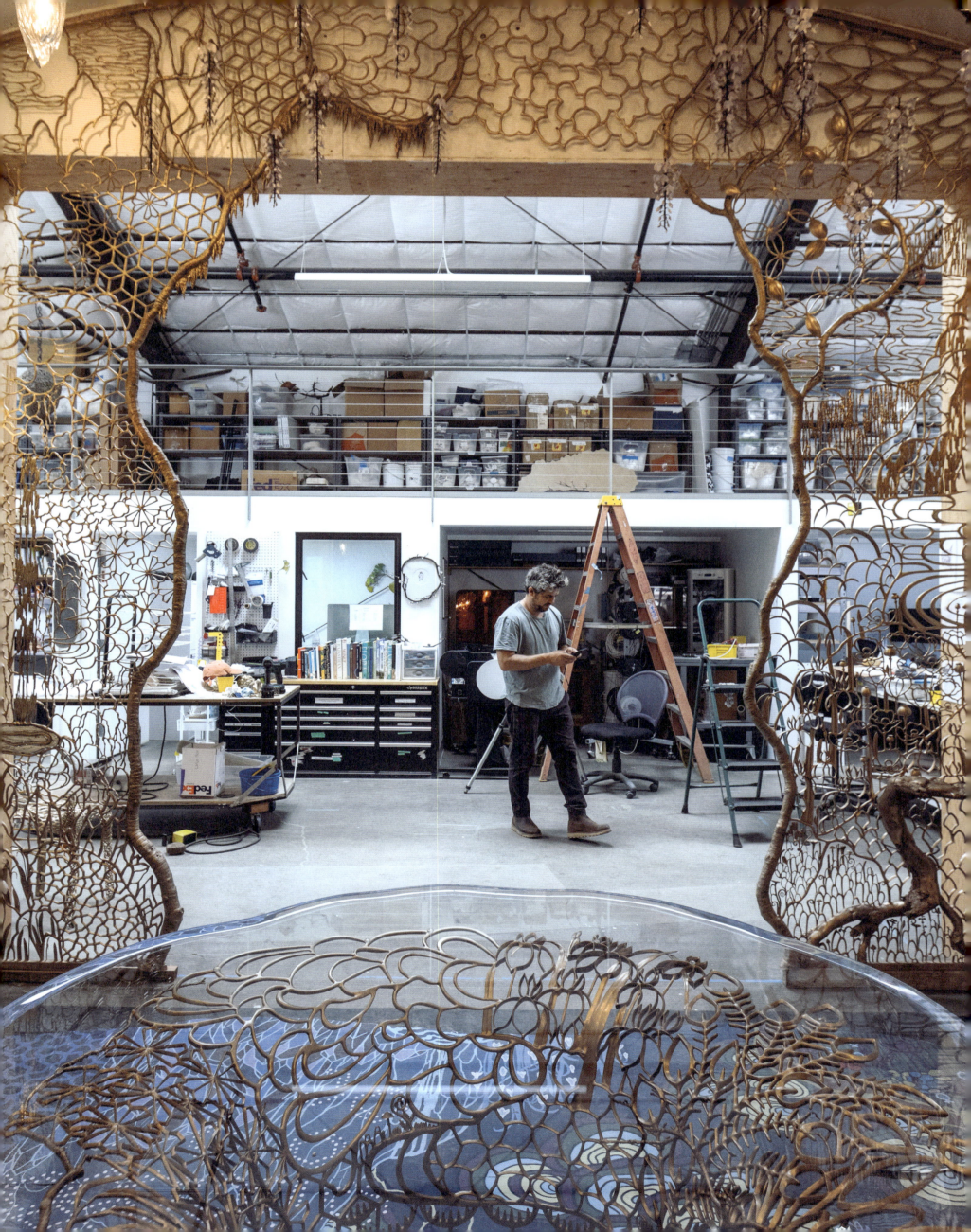

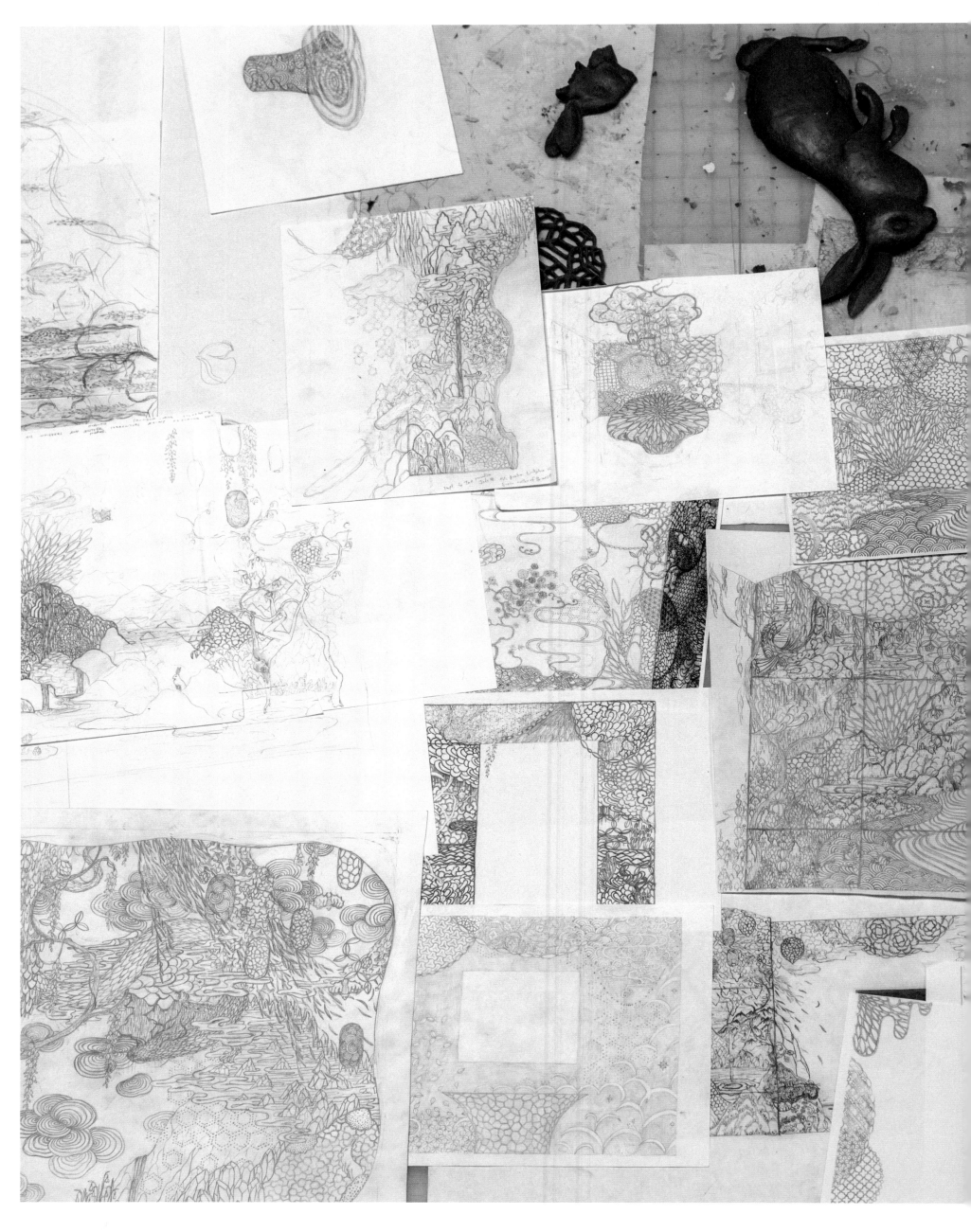

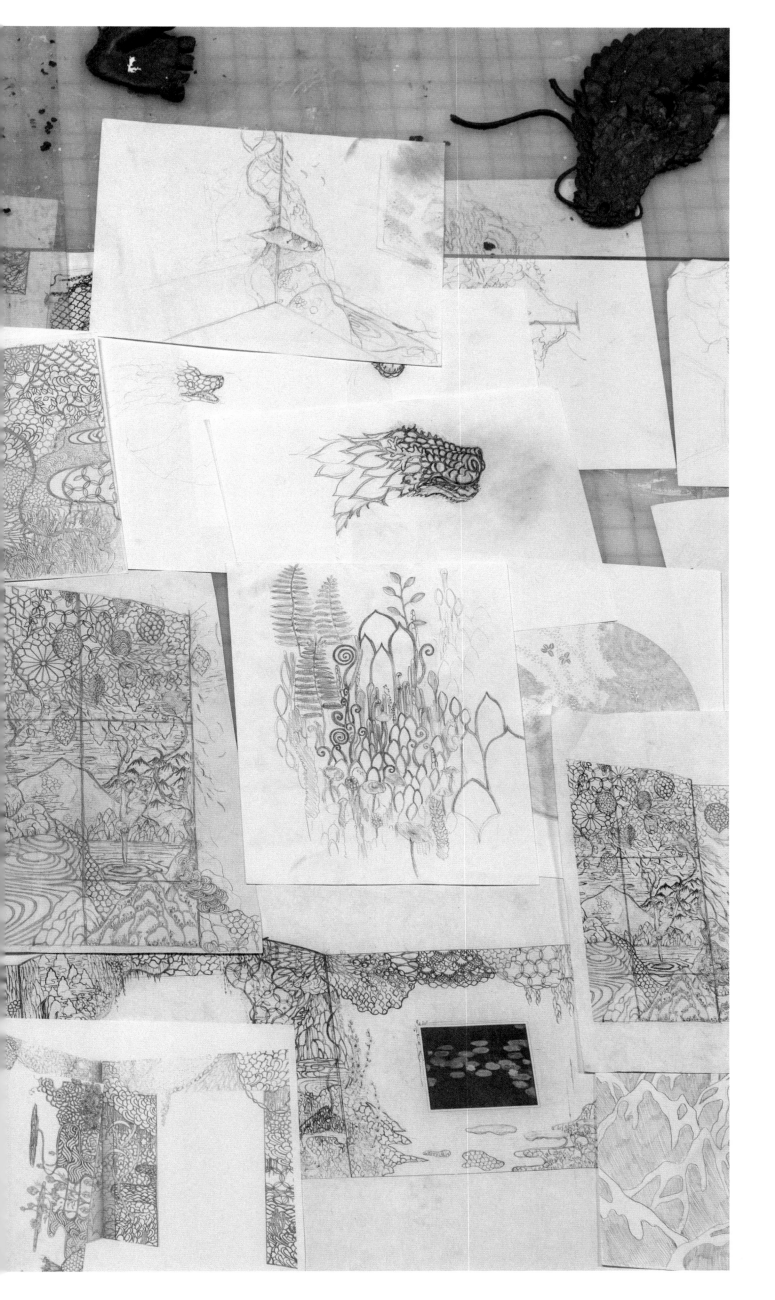

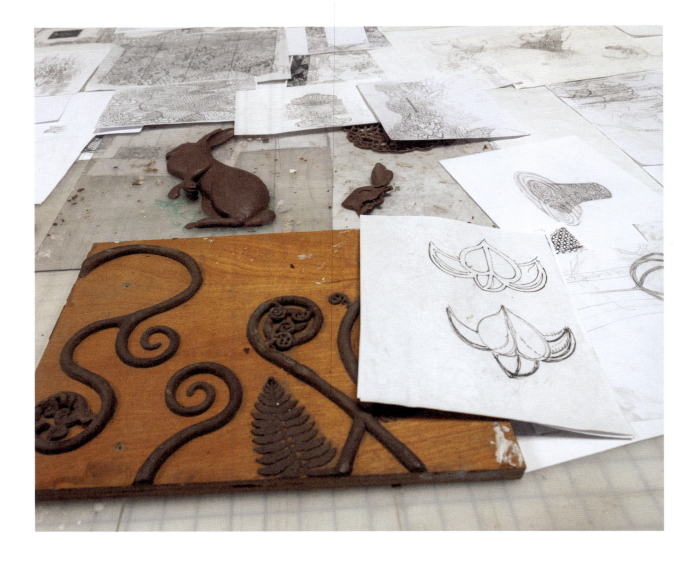

BRONZE CASTING

The first time I dropped off a wax sculpture at a foundry, I returned a few weeks later to pick up the finished bronze. Beyond a simple material change, I felt a magical transformation had taken place.

I needed to learn more.

I soon realized that jumping past the customer service desk and chatting directly with the foundry staff was necessary to uncover what I wanted to know about this process. I developed a friendship with the head of the foundry and, before long, his advice turned into demonstrations of different casting techniques, and, eventually, help assembling much of the equipment to cast bronze in-house. We built a small-scale foundry together using only a propane tank, an oil drum reinforced with kiln bricks, a sandbox, a kiln purchased on Craigslist, and a crockpot to heat and pour wax.

It was a revelation to now be a part of every step of the fabrication process. I had eliminated the need to drop off my work and hope that, after the passage of several months, I'd be delivered something that met my expectations. Having a working foundry has been such an engine for creativity. As I learned more about the casting process, I started to develop works with an awareness from the outset of all the steps involved in their creation. I could treat the material with near-total freedom and fully explore its potential, sometimes using it in unconventional ways, like pouring outside of a mold to allow the bronze to flow like lava and create interesting textures as it cools and reacts to the open air or a new surface.

My newfound understanding of the material and process of casting bronze meant that, from the moment I began conceptualizing a new project, I was already envisioning how my drawing could be transformed into bronze. All of my work begins with a sketch. It's the best way to translate an idea into something material: something that I can see clearly and that I can share with others. Once I uncover the idea and the feeling of the piece in the sketch, I use clay to make a three-dimensional sculpture. We make a rubber mold of the model and cast the form in wax. A high quality wax casting is essential to create a bronze. The process is known as the lost-wax technique for casting and has been around since the third millennium B.C.E. in many cultures, both Western and Eastern. Though more modern materials are used nowadays, the process remains the same.

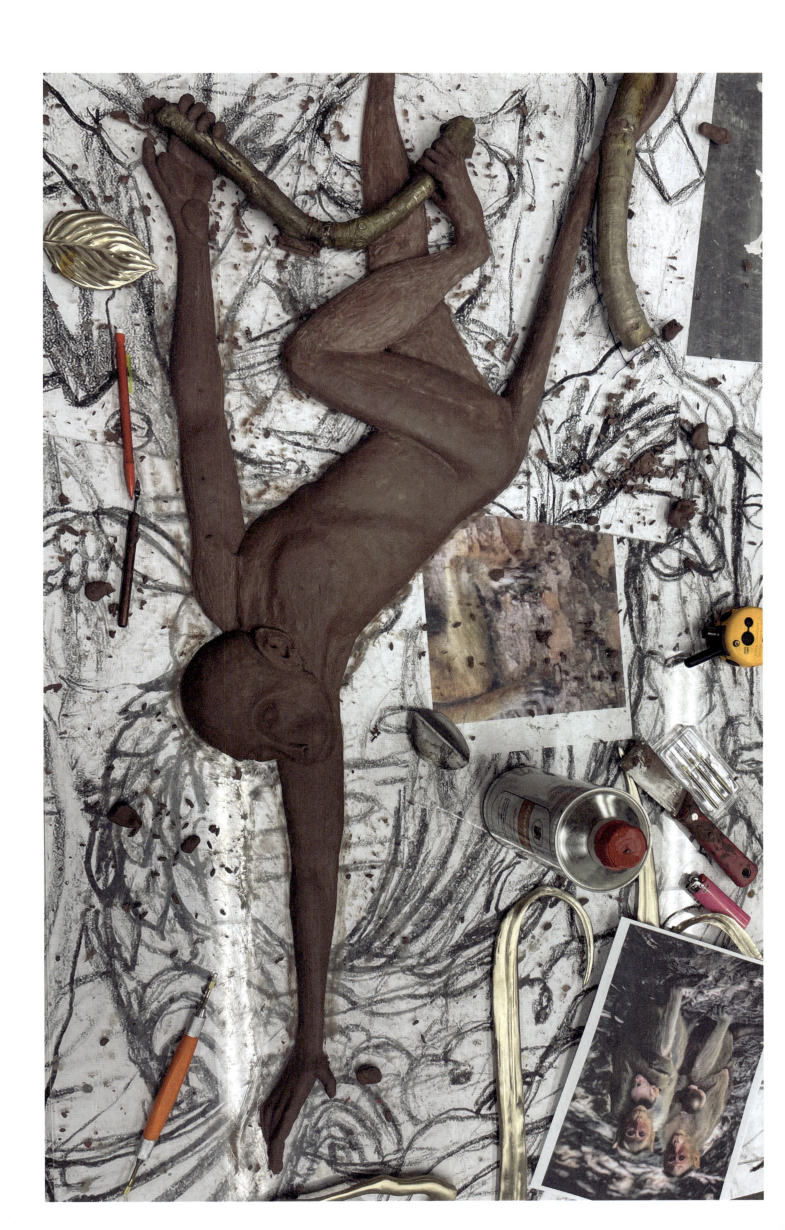

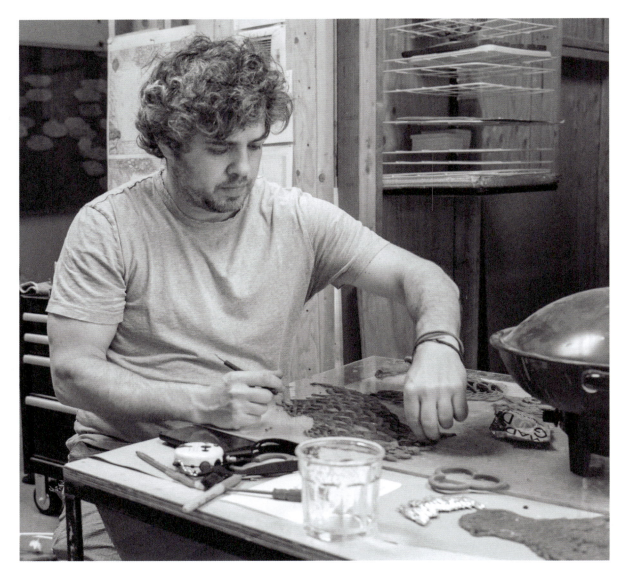
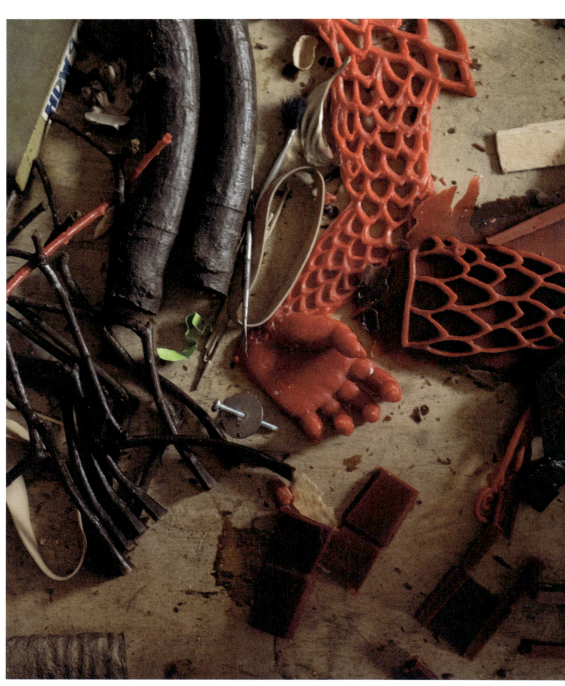

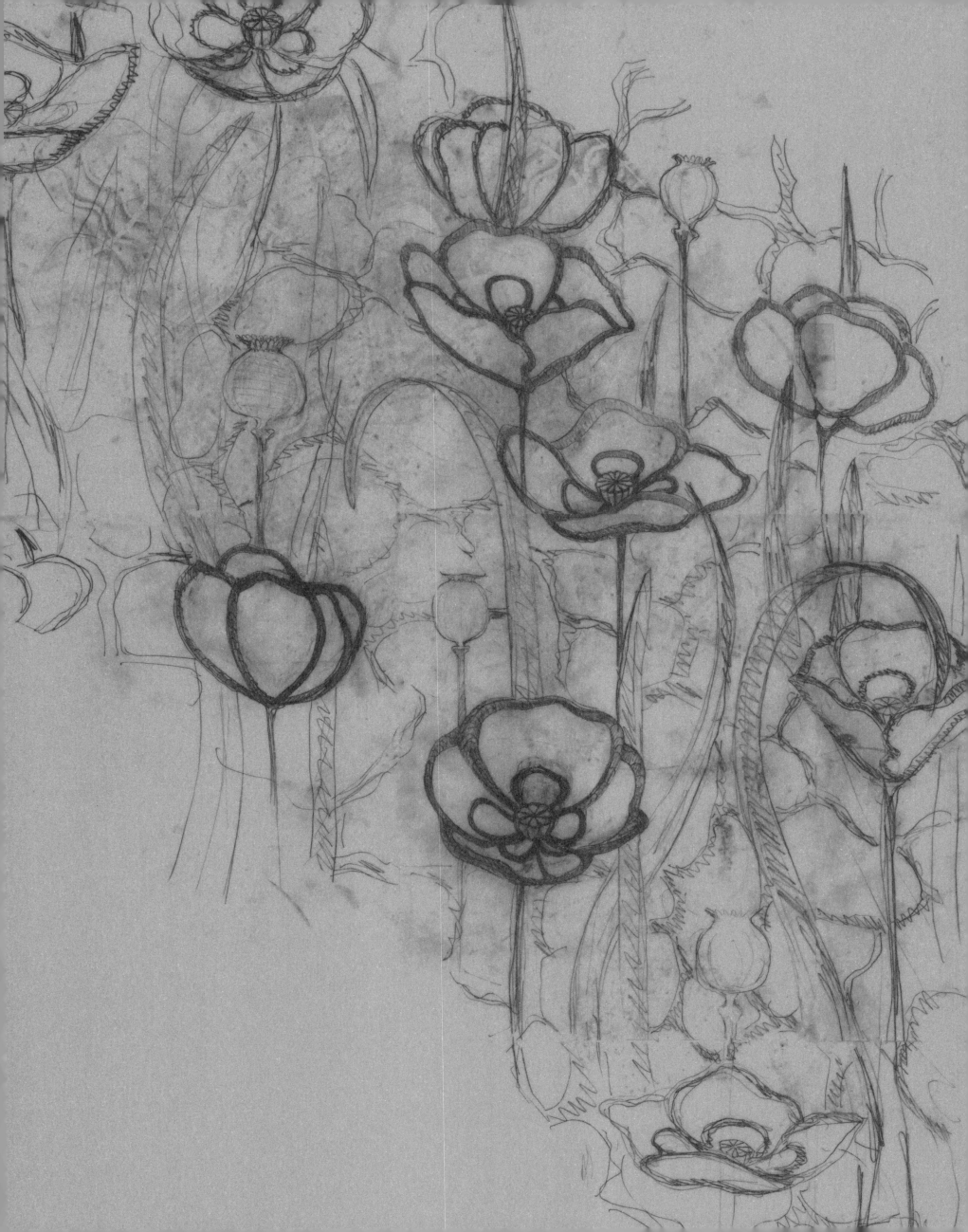

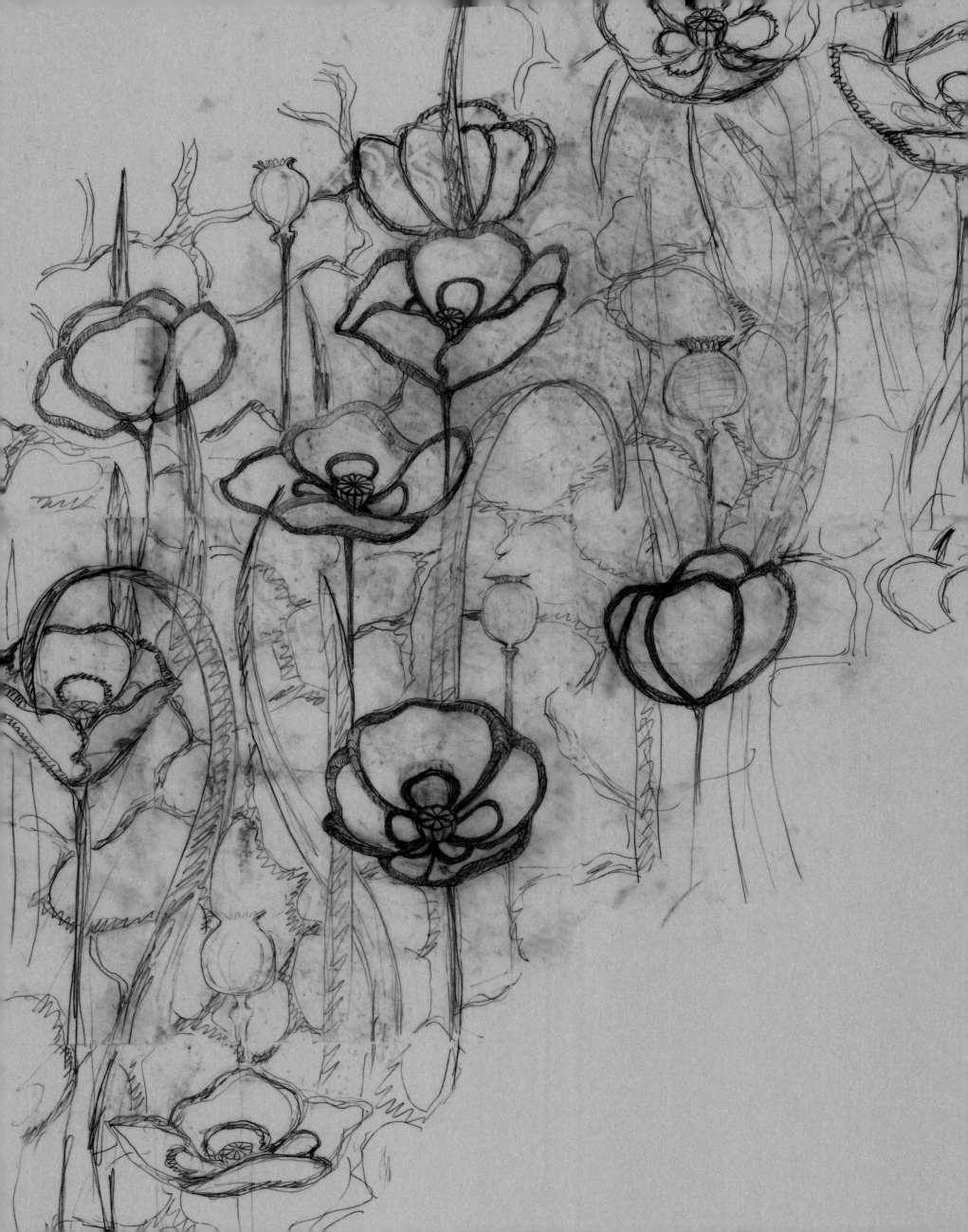

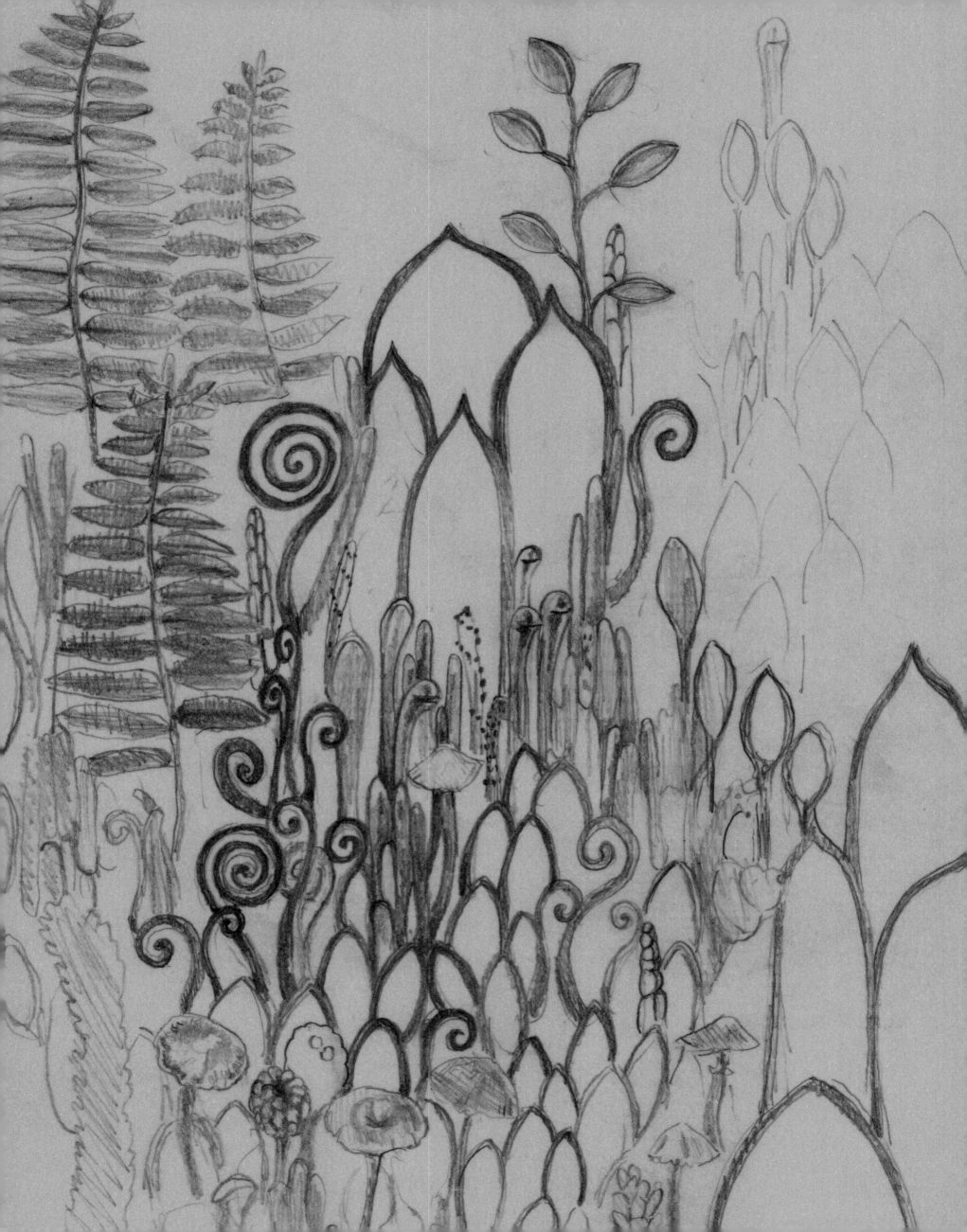

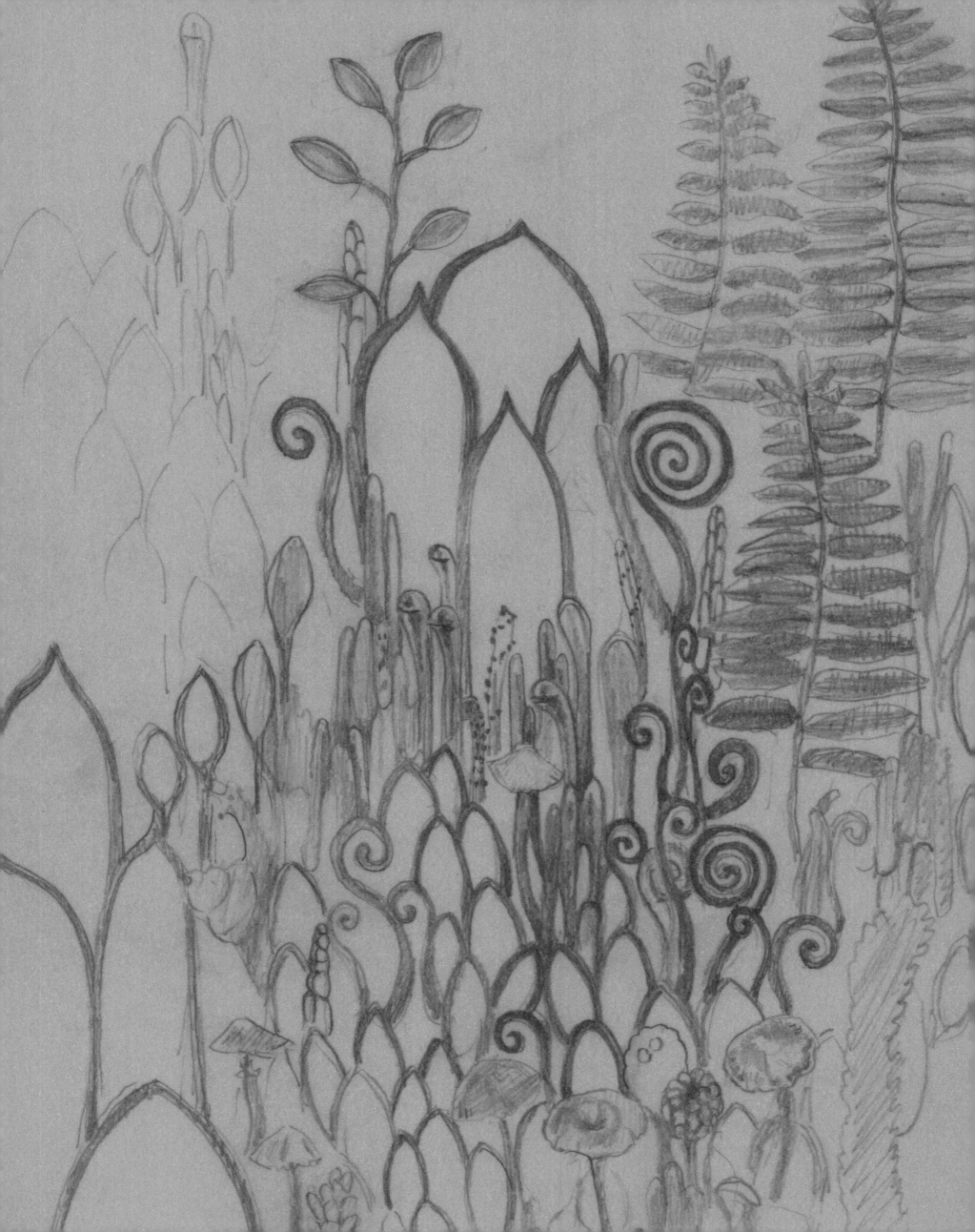

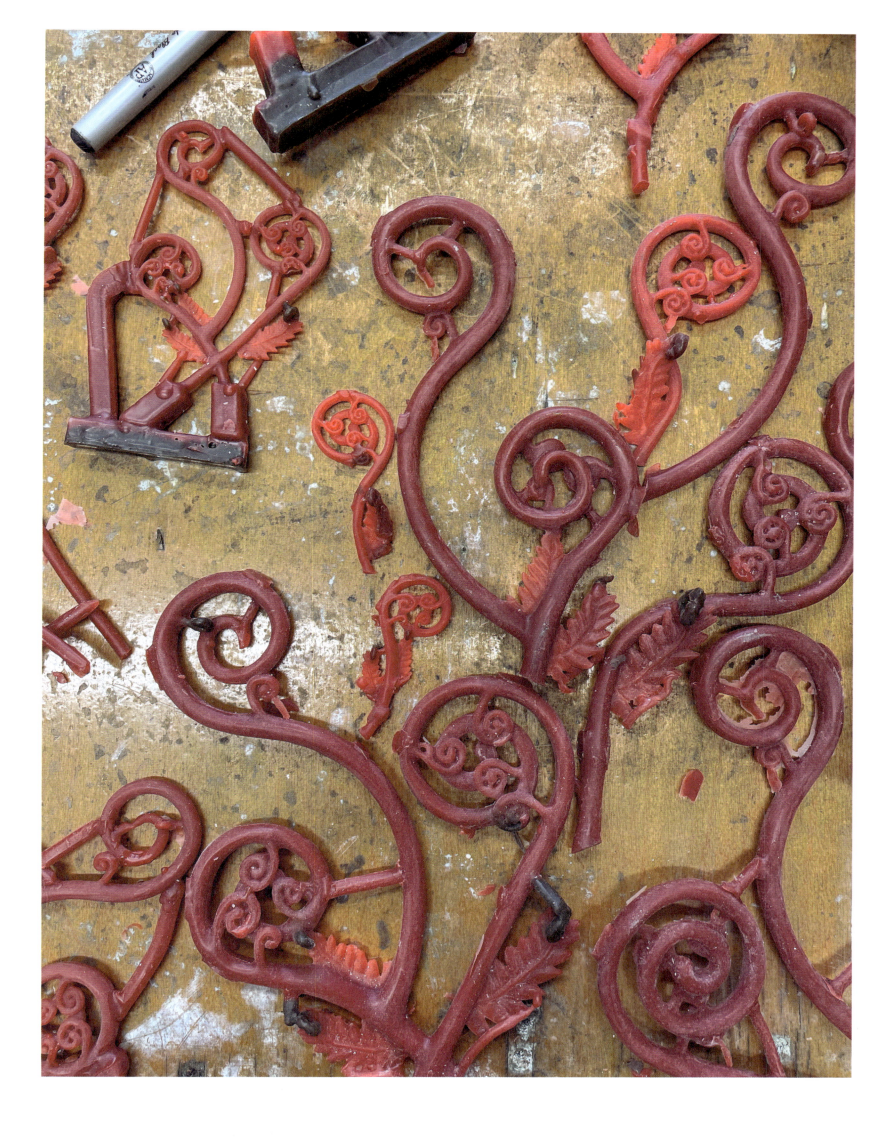

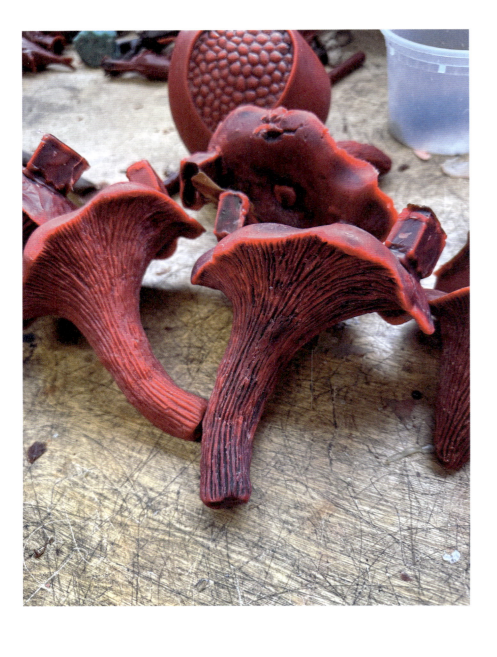
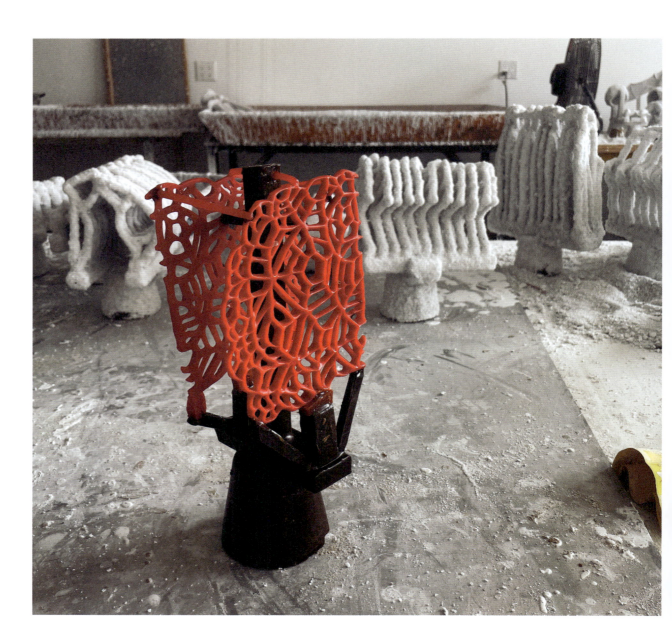

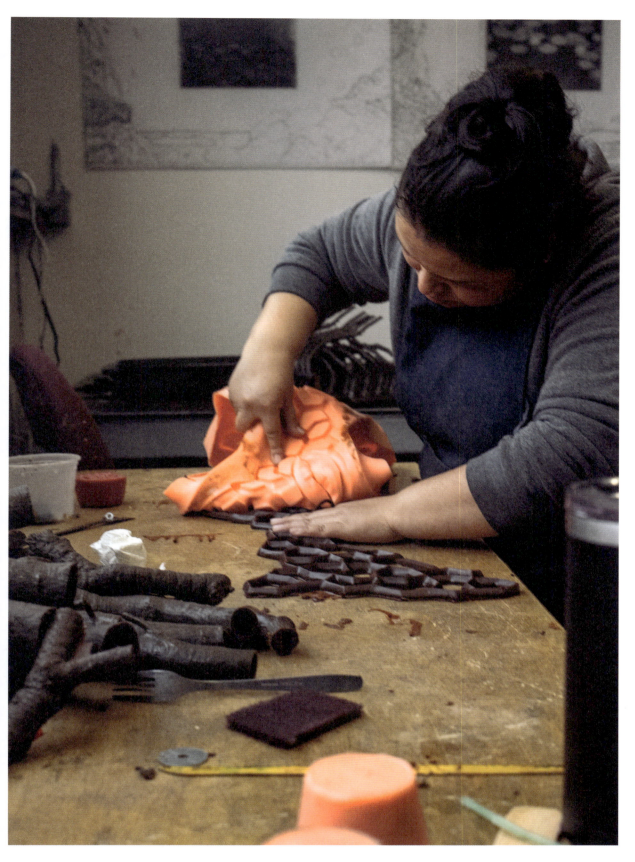

A mold is made of the original clay artwork. It can be made of materials like plaster, latex, alginate, or metal, but we primarily use silicone rubber. Hot wax is poured into the mold, then removed once cooled, revealing a casting of the original sculpture. We then examine the piece and determine how best to engineer the flow of liquid bronze as it enters and inhabits the sculpture. We have to decide where the molten bronze "gates" of entry will be, usually an inconspicuous place on the underside of a piece, as they will inevitably need to be cut and "chased," or detailed, once cast in bronze. Once the wax gates and wax pour cups are secured to the casting, we then dunk it in a liquid slurry that coats the exterior. Then, a fine, dry silica sand is sifted on top and left to dry before a fan for a couple of hours. This process is repeated—dunk and sift, dunk and sift—but each time with coarser and coarser sand. After about six repetitions, a thick, durable outer layer of silica-based ceramic shell completely covers the wax. The whole structure is then heated with a torch—the outer ceramic shell is totally unaffected by the heat—while the inner wax casting easily melts away, hence the term "lost-wax." The wax has completely melted away but its form and impression are safely preserved by the ceramic shell.

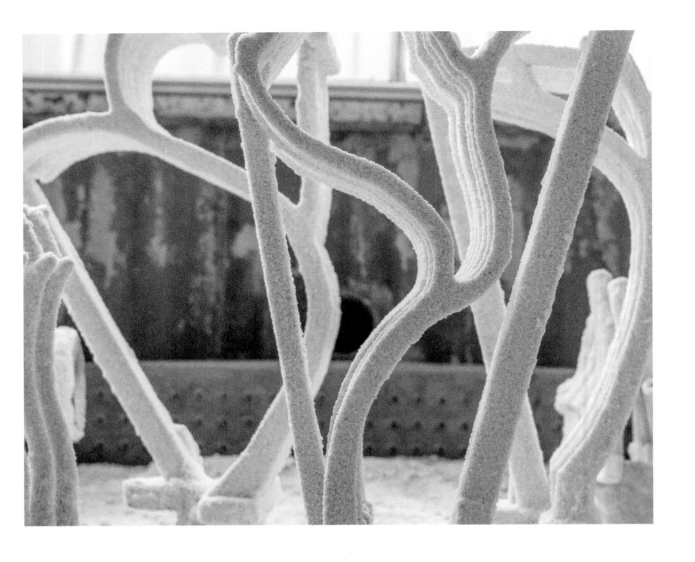

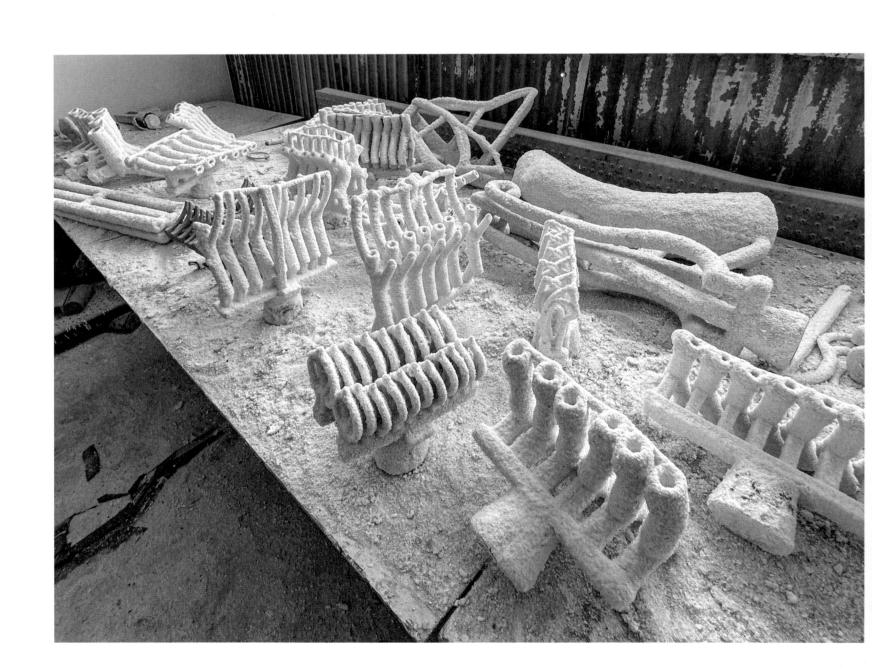

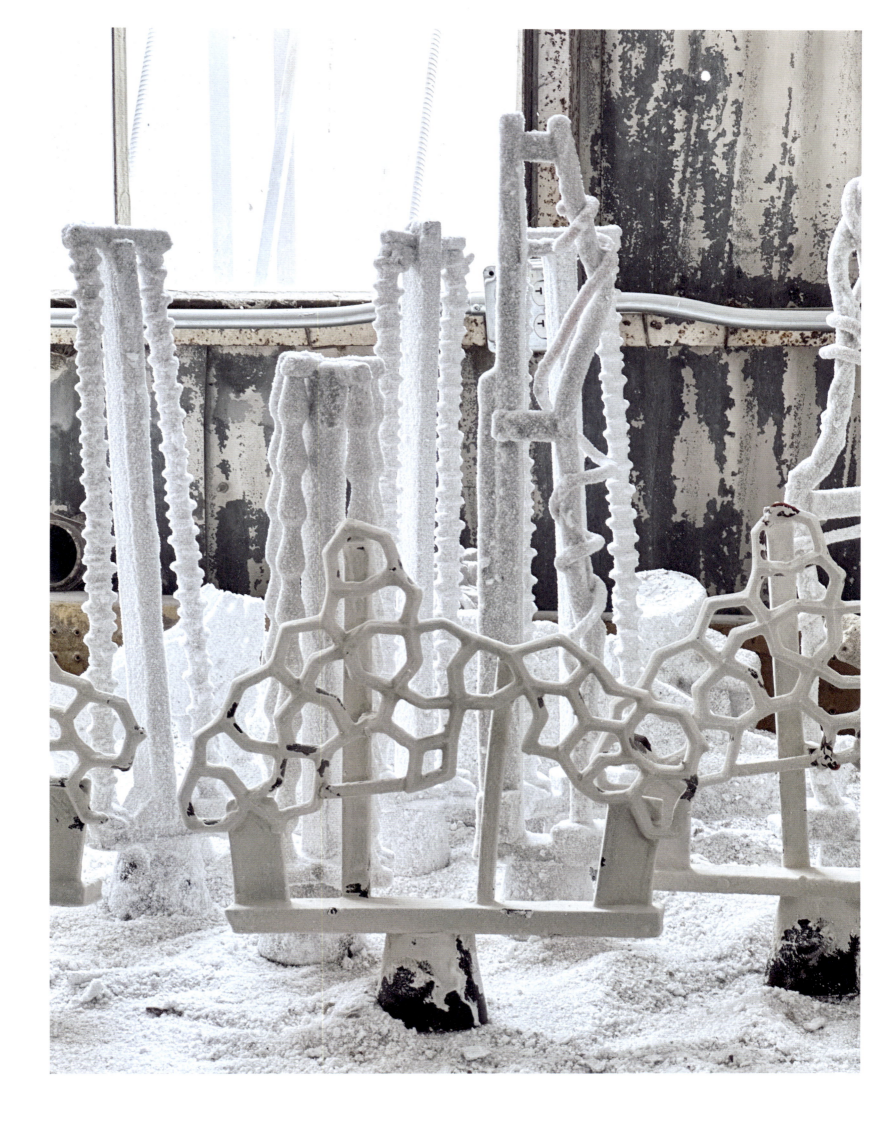

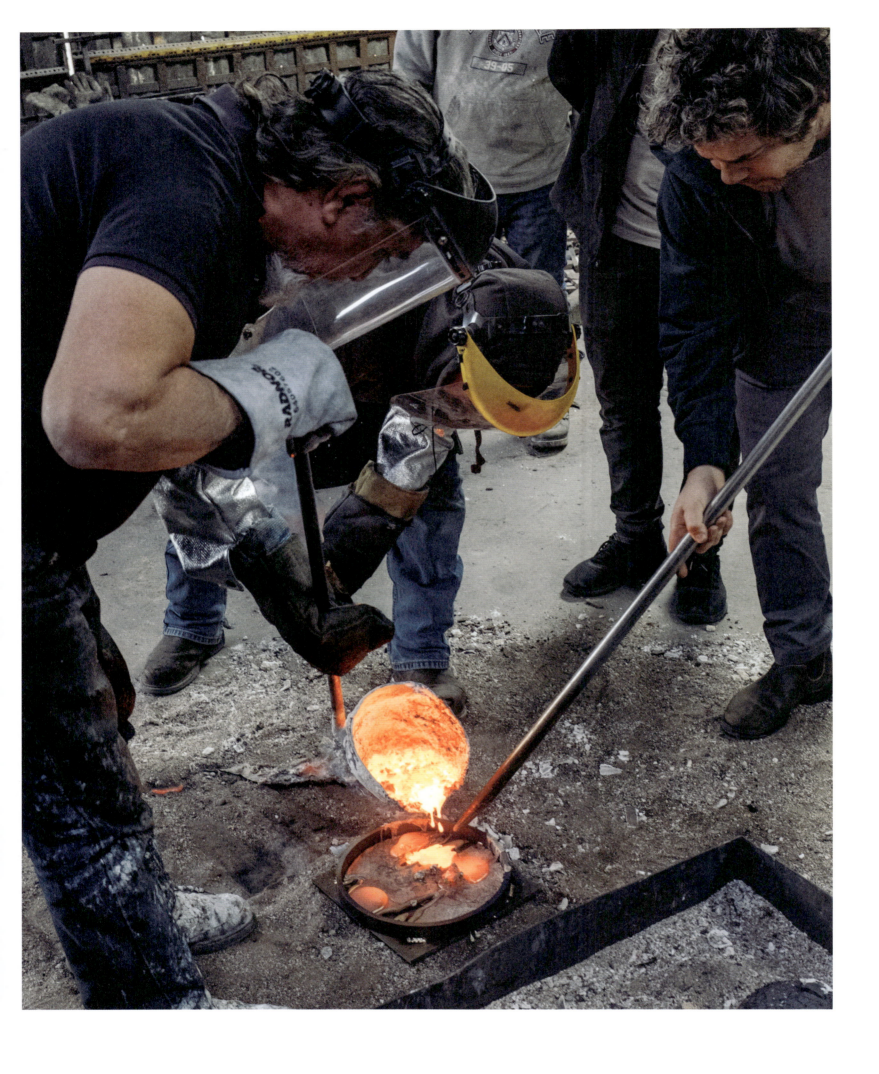

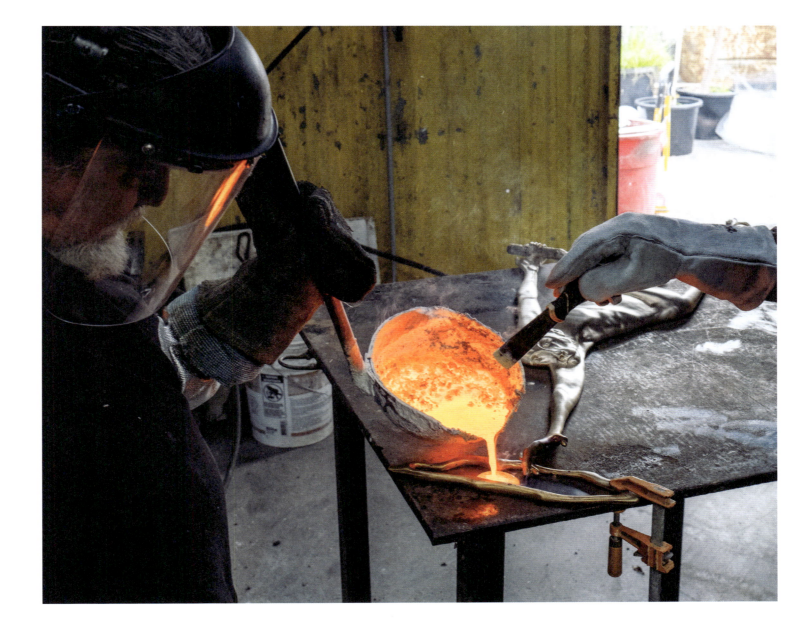

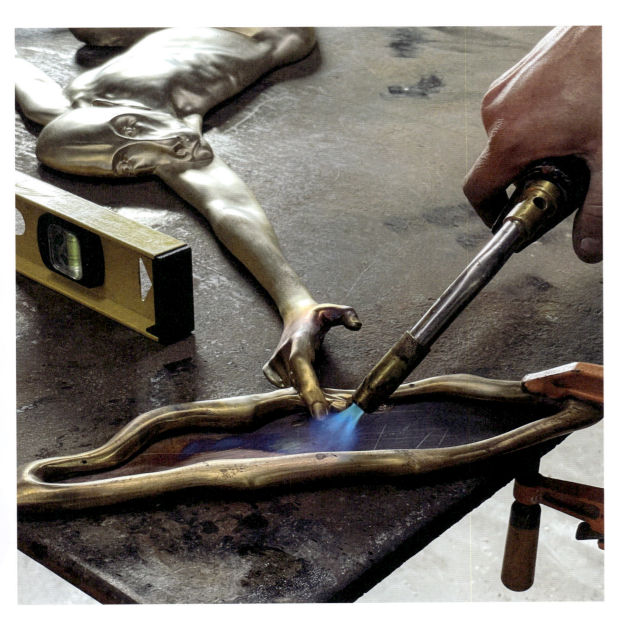

We collect the wax and reuse it for future castings, while the ceramic shell is then placed in a kiln and fired for four hours at around 1700 degrees Fahrenheit. Once our shell has reached the temperature, it is ready to receive the molten bronze. We ignite the furnace, which contains a vessel of high heat capacity, known as a crucible, to hold the bronze as it melts. We load the crucible with bronze ingots, and, after around two hours of heating, we have about 400 pounds of molten bronze. The hot shells are now removed from the kiln and positioned in a sandbox where we can ladle out the molten bronze into each. The bright yellow-orange of the hot bronze then starts to cool, turning from darker orange to cherry red, then maroon, and finally a sooty, brown-gray.

At this stage, the filled shell is cool and the bronze has solidified enough to hammer, dislodging the casting from its ceramic shell. All that work to create the shell is now in pieces on the floor, revealing what we hope will be a perfect casting. Imperfections are often the case and require us to recast a new wax entirely or to weld, chase, and finish the revealed bronze. When the clean bronze casting reaches its final state, it is ready for assembly in many different works—a monkey on a patterned screen, a branch weaving through a table, a chipmunk resting on a branch chandelier, and so on.

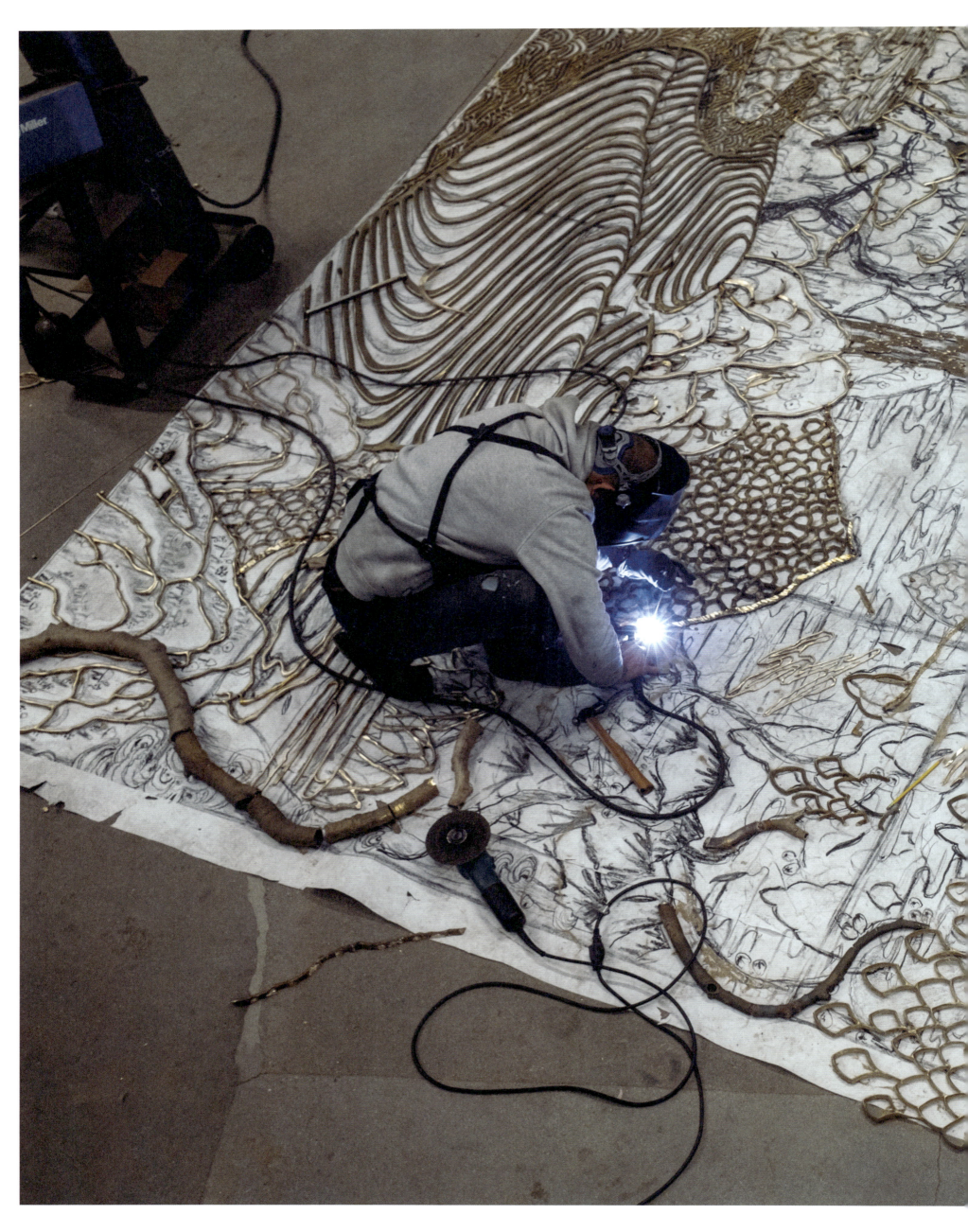

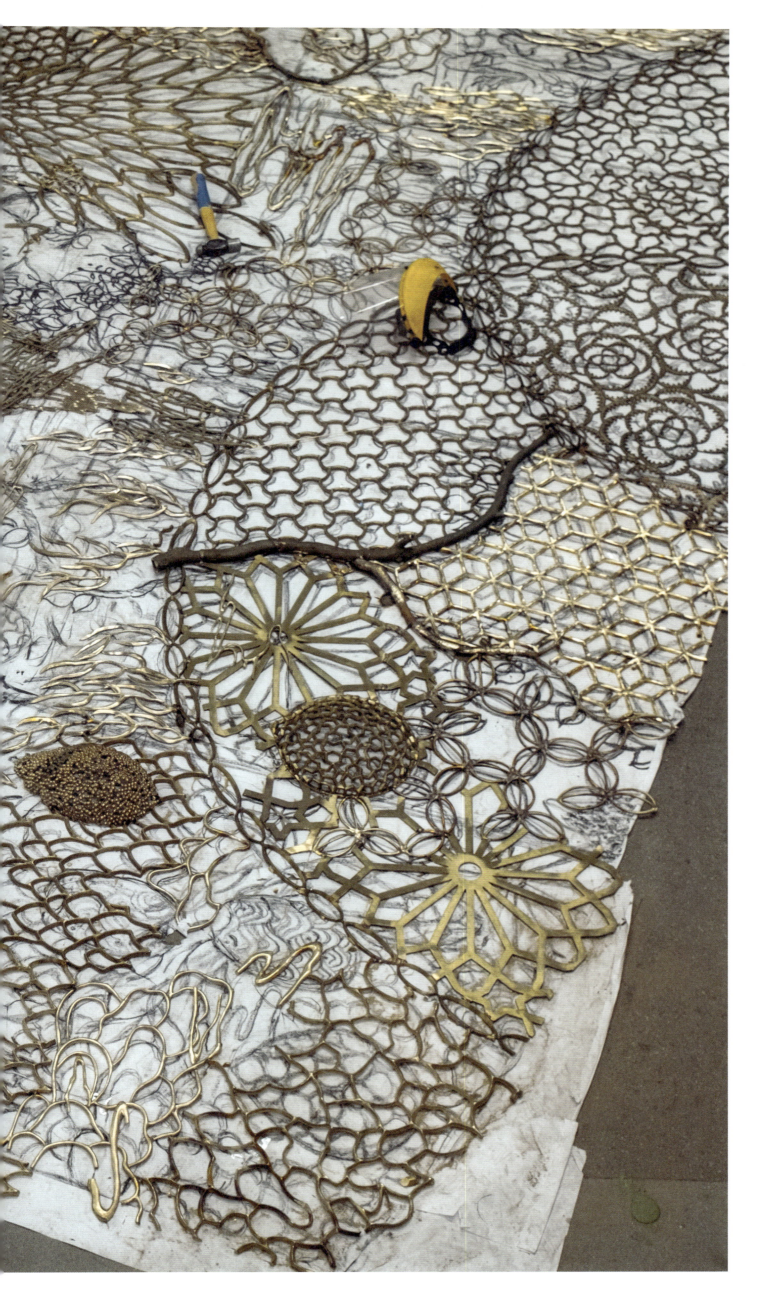

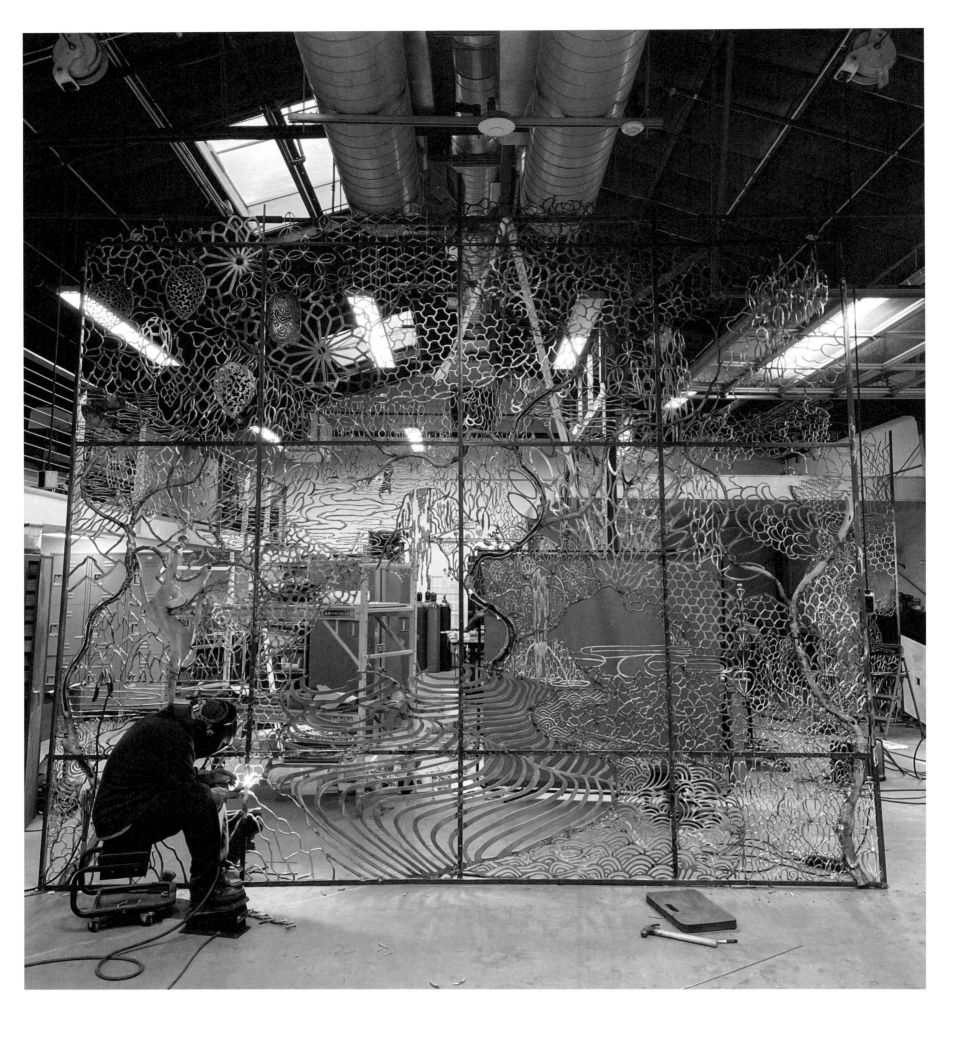

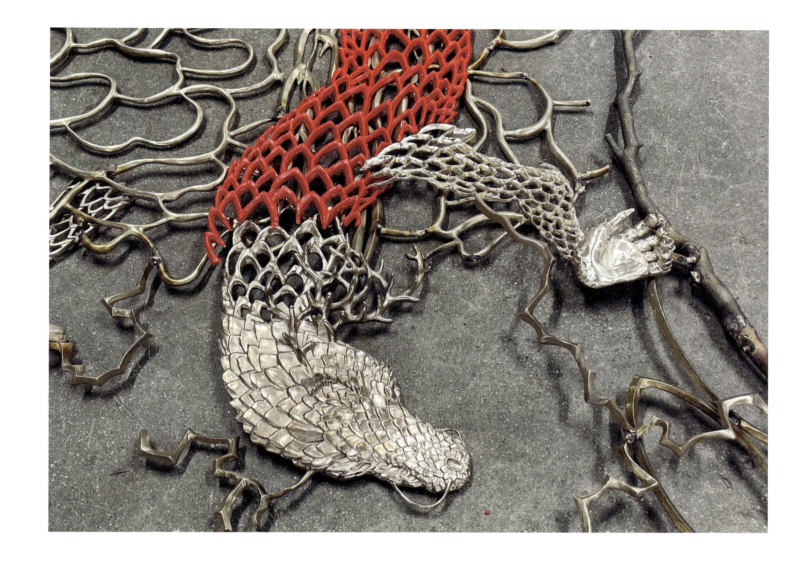

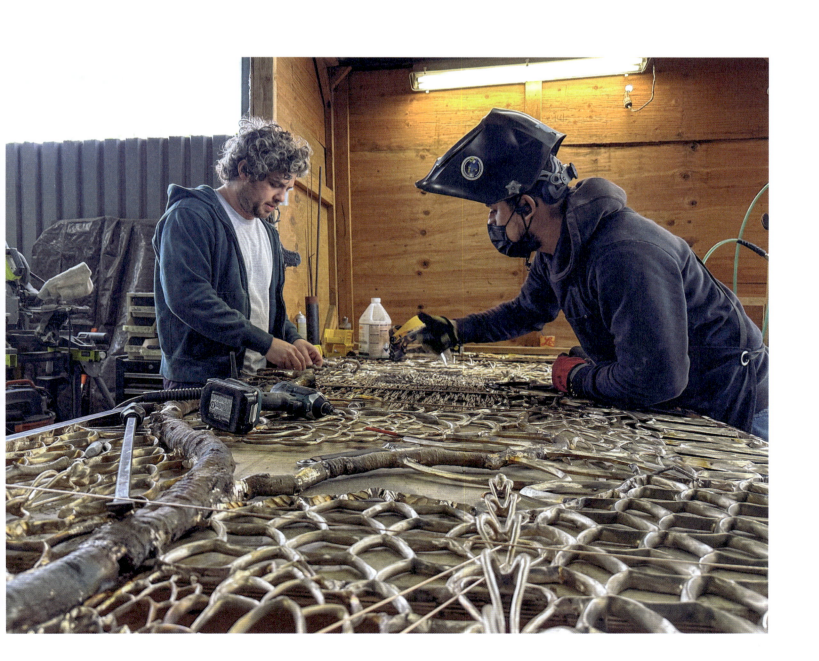

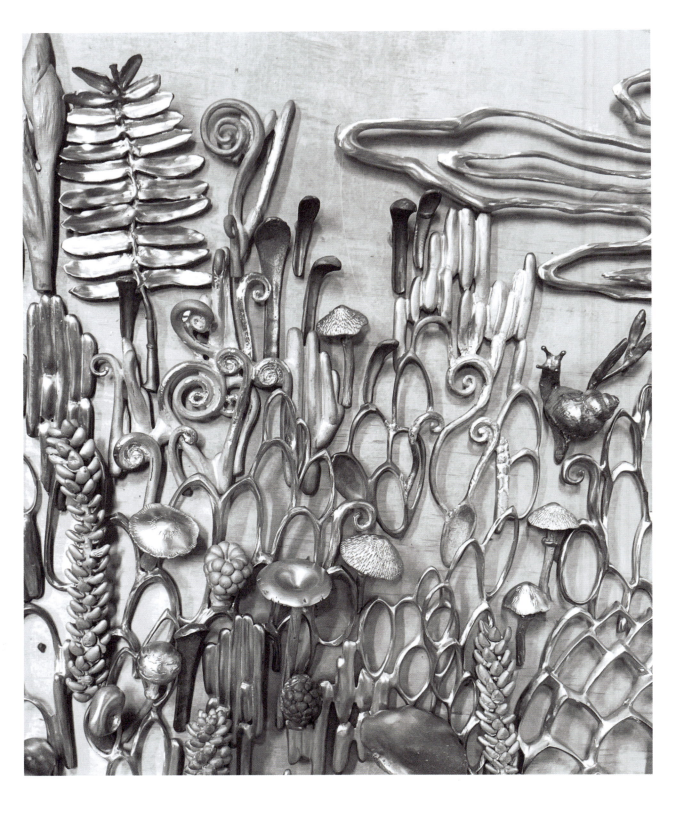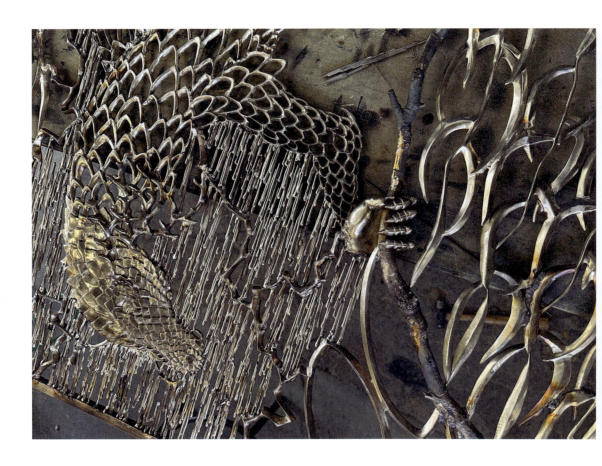

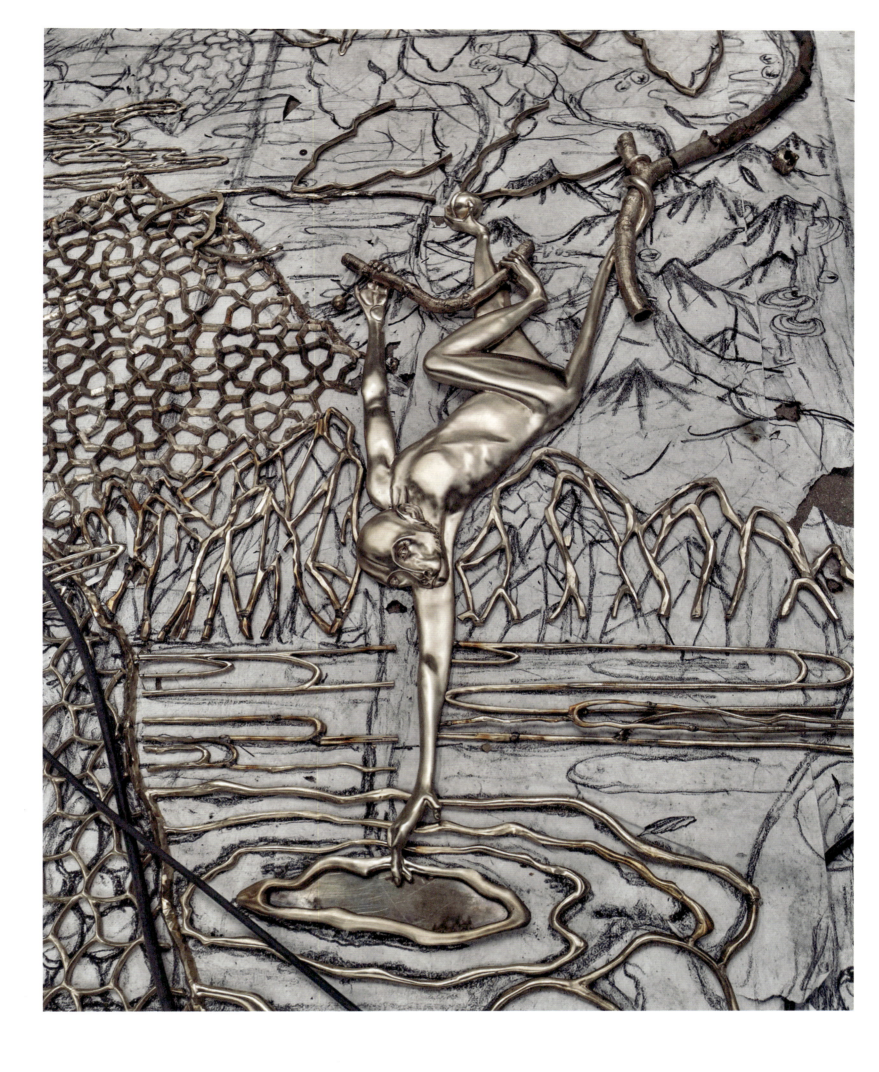

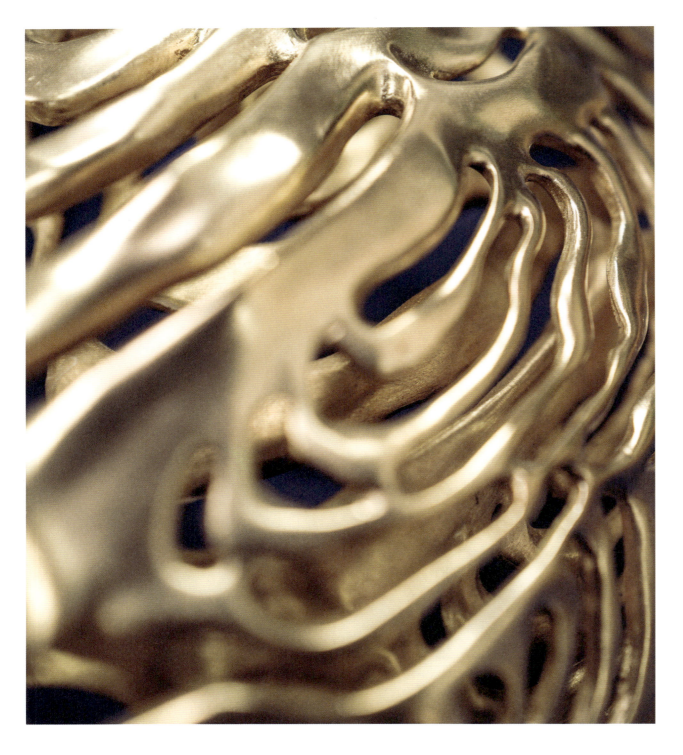
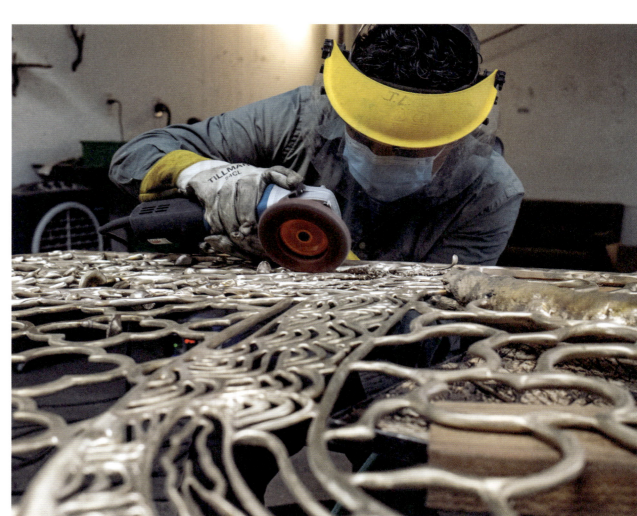

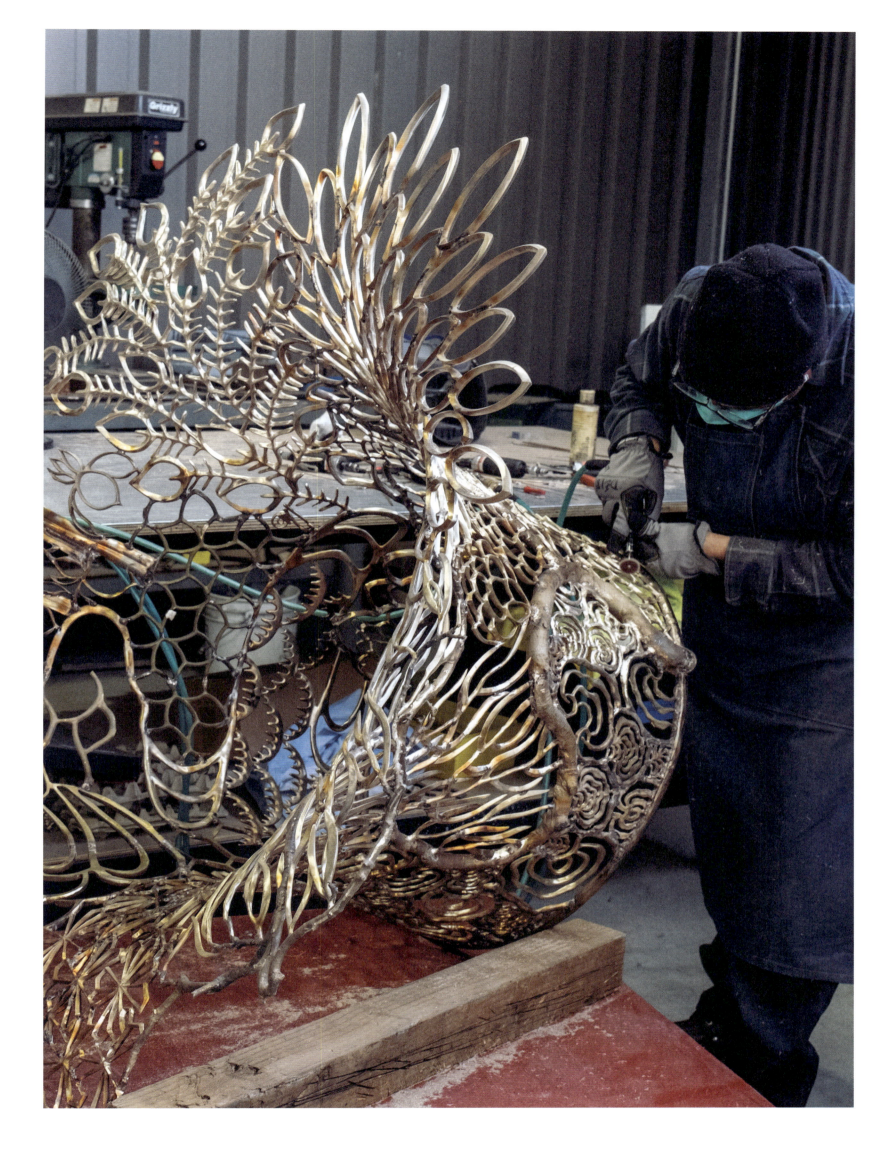

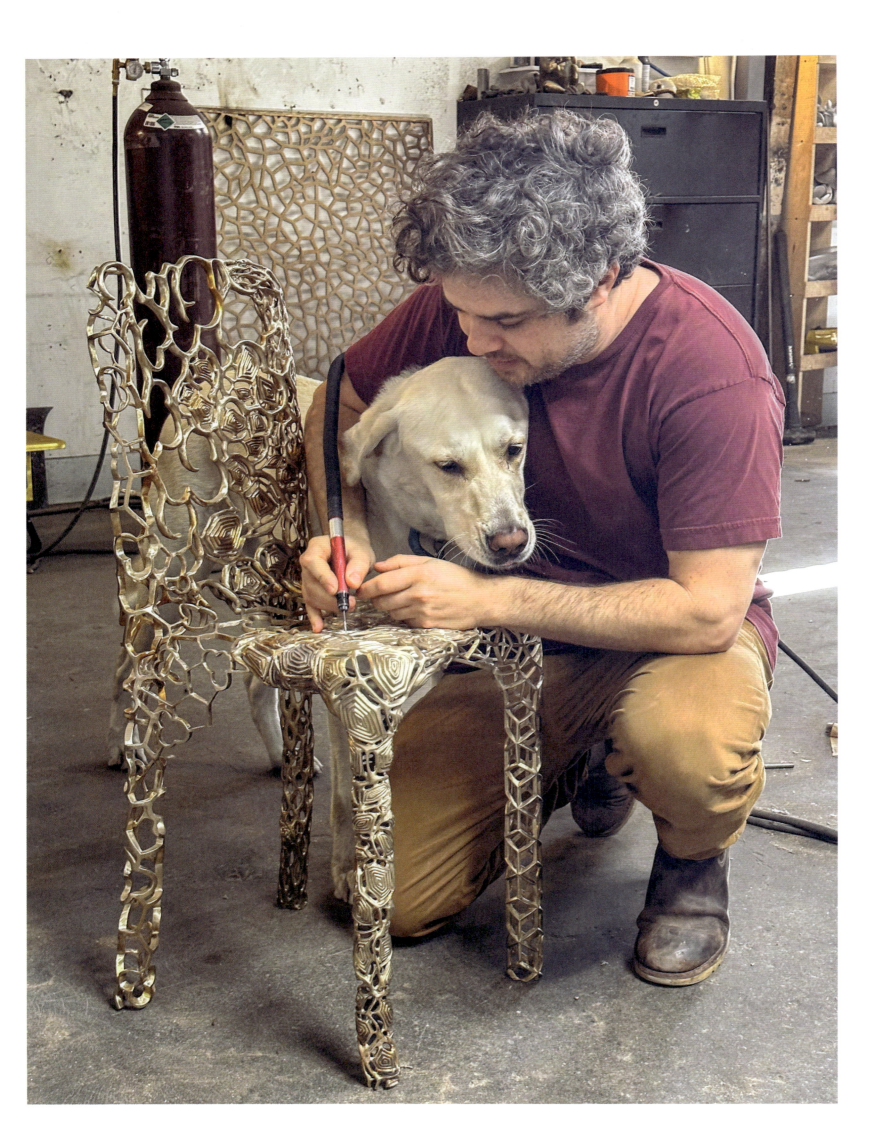

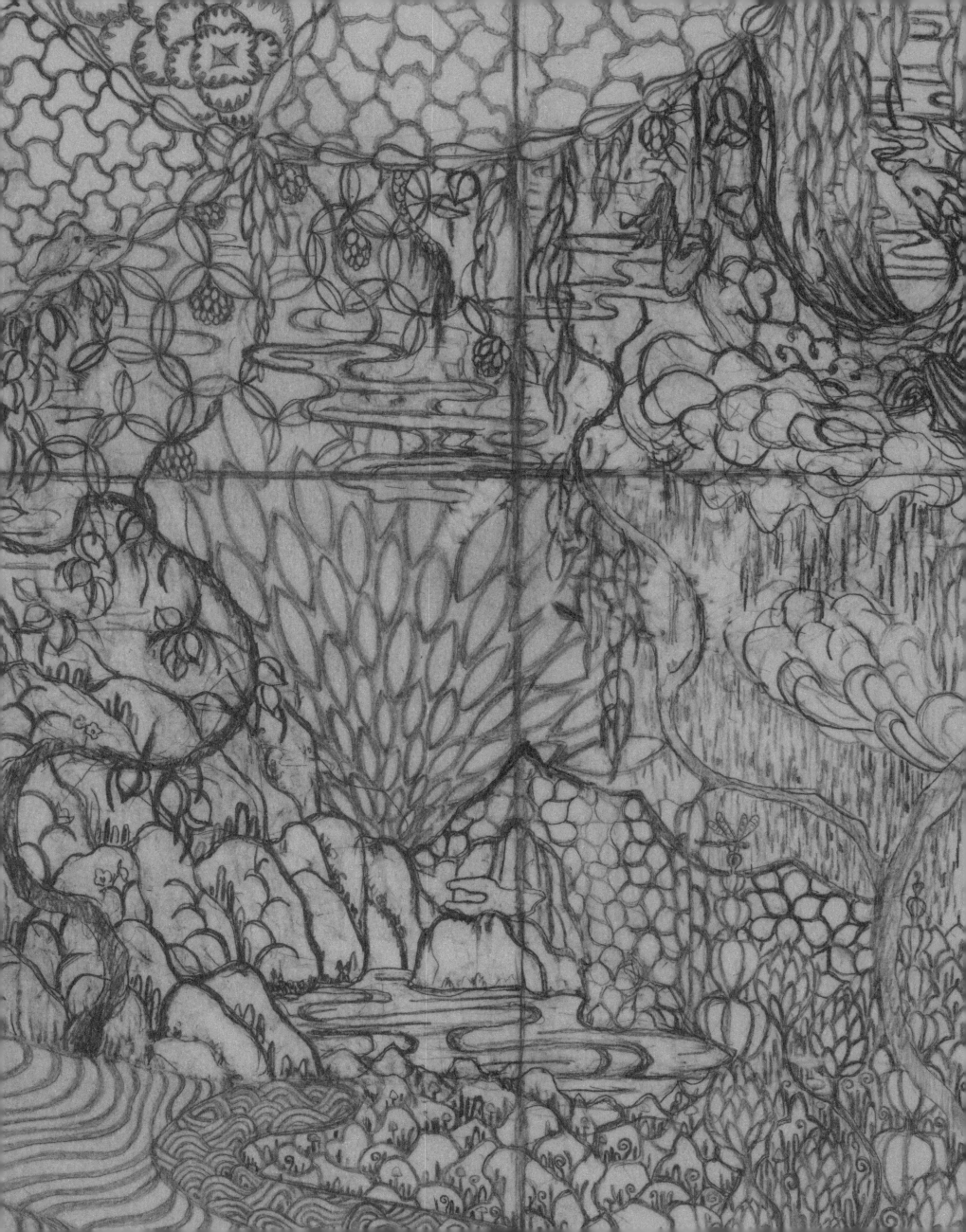

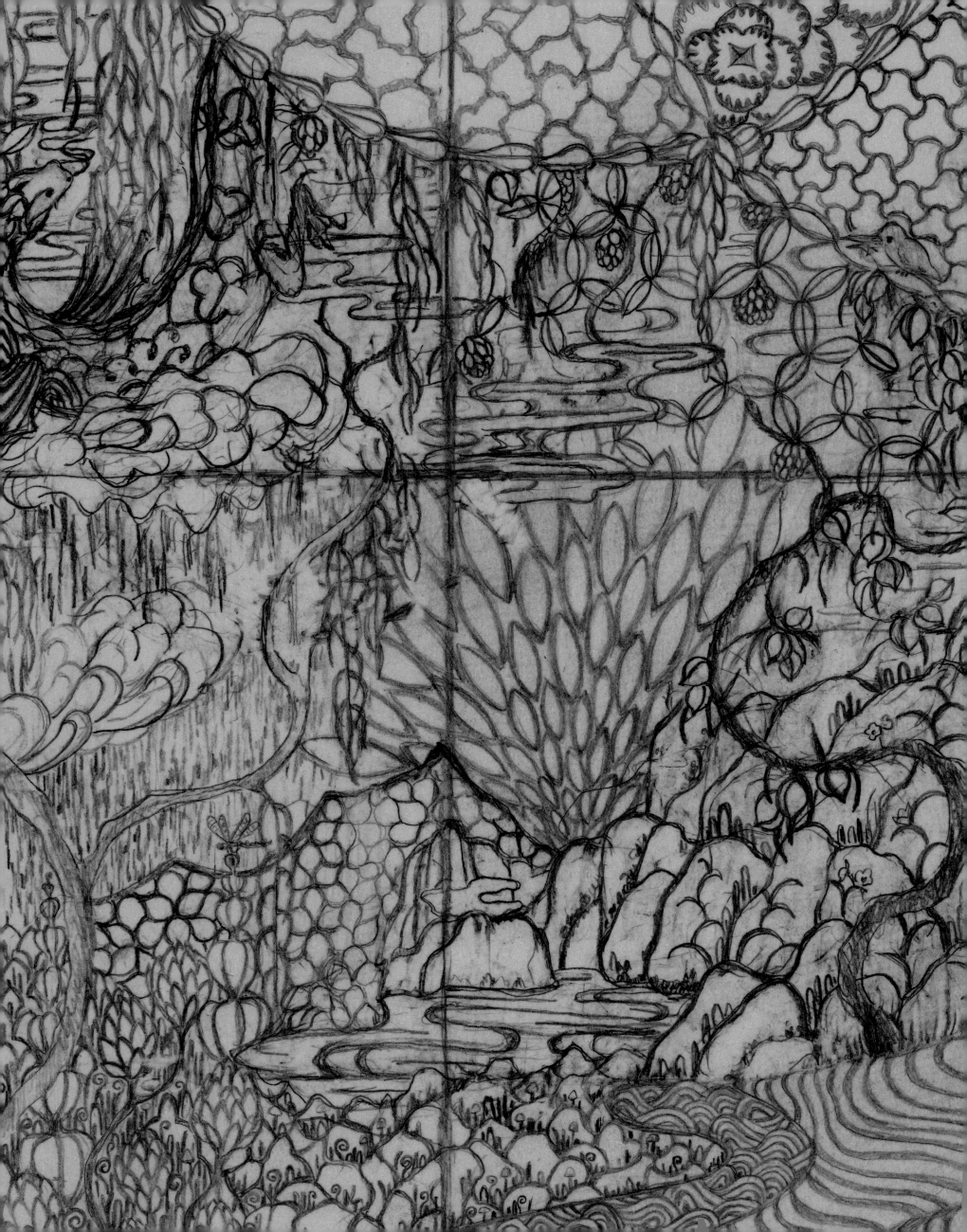

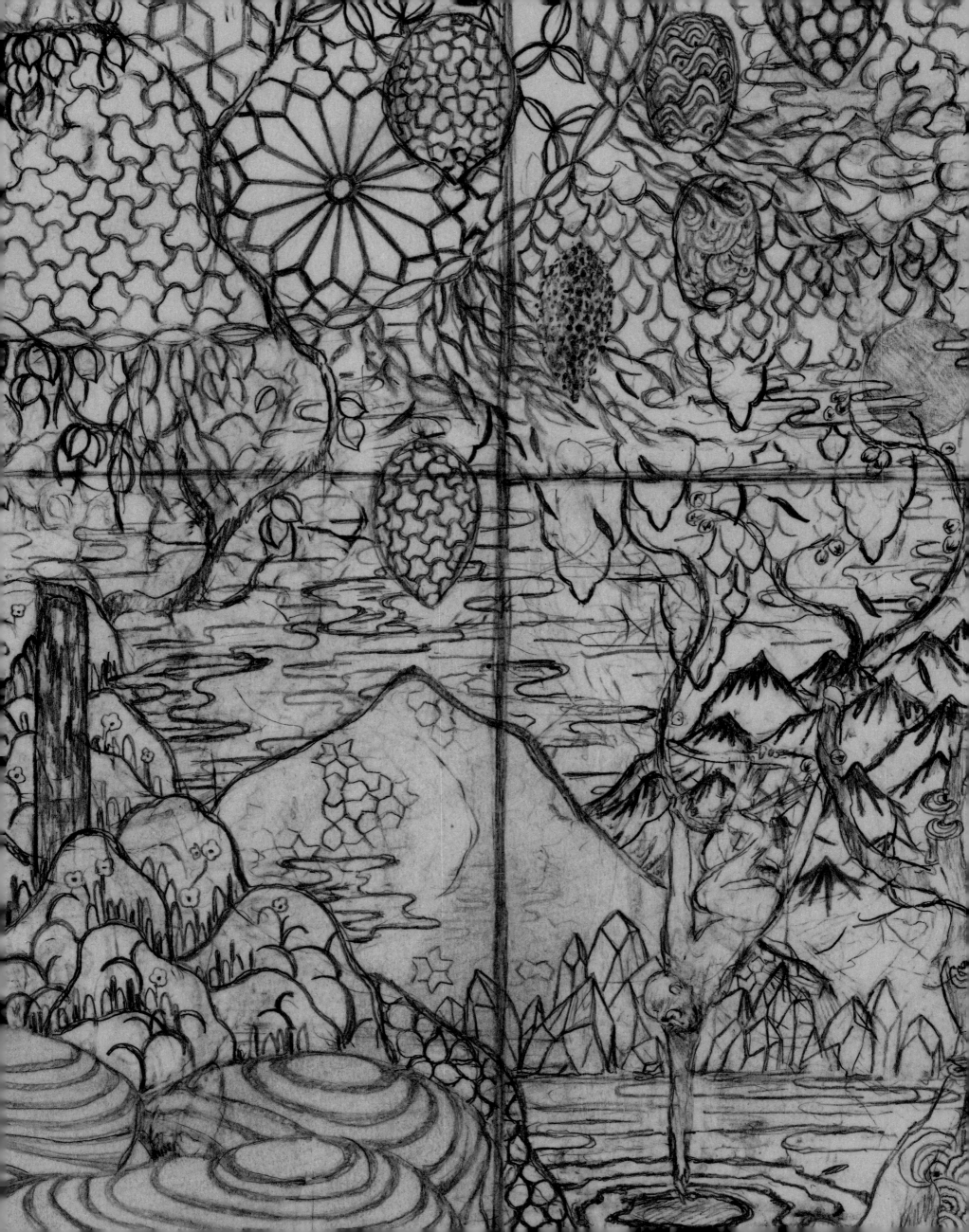

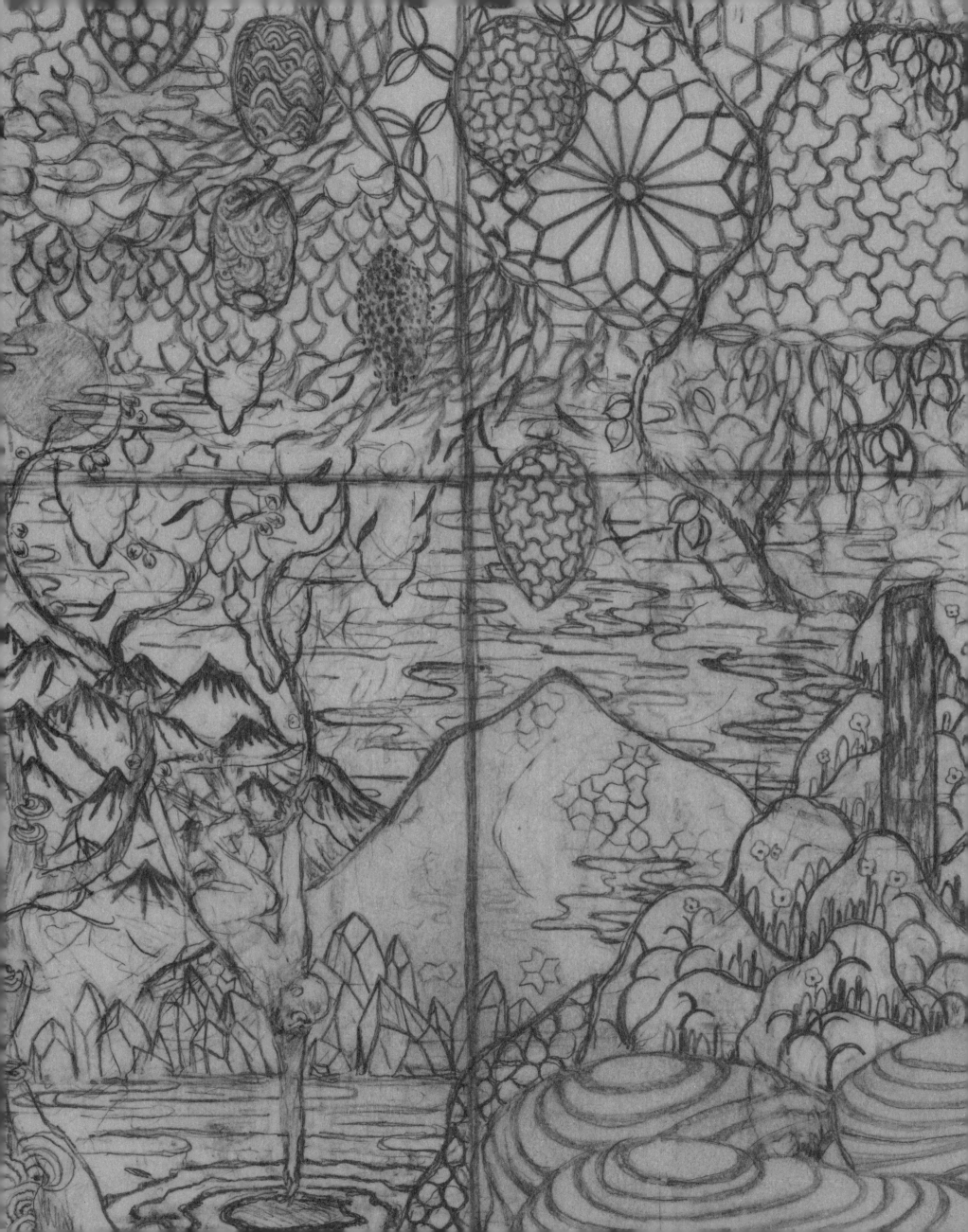

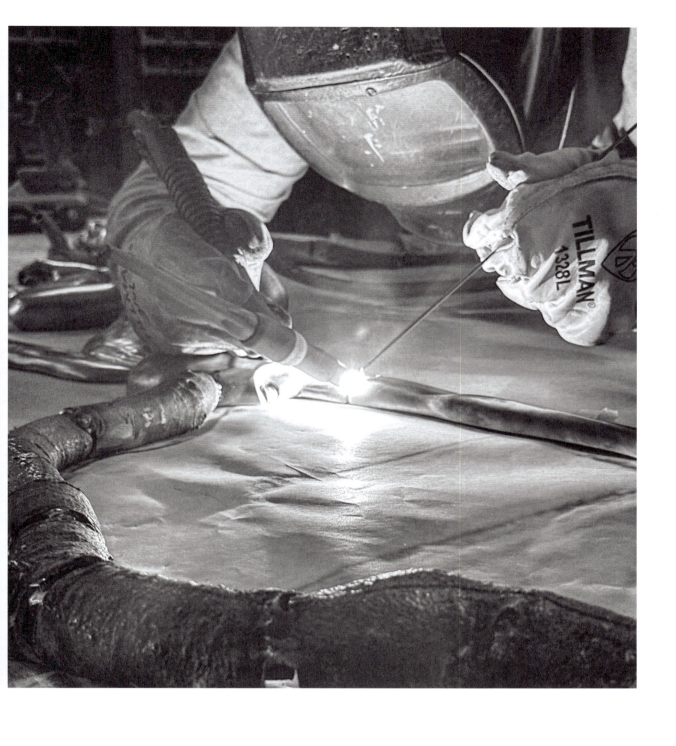
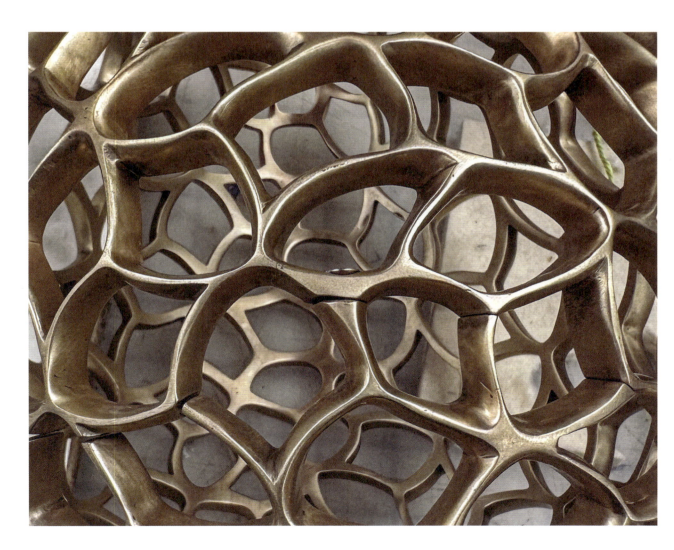

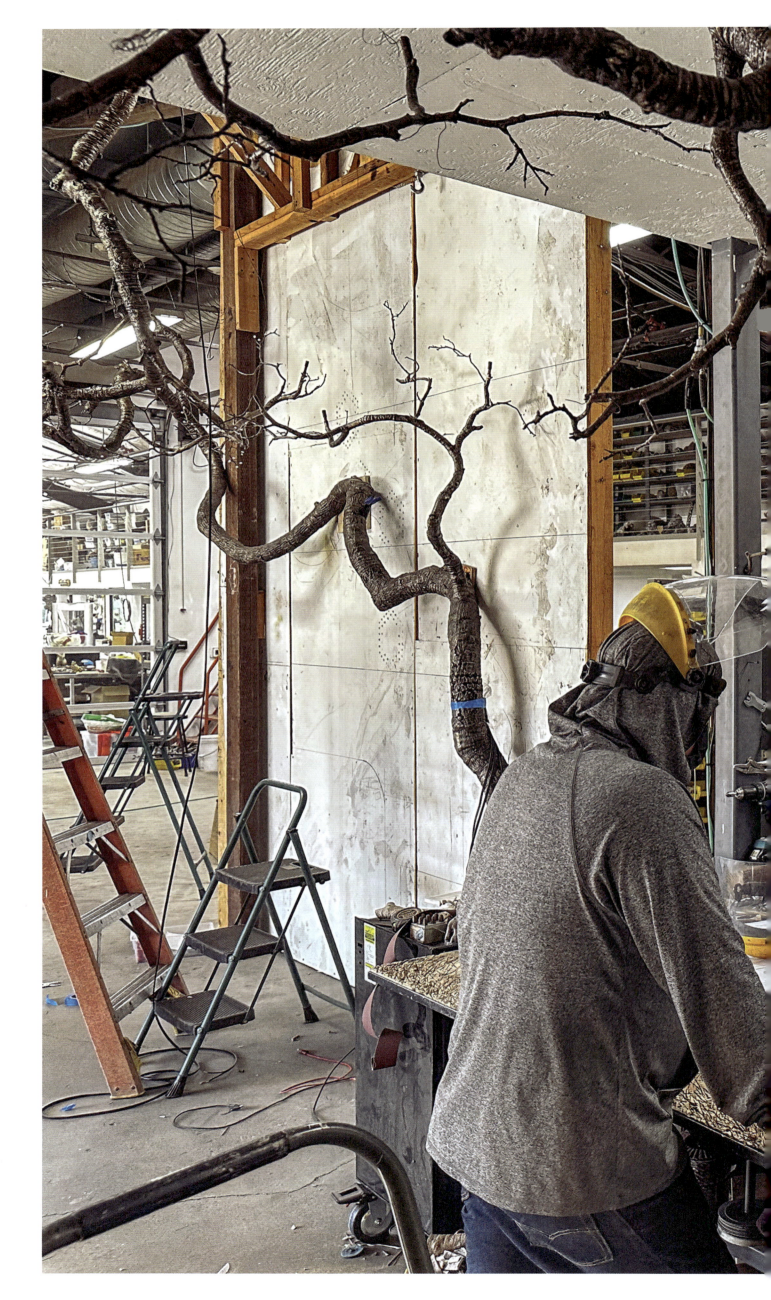

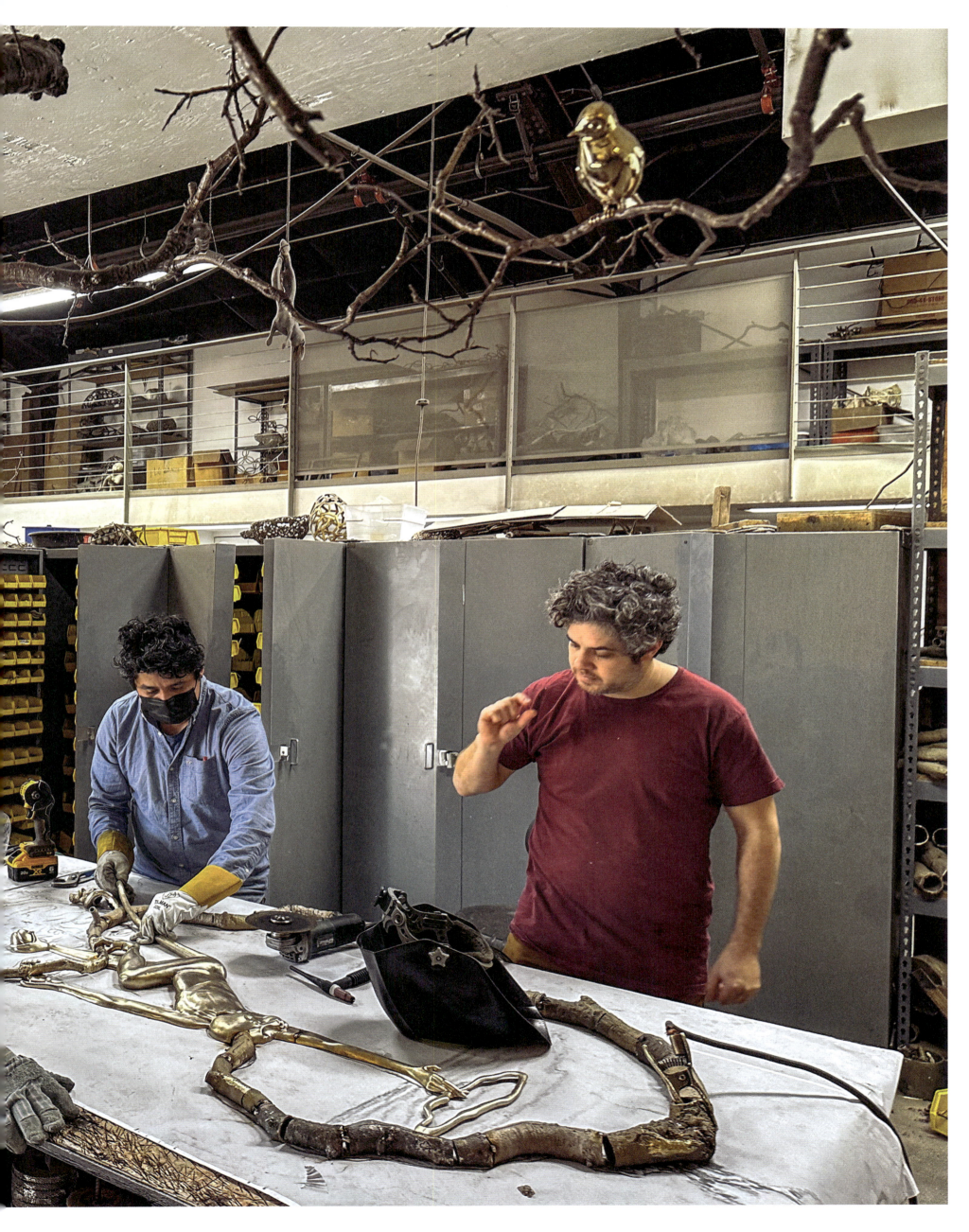

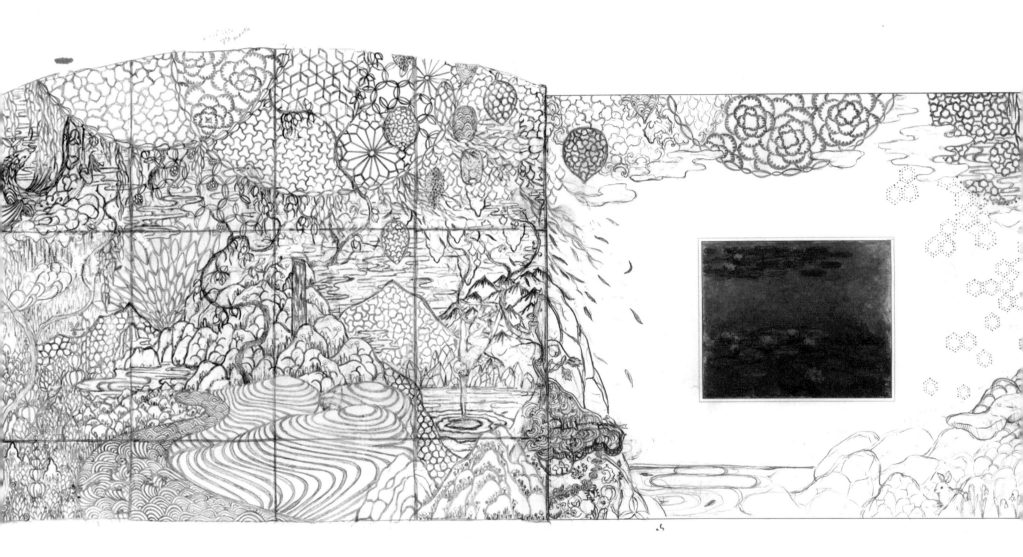

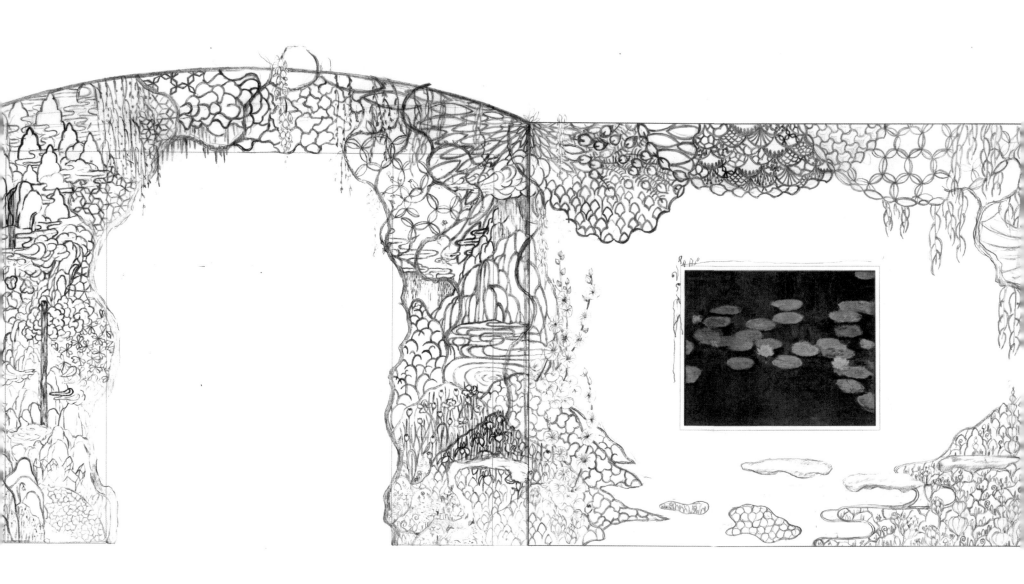

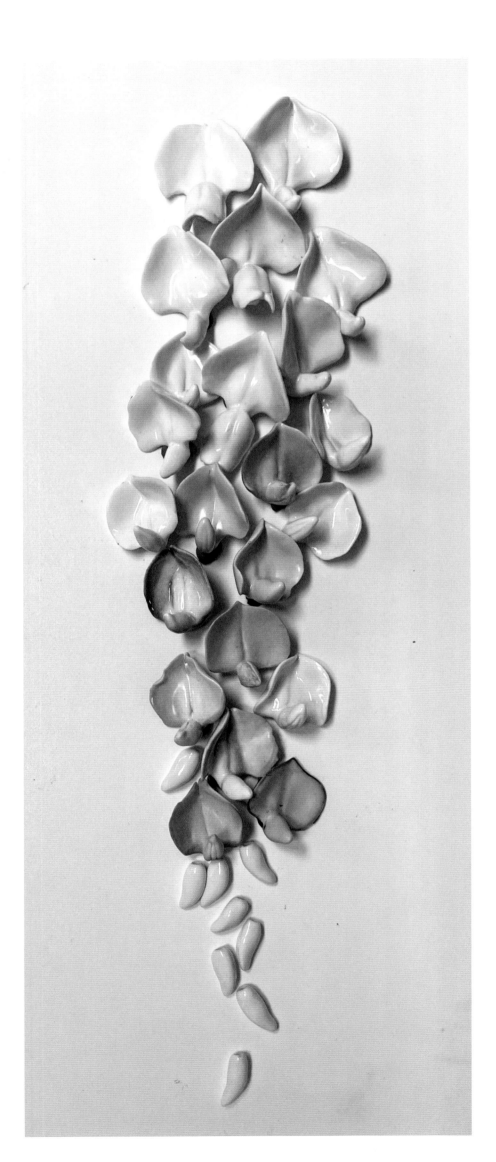

PORCELAIN

There is no other material I know of that can evoke such subtle delicacy and fluidity of form and surface as porcelain. It has captivated my interest since I first began using it many years ago in order to depict glacial mountainous surfaces and sinuous magnolia blossom petals. Like the bronze sculptures, porcelain forms are also derived from my sketches of natural forms, usually to highlight or simplify an element from nature. A slightly enlarged sculpture is created in clay or plasticine with the understanding that the final porcelain casting of the original form will be about 20% smaller after firing. A plaster "slip-cast" mold is created. If it is a simple form, the mold is one single piece. More complex forms require multi-part molds that key together like three-dimensional puzzles. For this process, we are relying on the plaster's unique qualities. In liquid form, it is a soft smooth consistency that can be carefully poured into or on top of a sculptural form. It slowly hardens, (in about twenty minutes) and beautifully captures the impression of the original work. Once cured and dried, plaster is a porous crystalline structure at the microscopic level, which allows it to act as a sponge, absorbing any water that it might come in contact with. The process of casting plaster is fairly simple: we measure the estimated amount of volume we'd like to pour, mix the plaster powder with the correct ratio of water, pour around the artwork, and subsequently remove it from the model once it hardens.

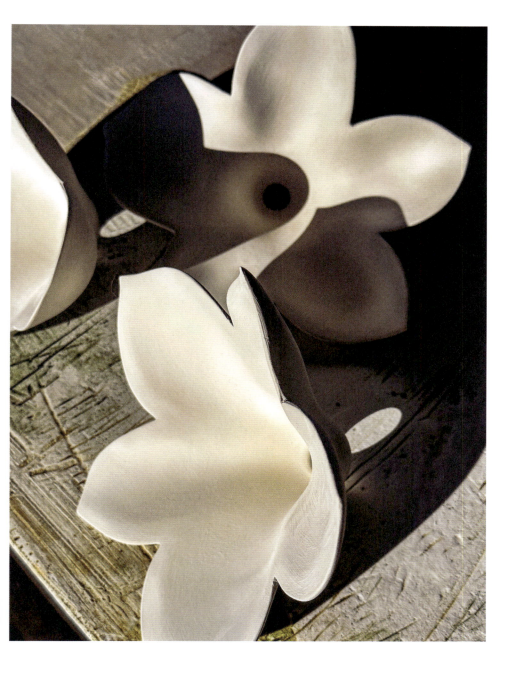

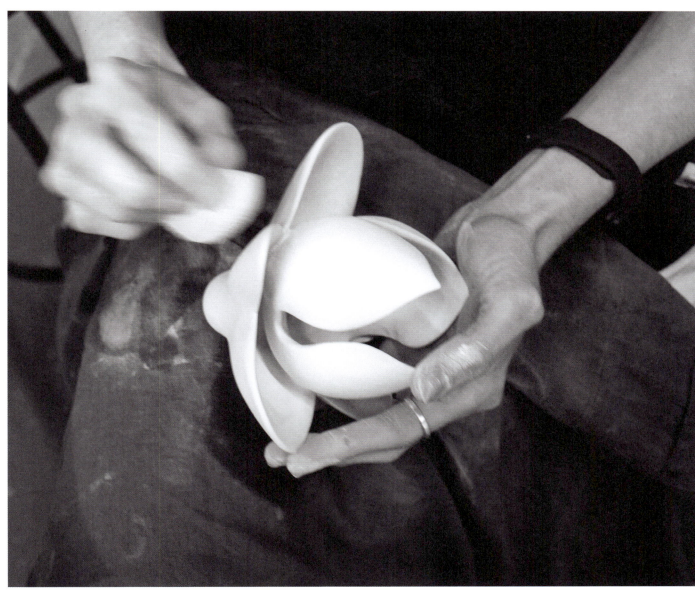

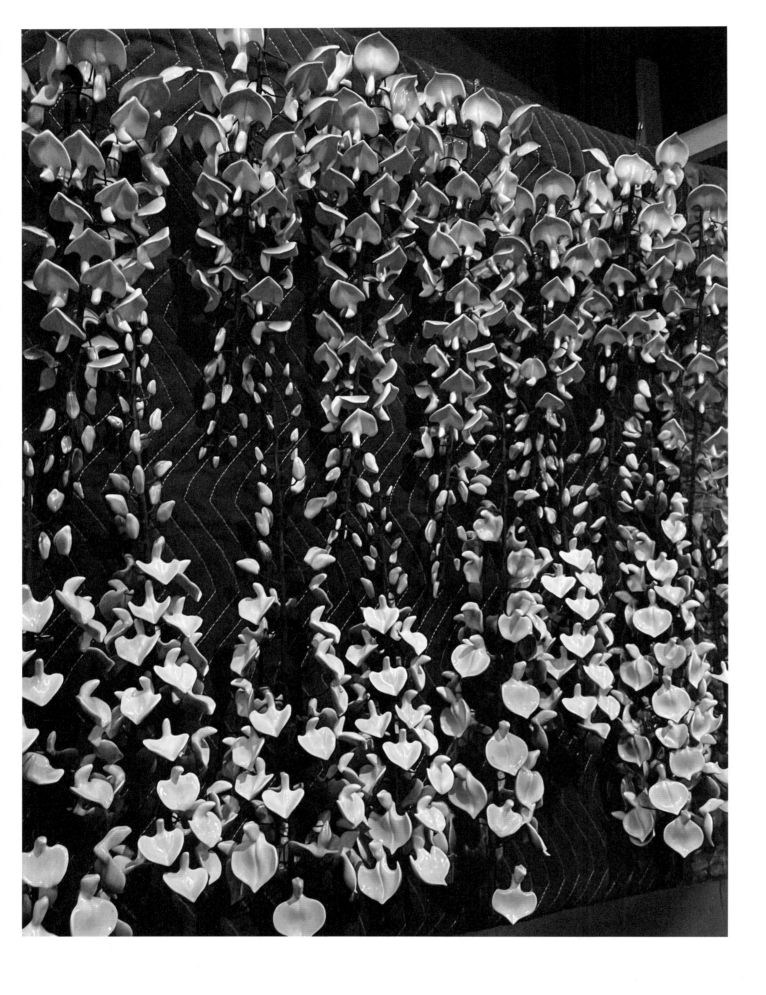

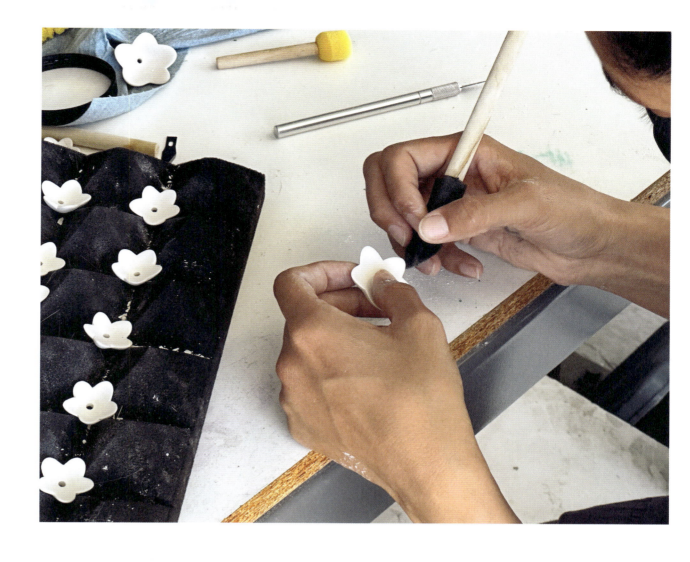
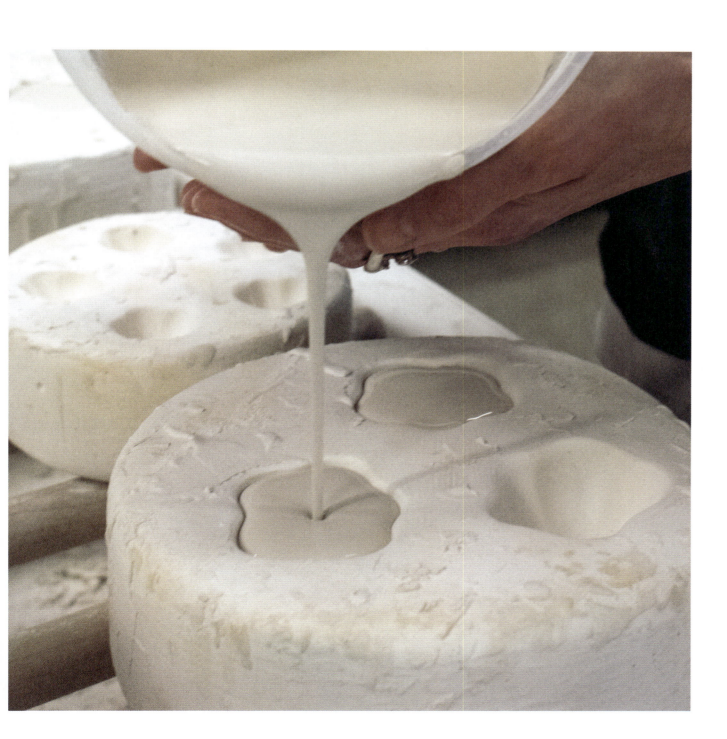

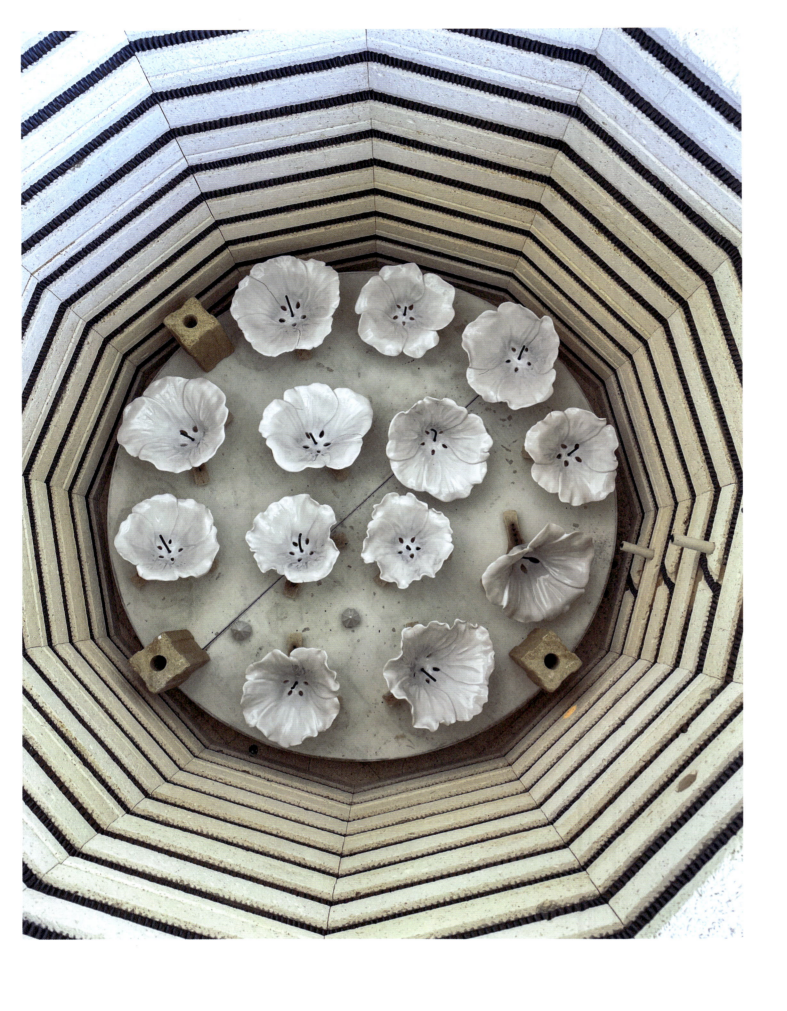

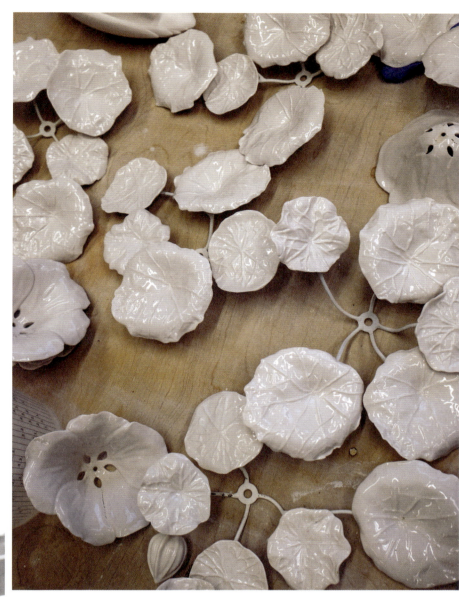
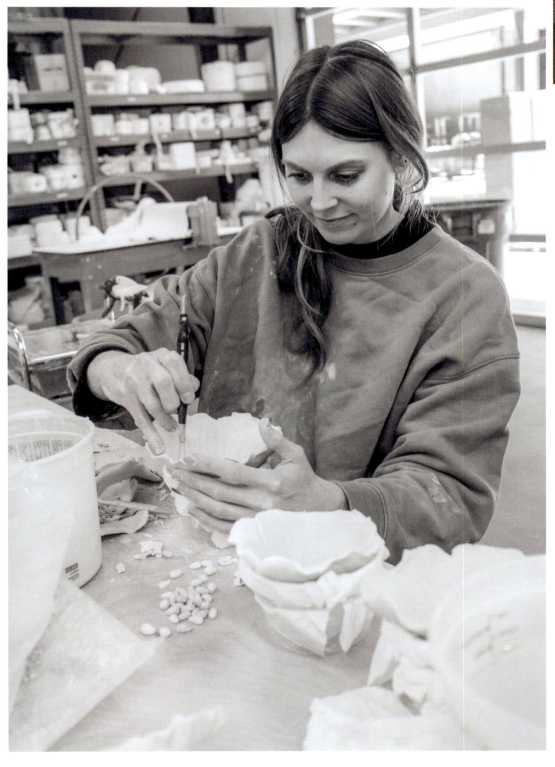

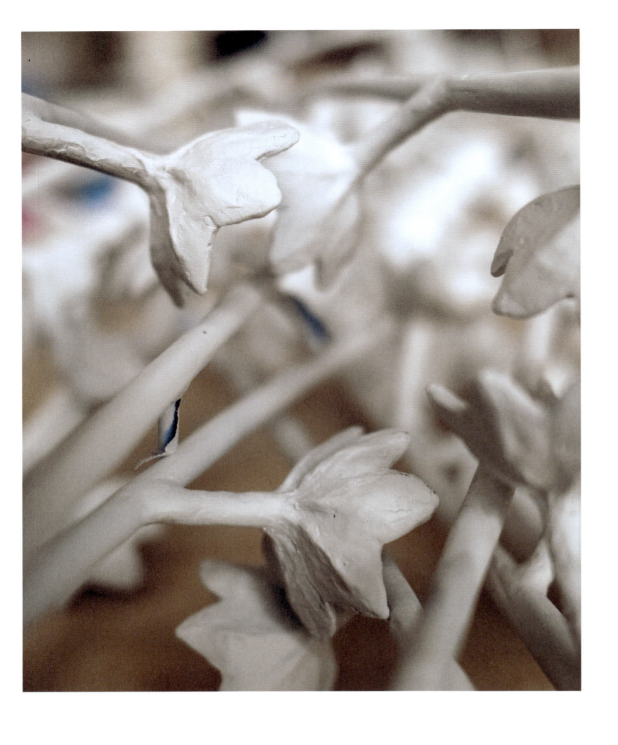
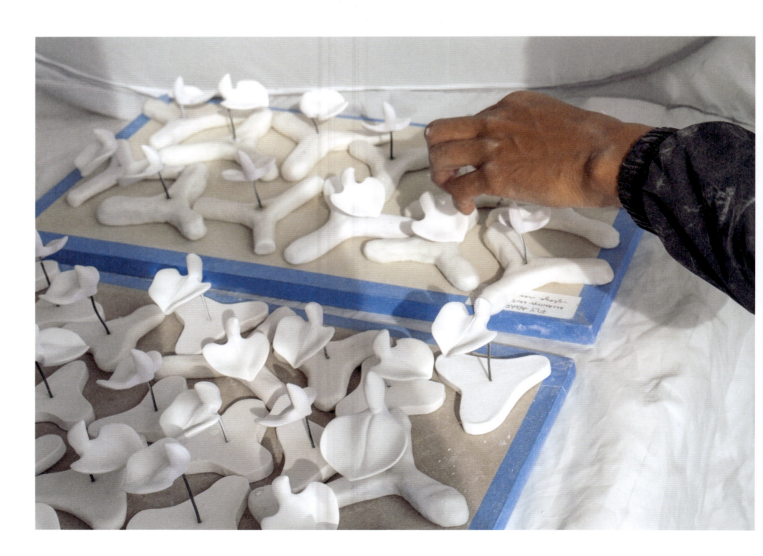

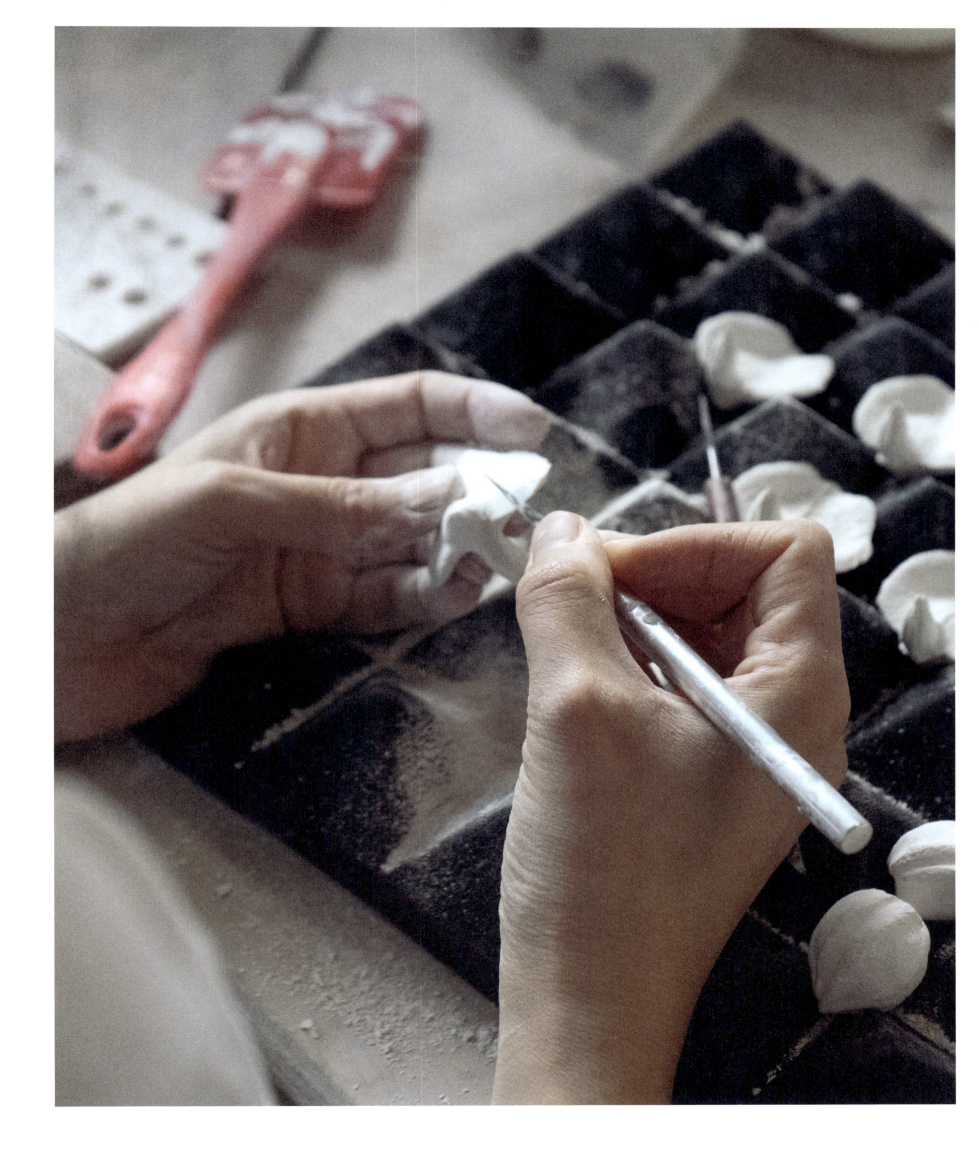

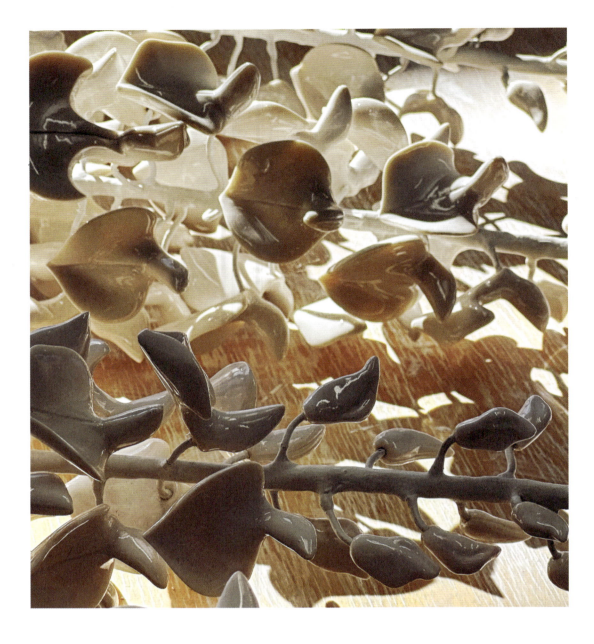

The freshly cast plaster mold needs to dry for a week or two before use. Once dry and ready, we pour our liquid clay, also called slip, into the mold, which immediately starts absorbing the moisture out of the slip, causing it to slightly dry out wherever it makes contact with the plaster. After a couple of minutes, a thin wall of dry-ish slip develops, growing thicker and thicker the longer the slip is allowed to remain in the mold. After the right amount of build up is achieved, we pour the excess slip out and allow the new casting to continue drying in the mold until it can be safely handled and removed.

Once the casting reaches a dryness stage called "leather-hard," it can be safely handled without fearing that it will fall apart. In this stage, the porcelain can be cut, sponged, textured, manipulated, and refined with relative ease.

The castings are allowed to completely dried out, eventually reaching a stage ceramicists call "bone-dry" wherein they can be safely loaded into a kiln and fired. The first firing brings the castings to around 1700 degrees Fahrenheit to change the nature of the material from fragile, crack-prone fresh clay, or "green-ware," to a more durable state known as "bisque-ware." In this half-fired state, the porcelain casting hardens, becoming more vitreous or glass-like. It can now be handled and glazed—a process of applying a fine ceramic and glass powder to the exterior, adding a particular coating, color, or sheen. There are so many glaze color and surface options and the studio is constantly experimenting with new recipes and application techniques, as each new form requires many tests and samples to achieve the desired result. Once applied, the glazed bisque-ware is ready for a full firing at 2200 degrees Fahrenheit. This process can require up to 24 hours in order to slowly heat and gently cool the porcelain before removing it from the kiln.

The porcelain pieces are then included in any number of works, some taking the shape of an illuminated magnolia blossom, others a dense installation of blooming wisteria buds and flowers. I've always loved the contrast between porcelain and other media like bronze and plaster. I often employ porcelain to heighten the experience of natural ephemera, petals, fruits, and blooms.

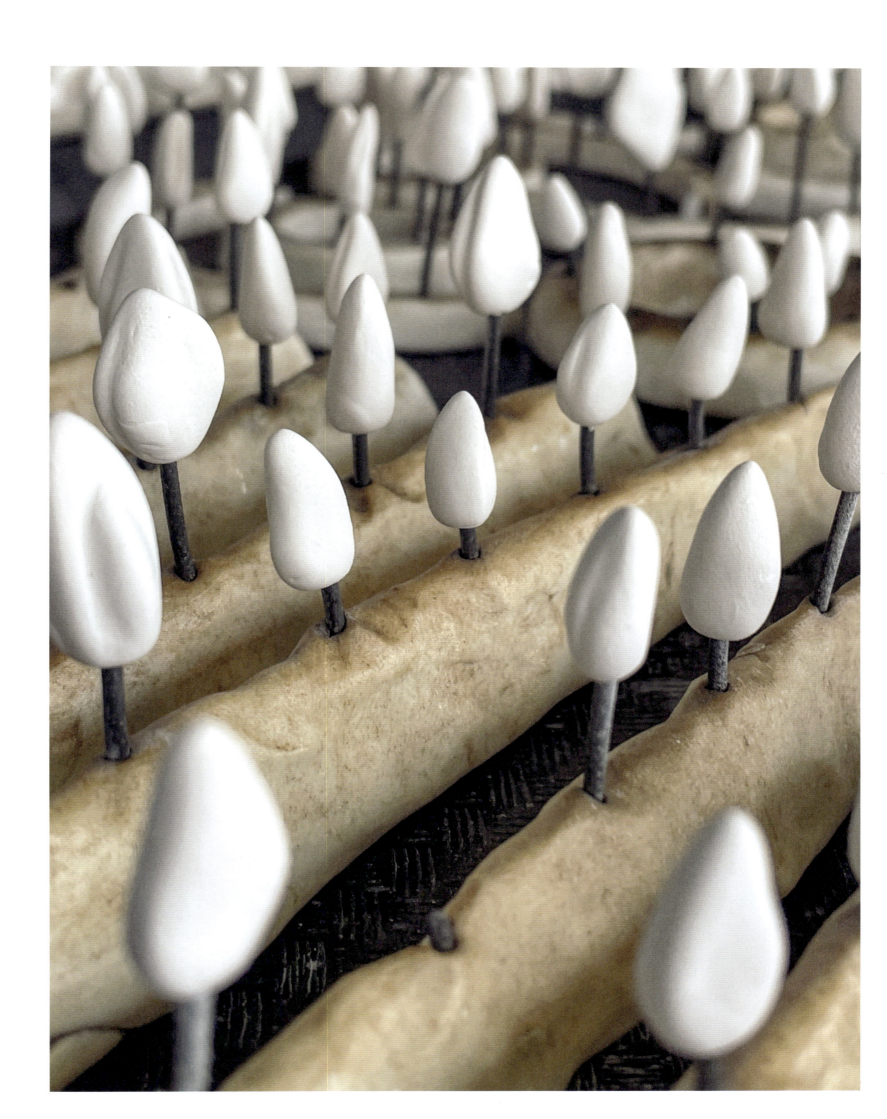

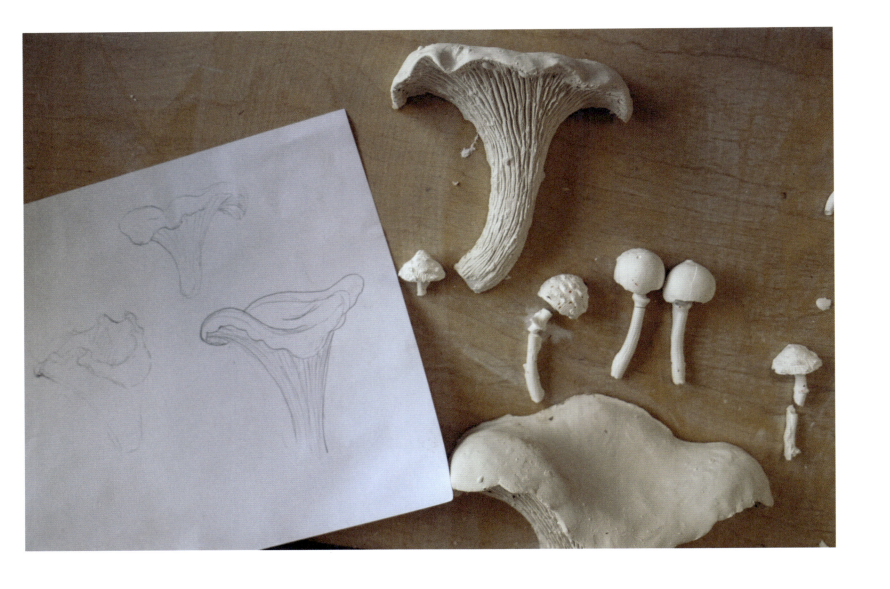
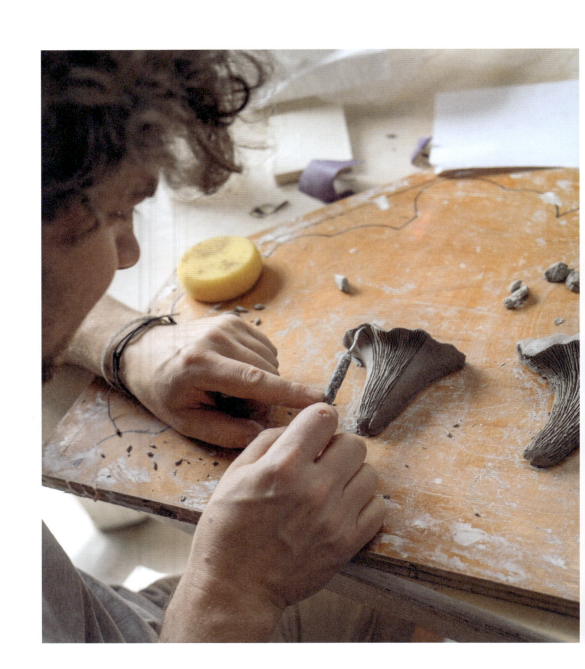

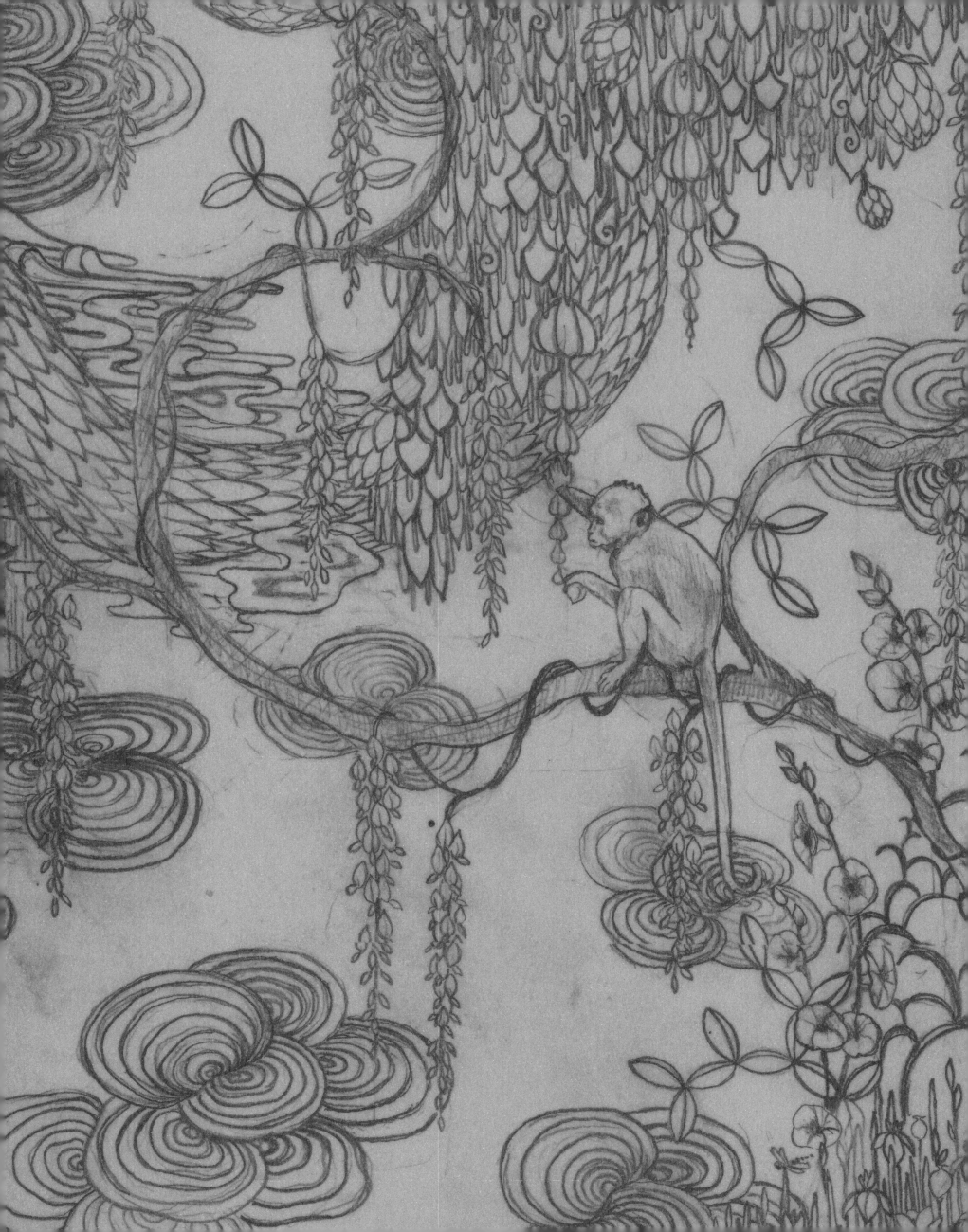

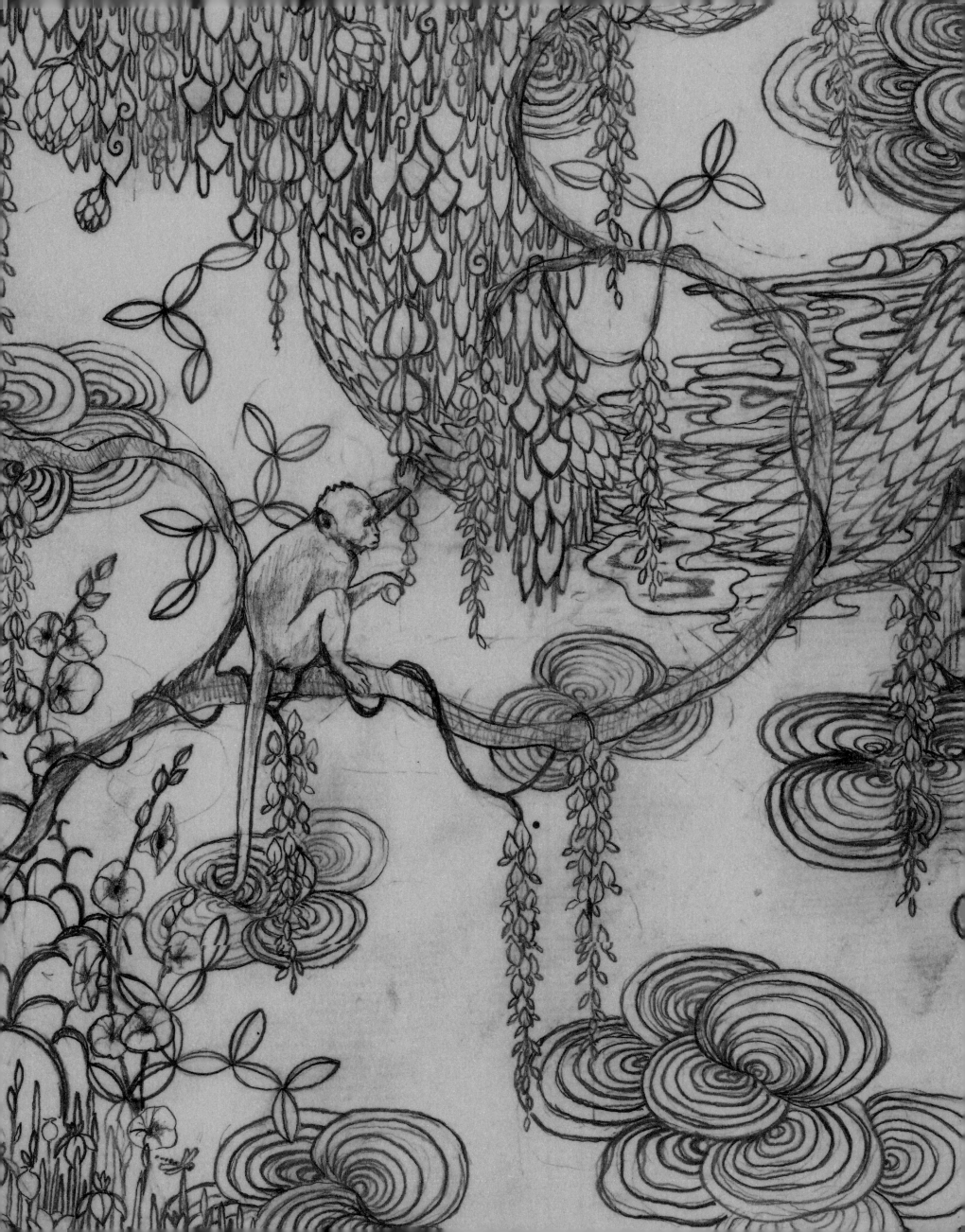

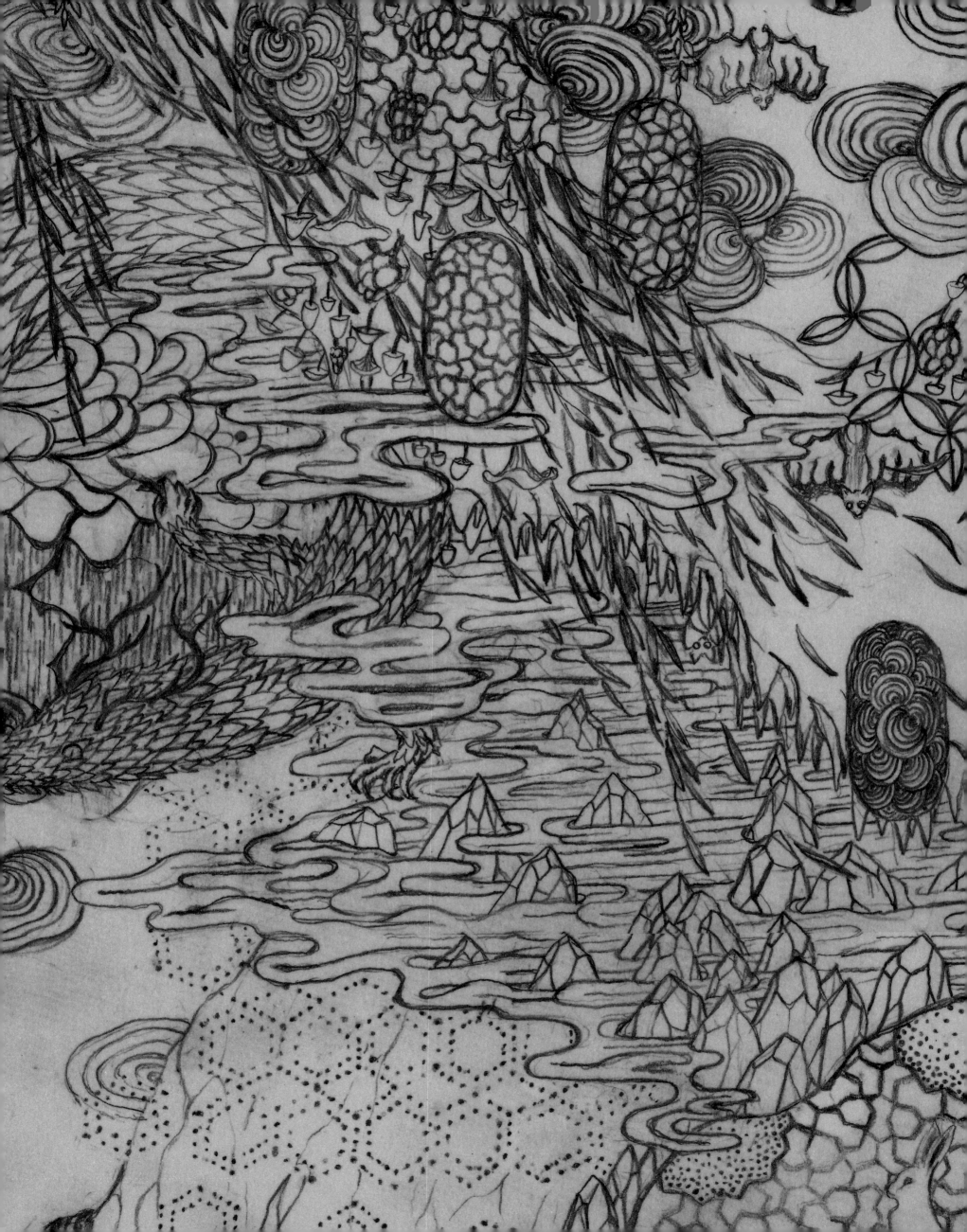

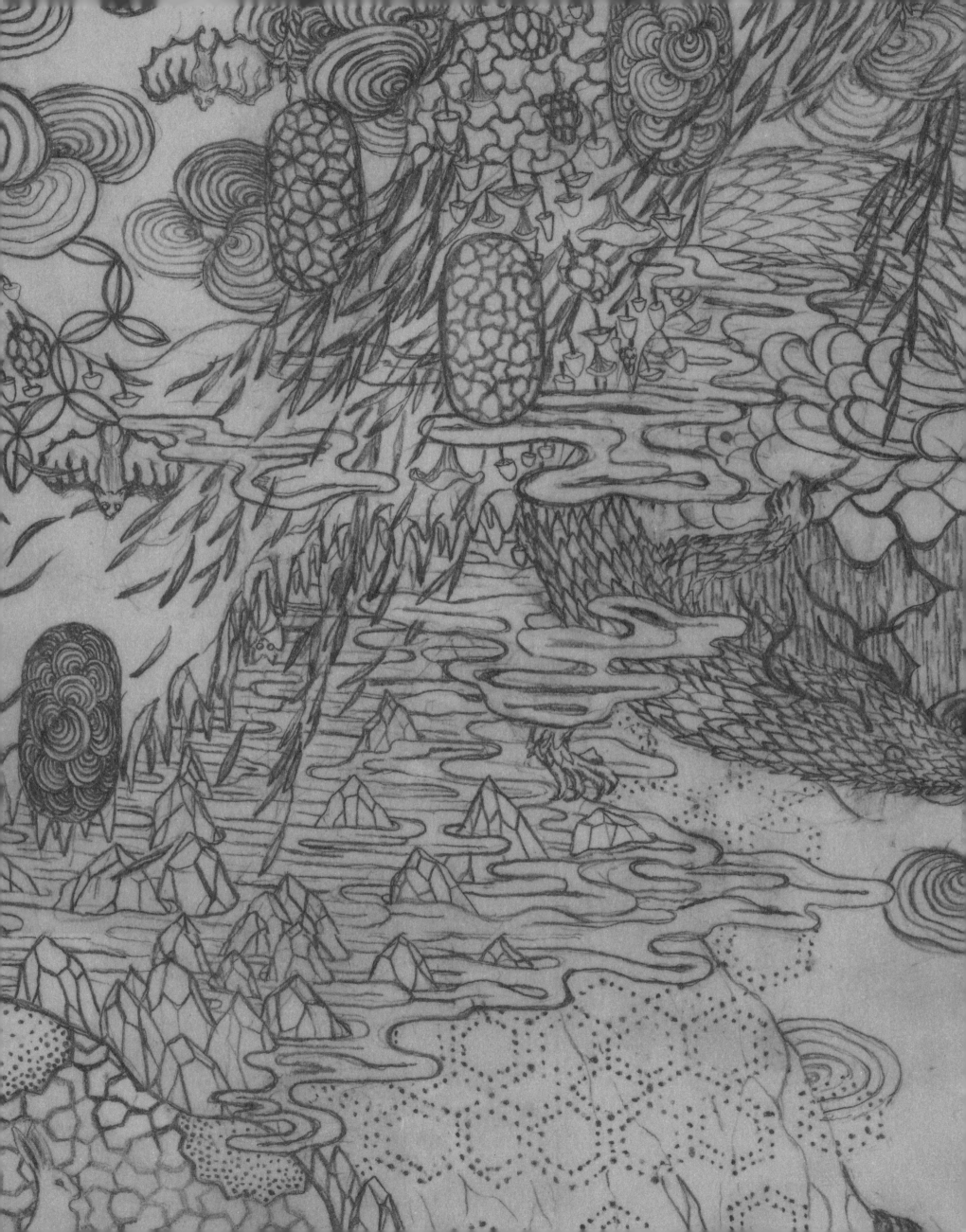

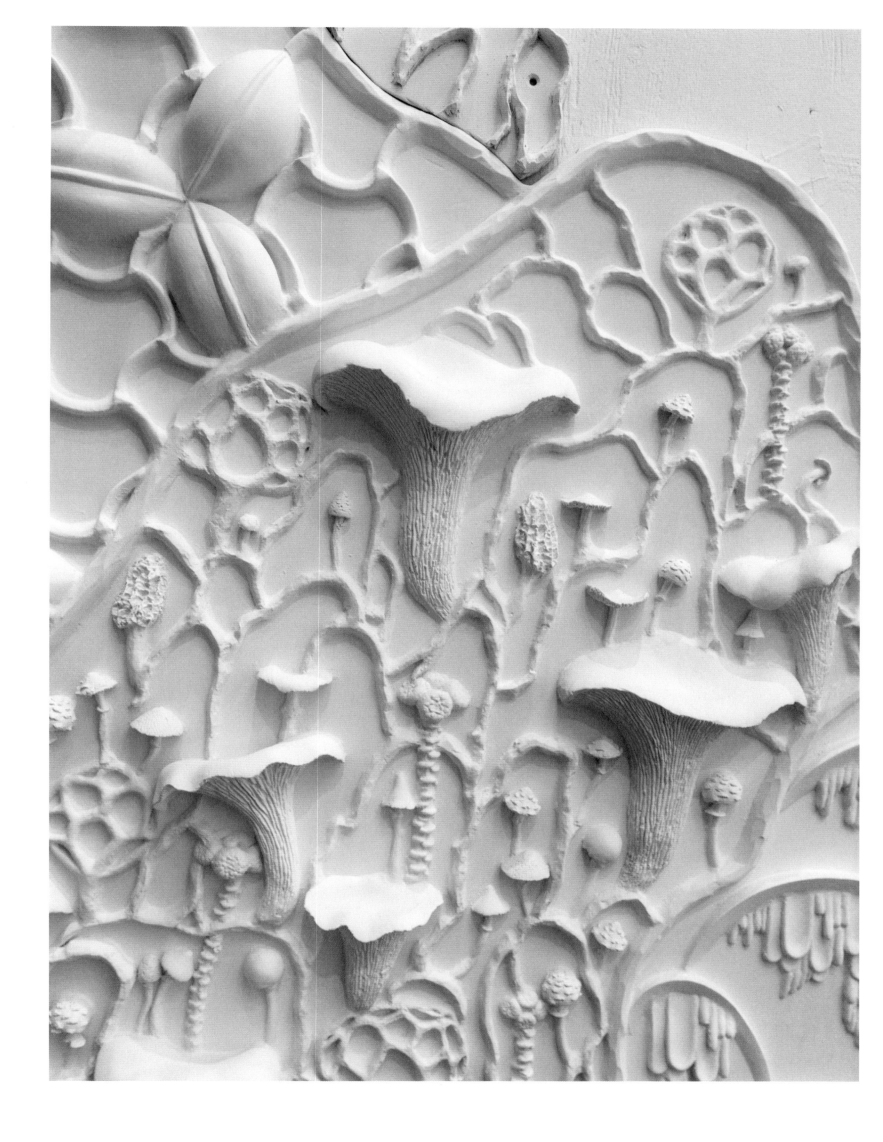

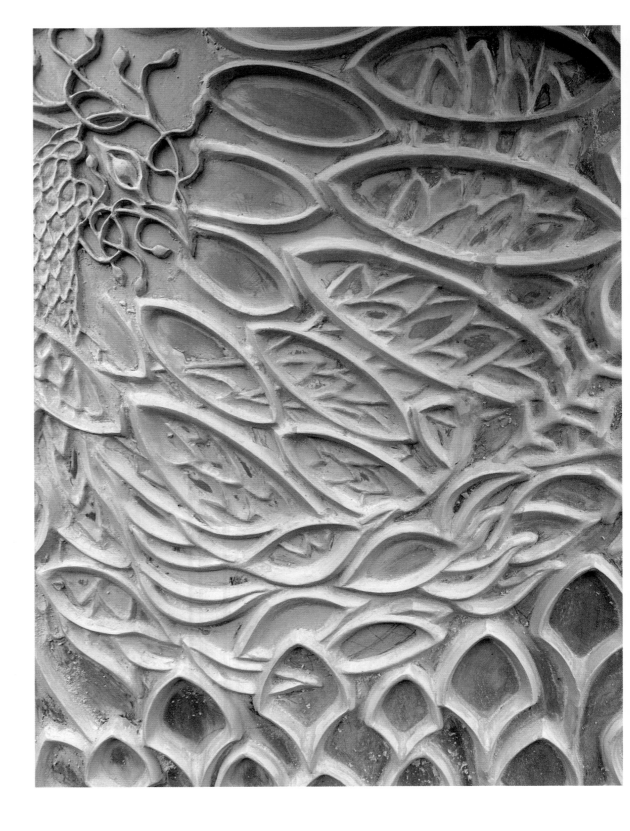

PLASTER

I created some of my first works using plaster because it is such a versatile material. I love the act of sculpting it, using chisels, rasps, and other tools to refine its form, and then seeing how quickly it can be sanded when it's wet and then refined into a finished form. I also love the ritual of mixing the dried powder into the bucket of water: how it feels, how it smells. After a few minutes of gently mixing, making sure to remove any remaining powder clumps, the plaster begins to thicken and is ready to pour, either into a mold or over a form for sculpting. After another few minutes, it thickens to a cool-whip consistency, and in a few more, it will be a solid.

Plaster is used frequently in the studio—sometimes as a mold making material, at other times as a finished work in and of itself. When that is the case, the goal is usually for the object to become one with its adjoining surface. Like each of the materials I use, the plaster forms always start from sketches that are then sculpted. A rubber mold is usually created and additional plasters are cast. They are dried, sanded, refined, and adhered to a ceiling, panel, or wall. Typically, my goal for the plasterwork is to feel integrated into the surrounding architecture, like an apparition beginning to emerge and disappear from the surface. I've always loved how a static wall can be transformed by relief and appear to be an ether through which animals, patterns, and branches can travel.

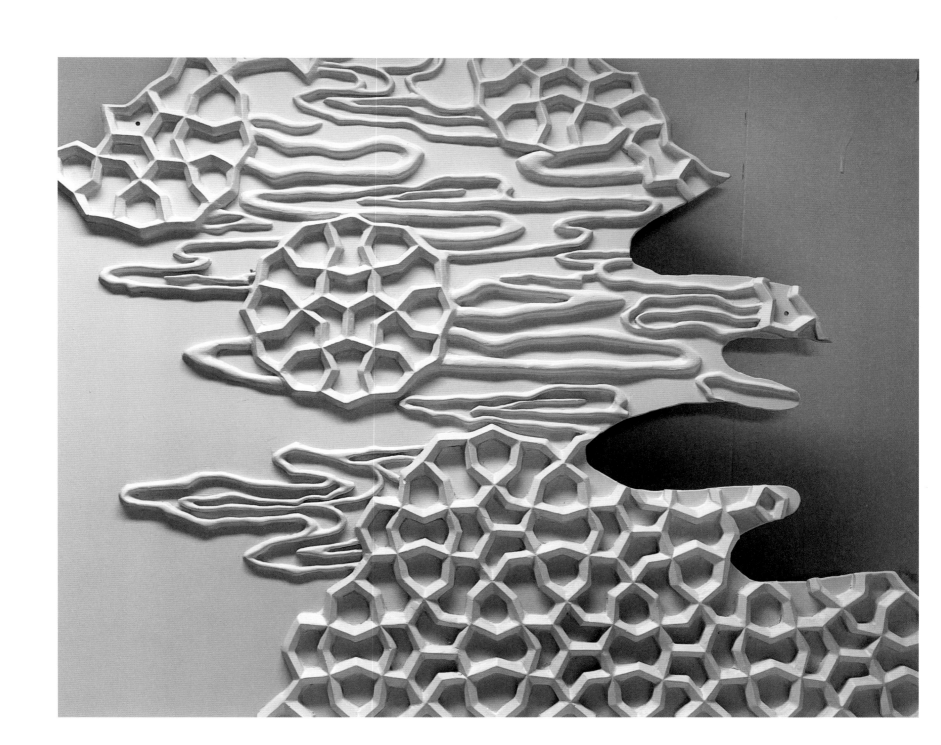

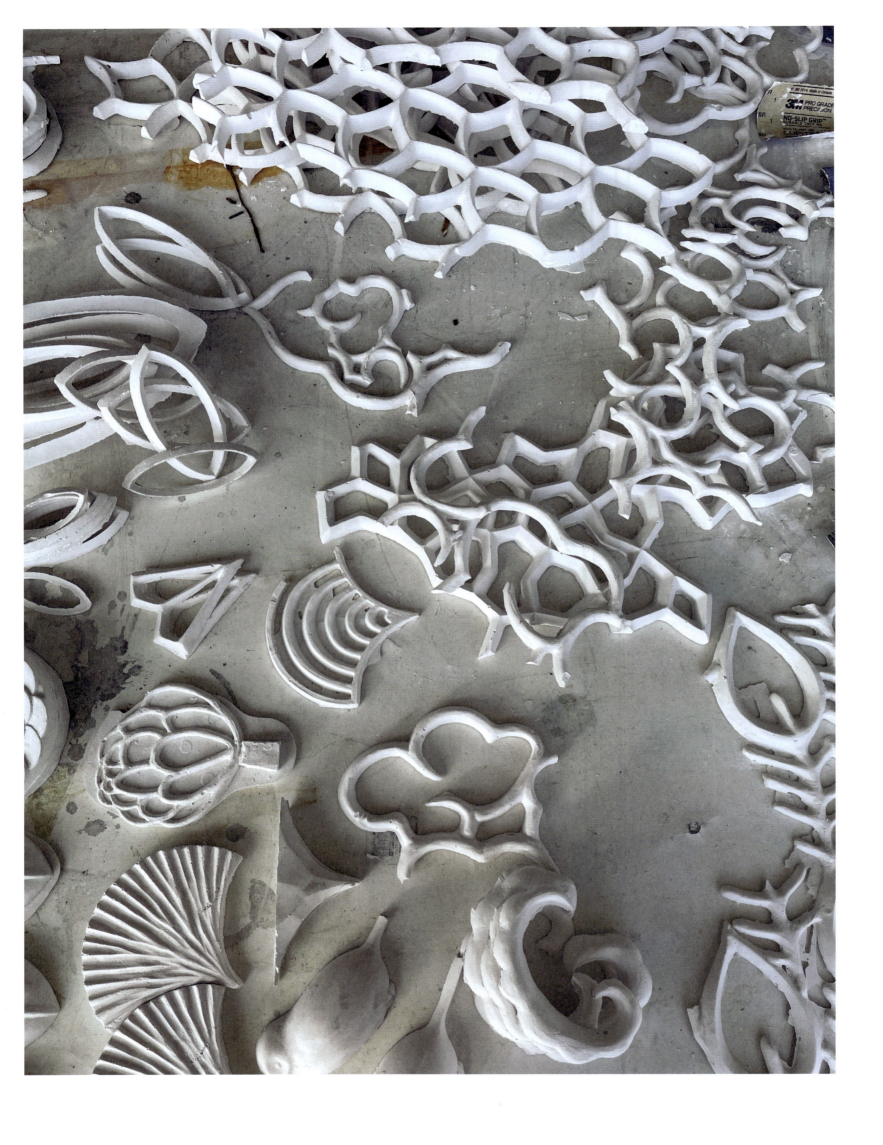

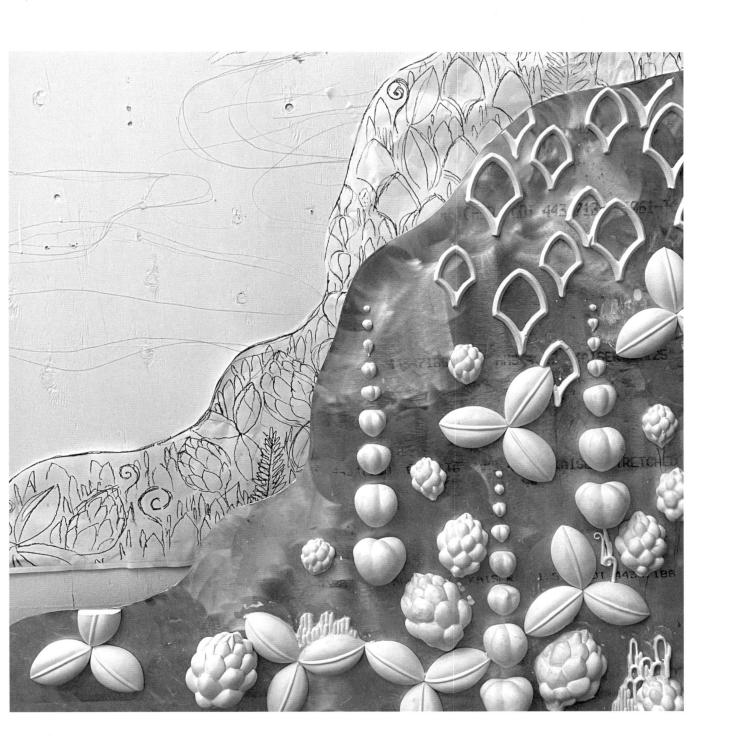

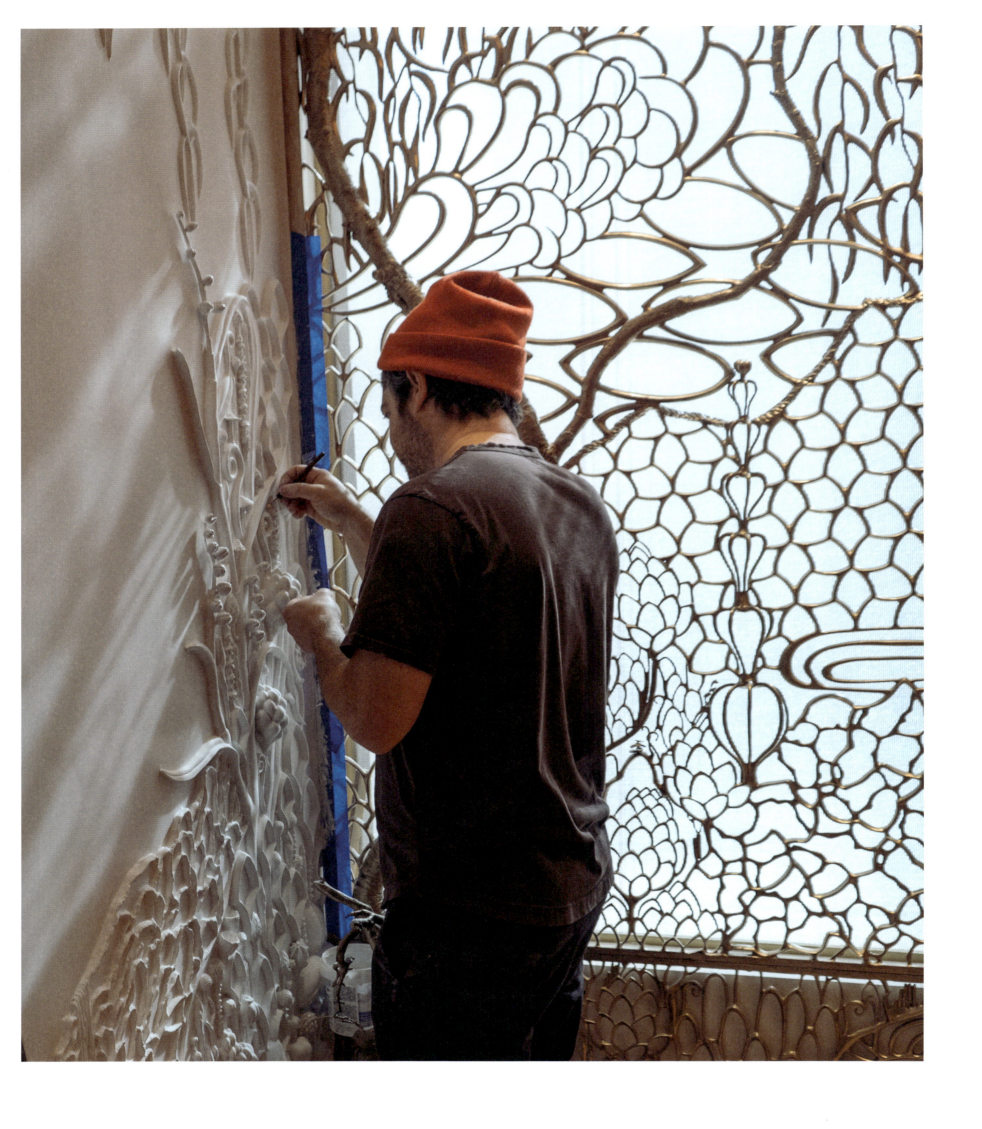

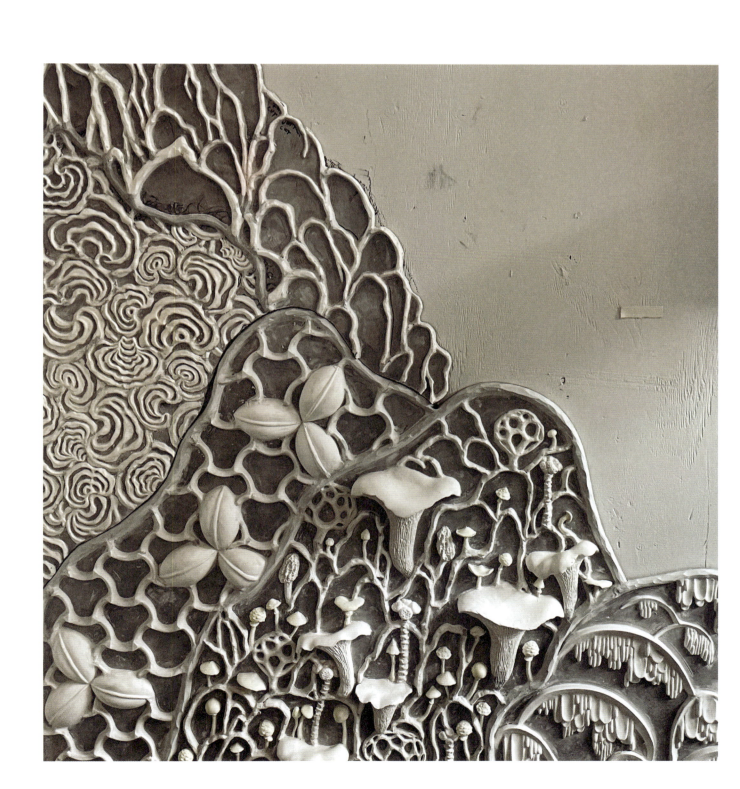

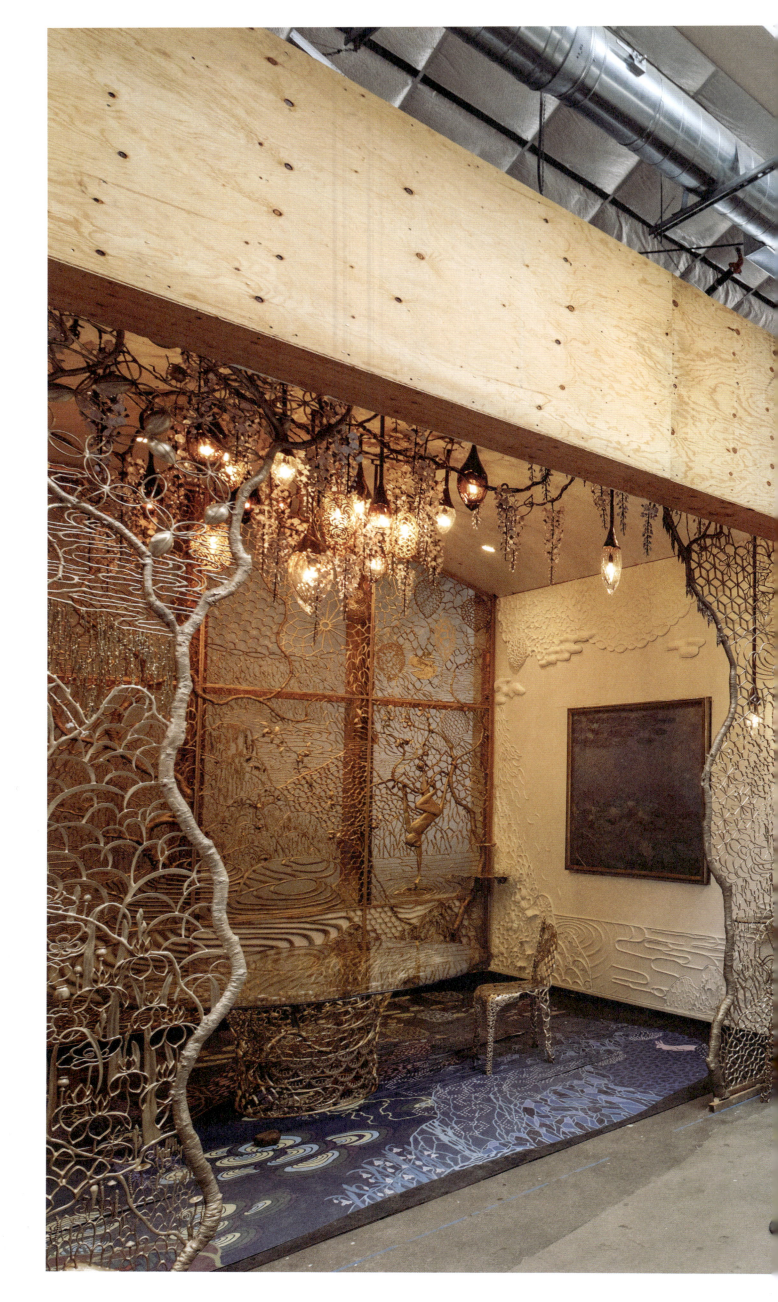

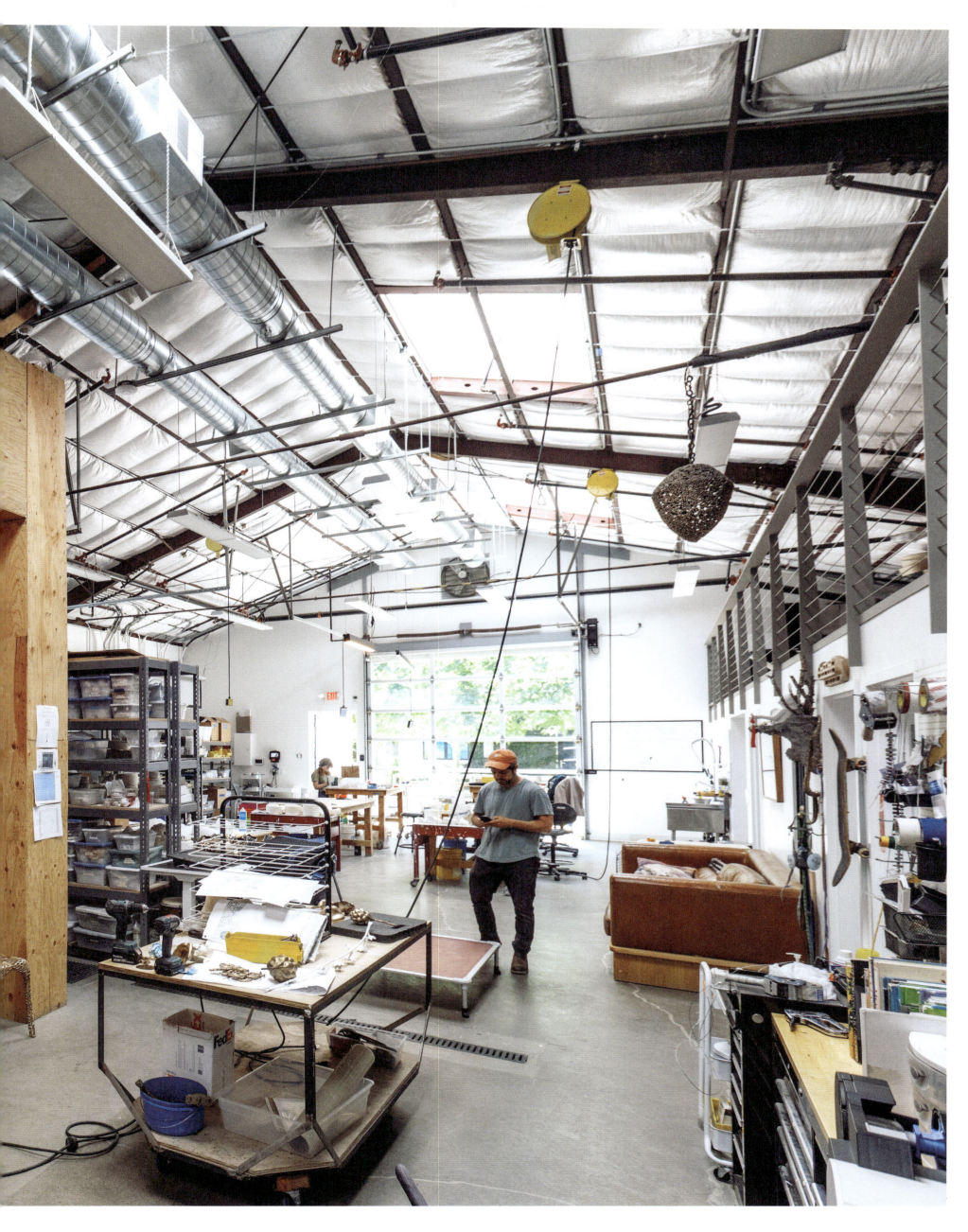

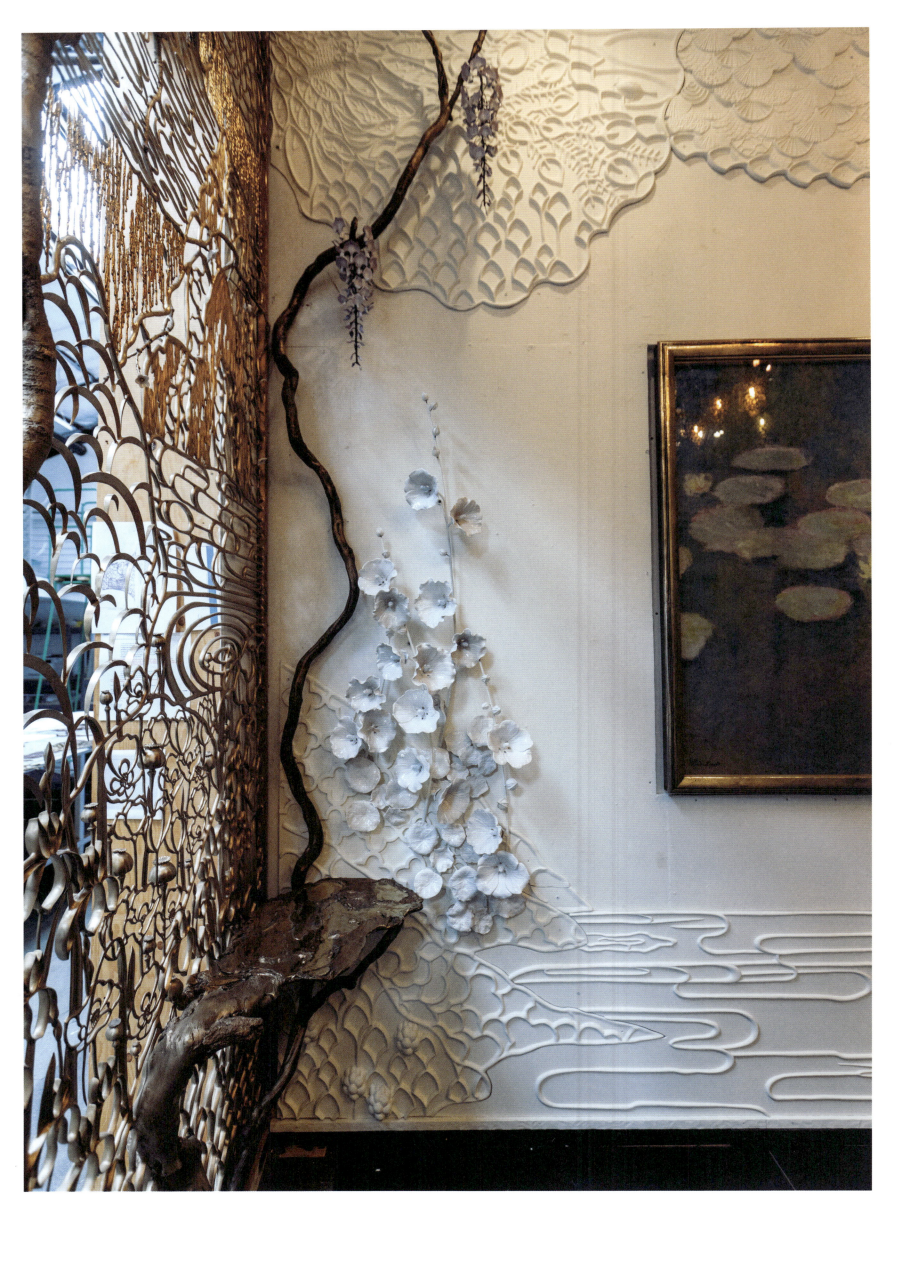

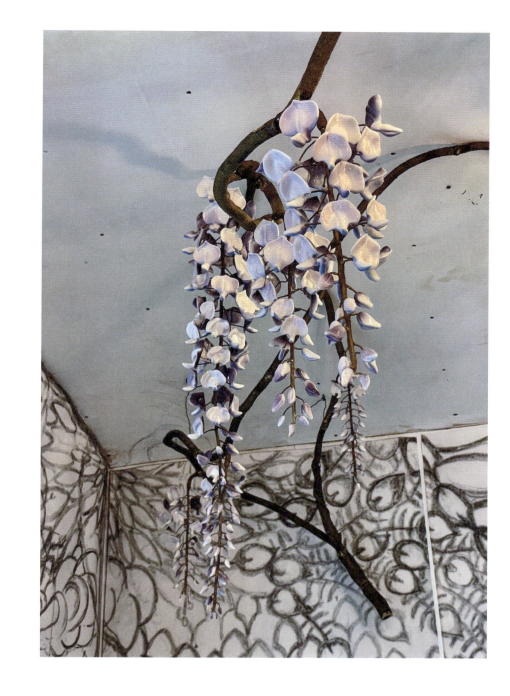
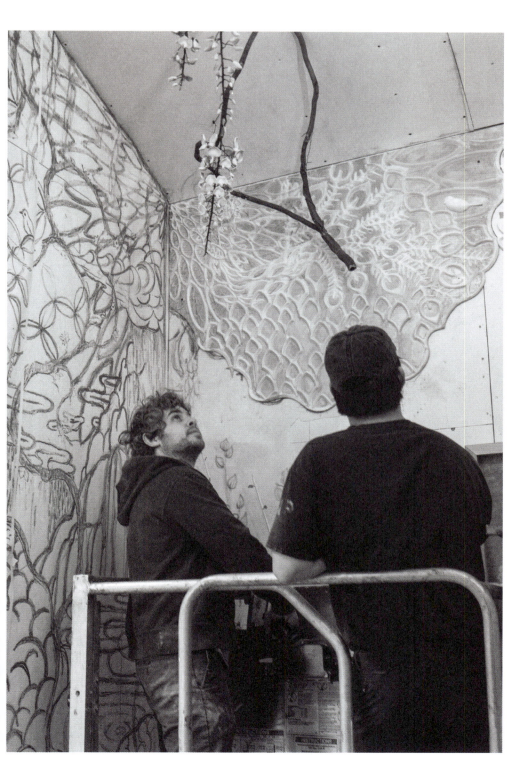

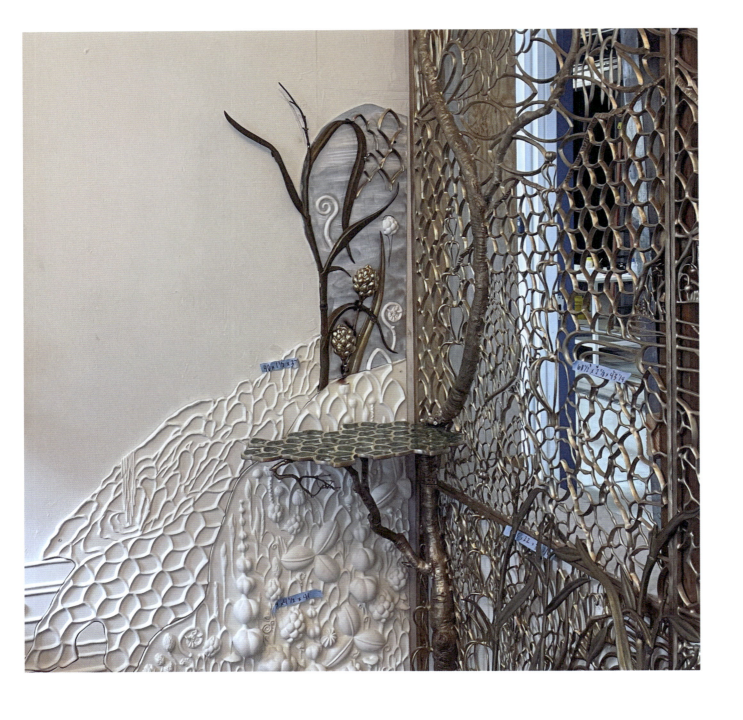
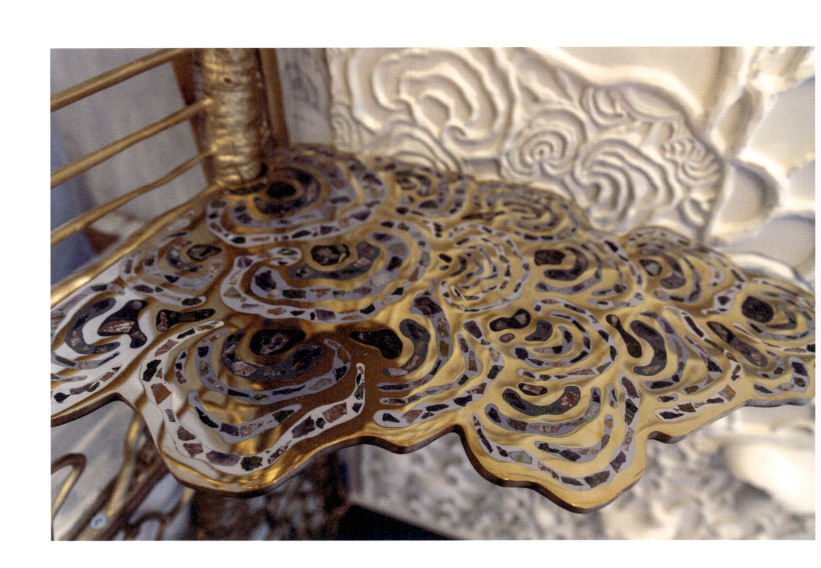

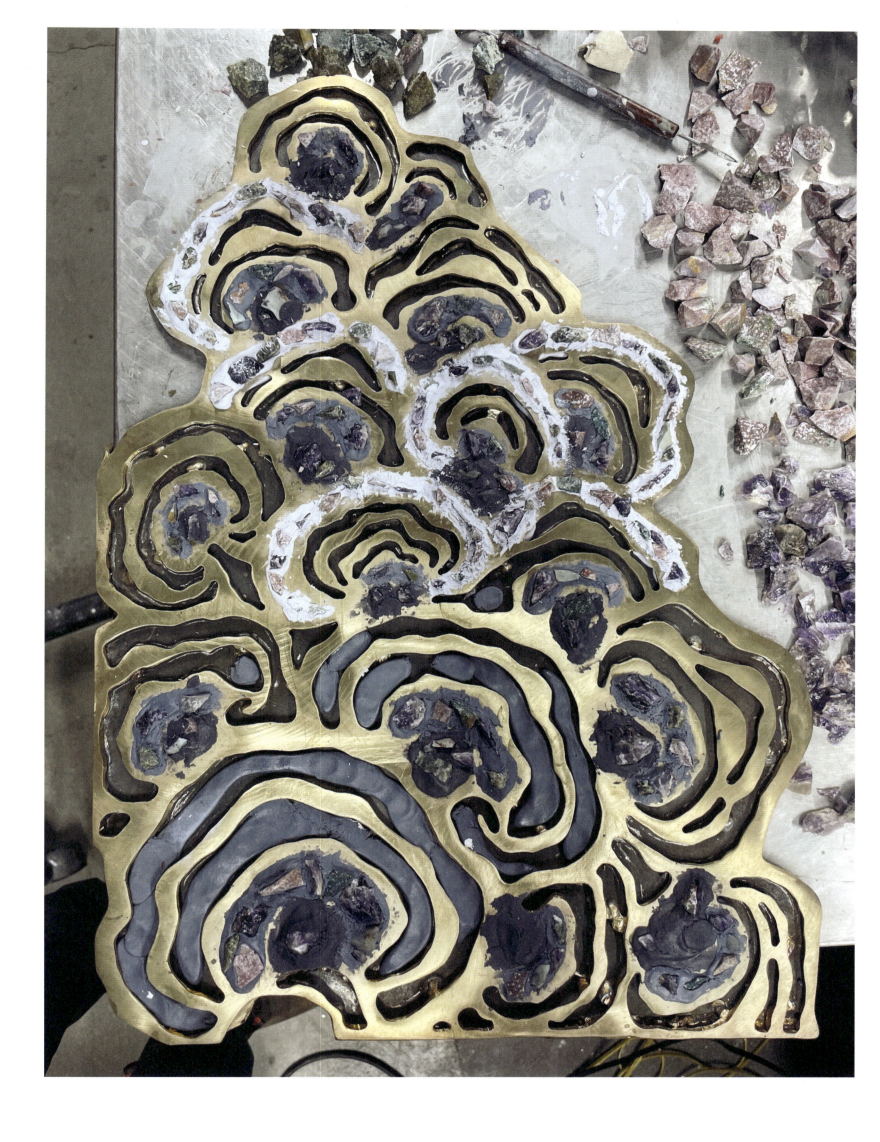

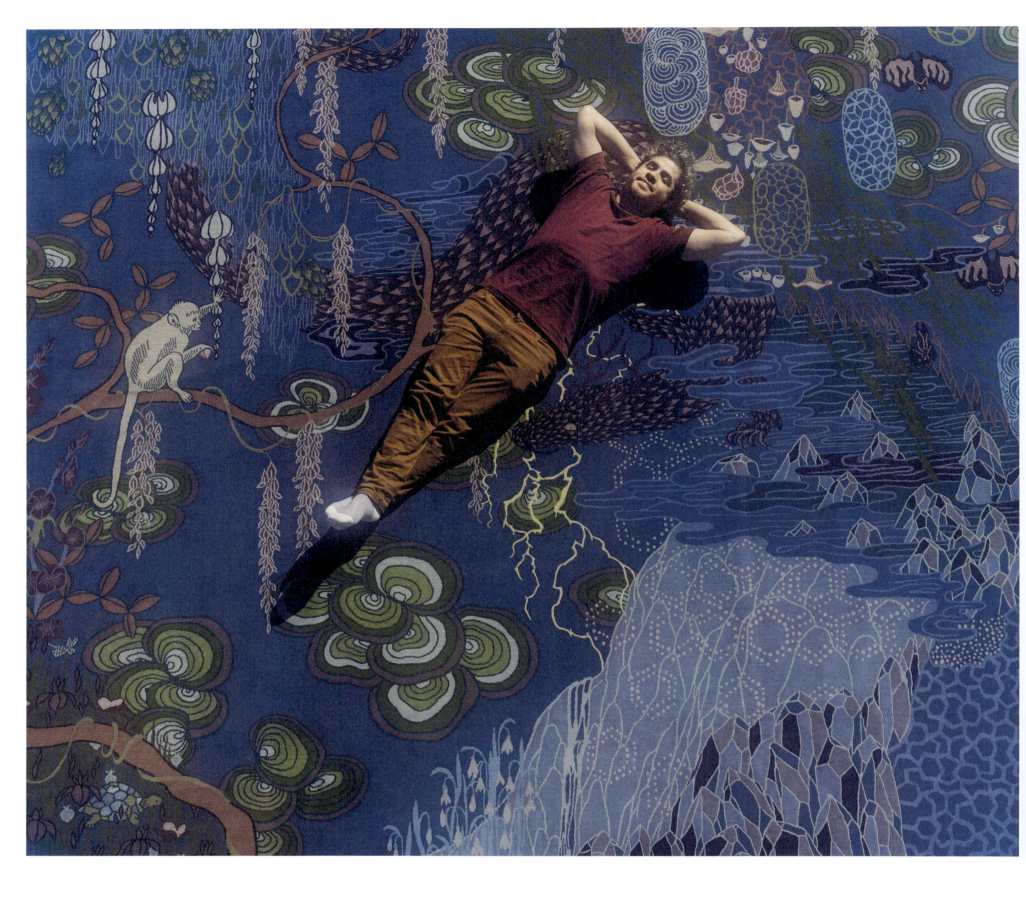

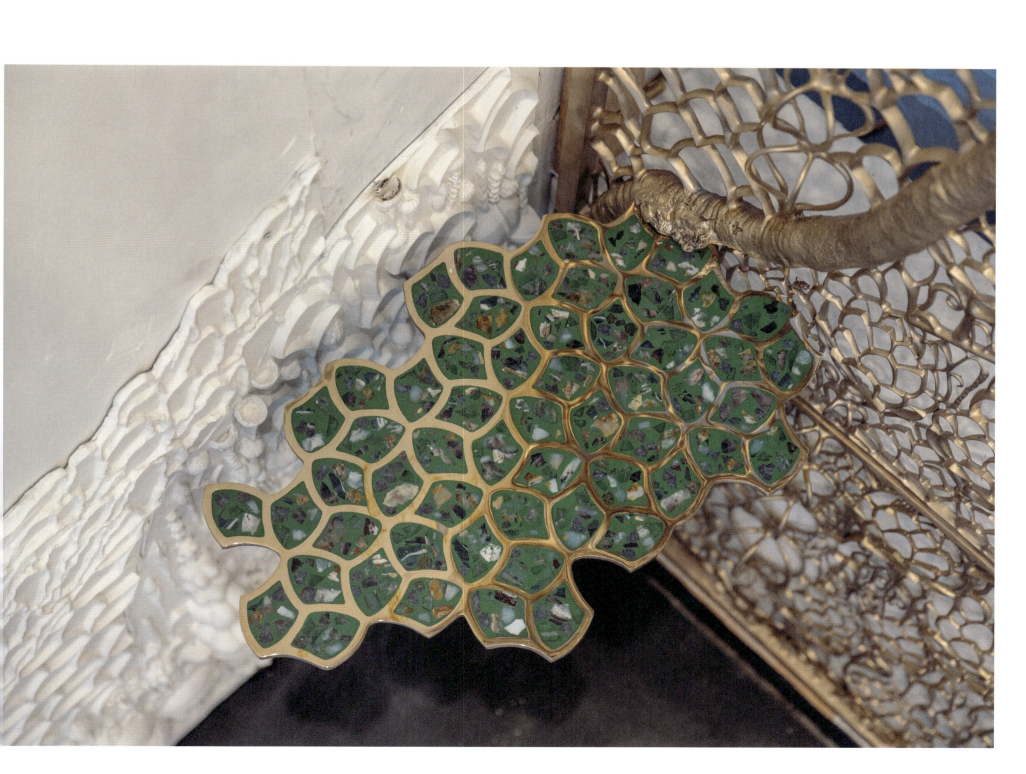

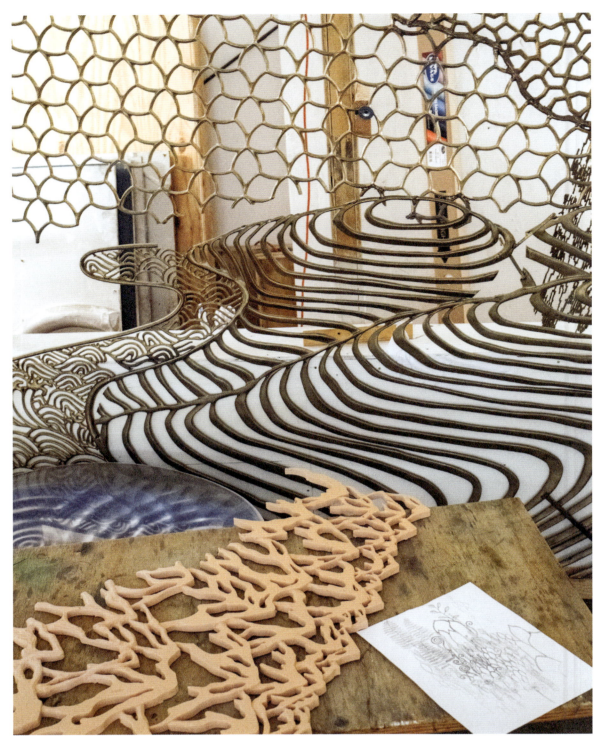
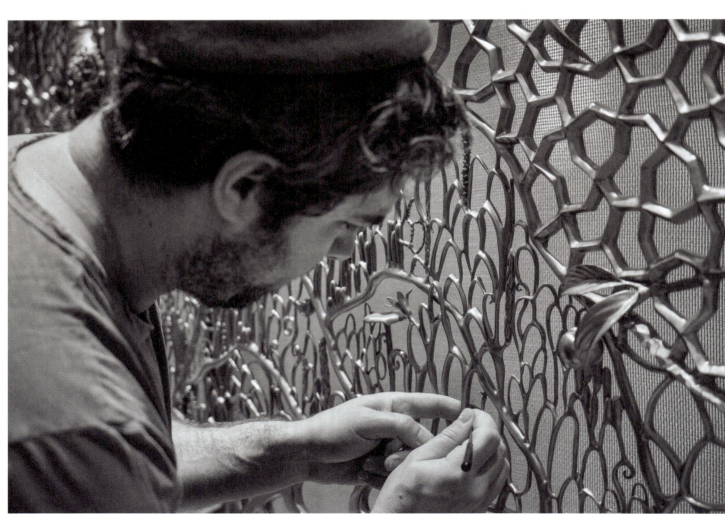

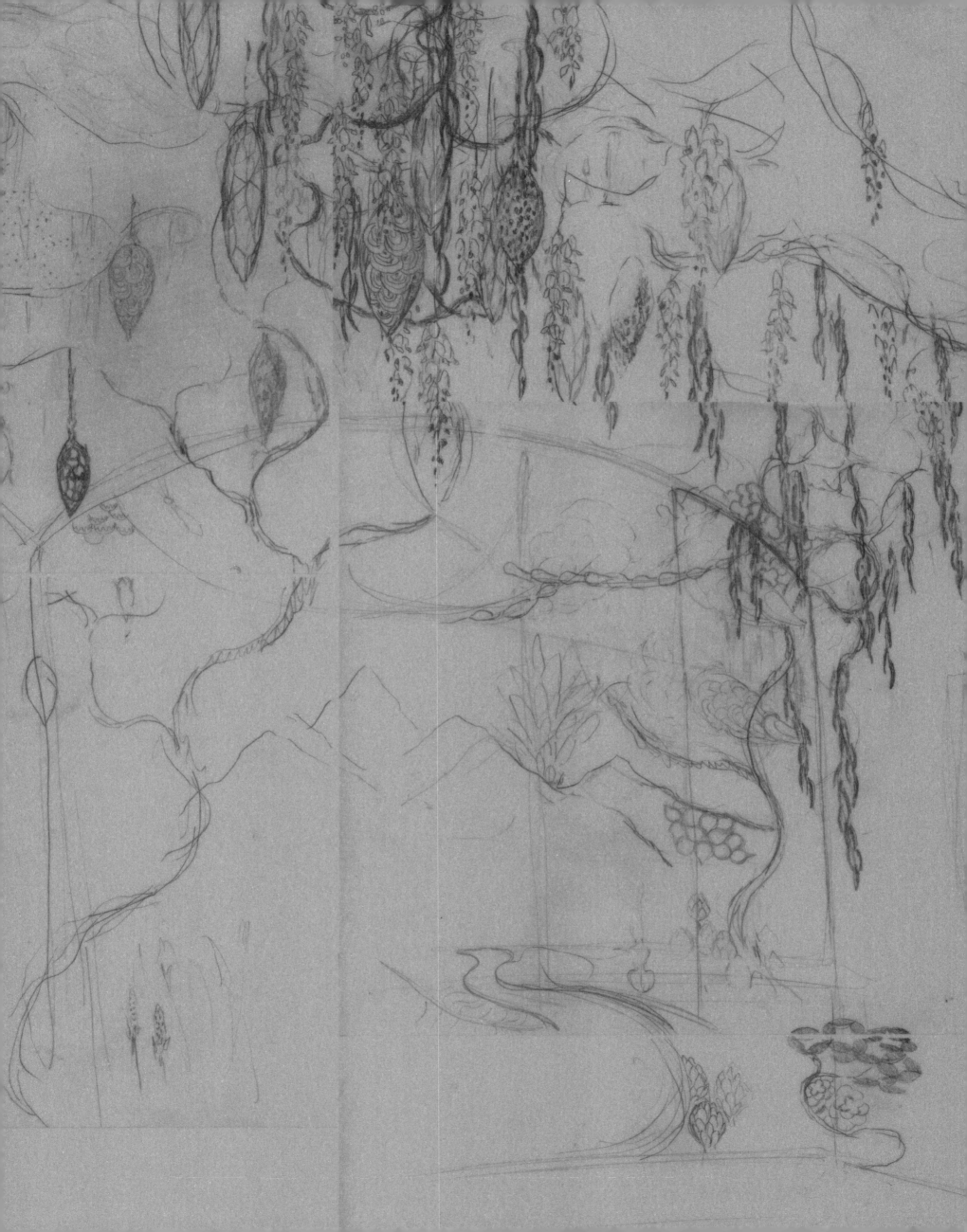

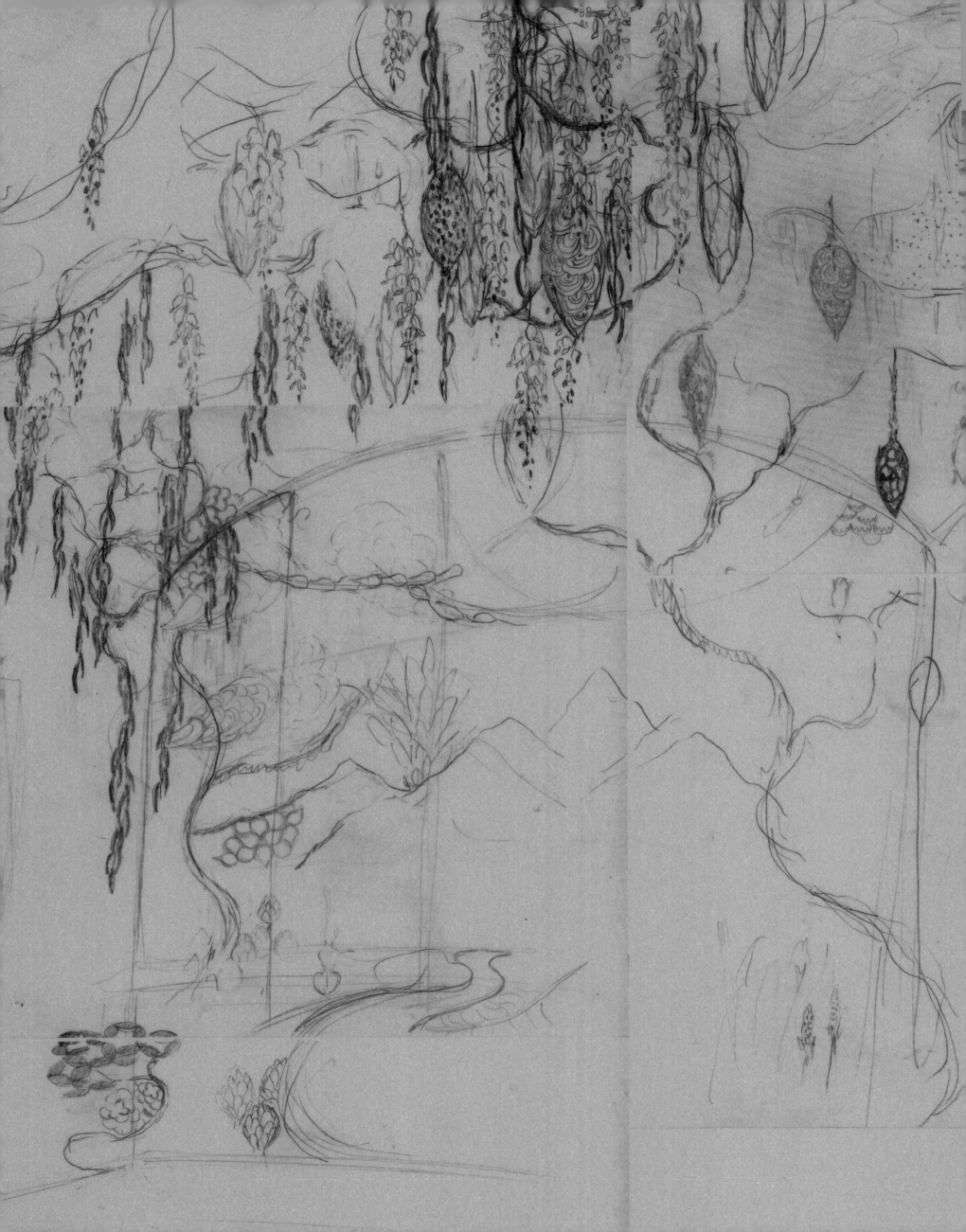

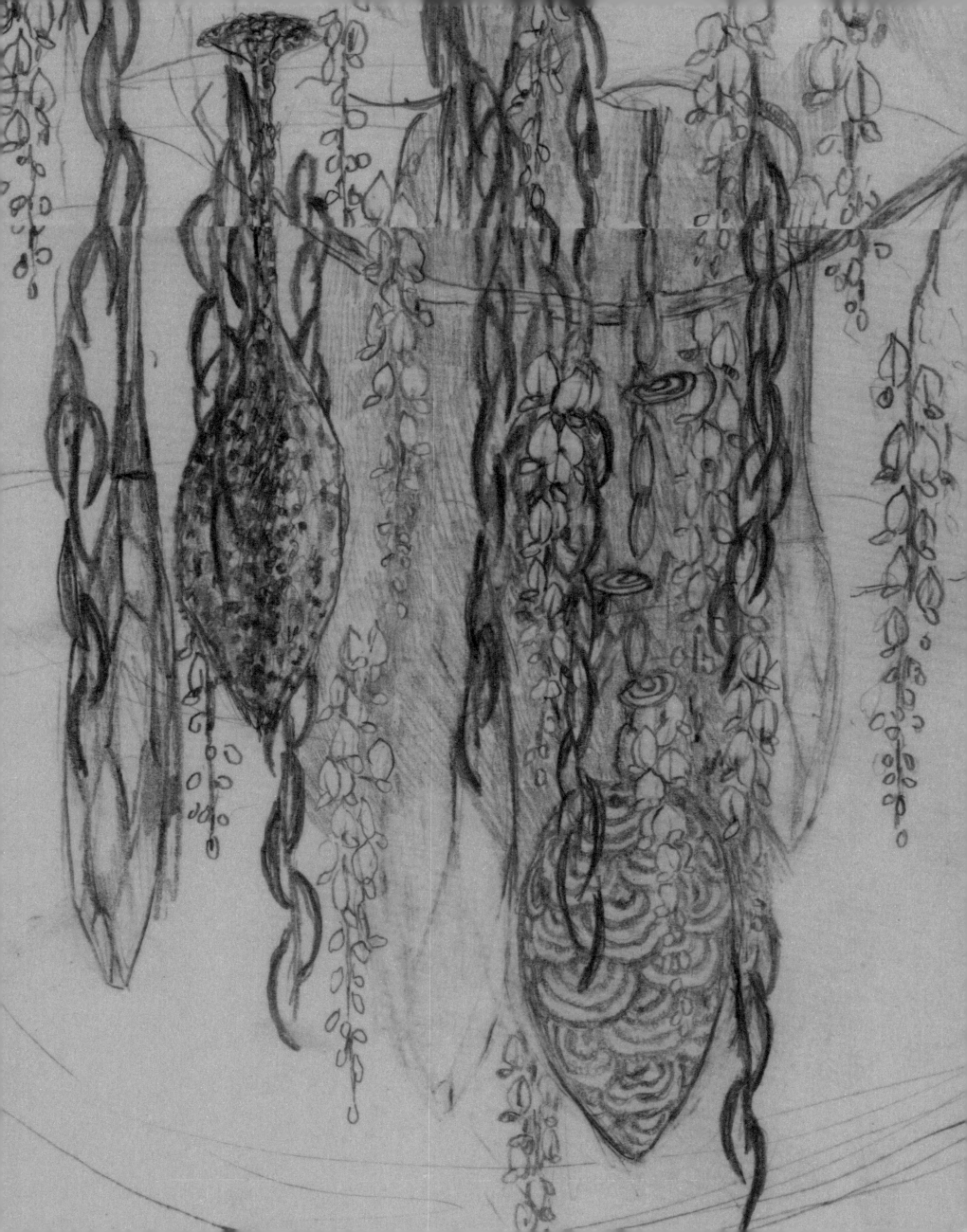

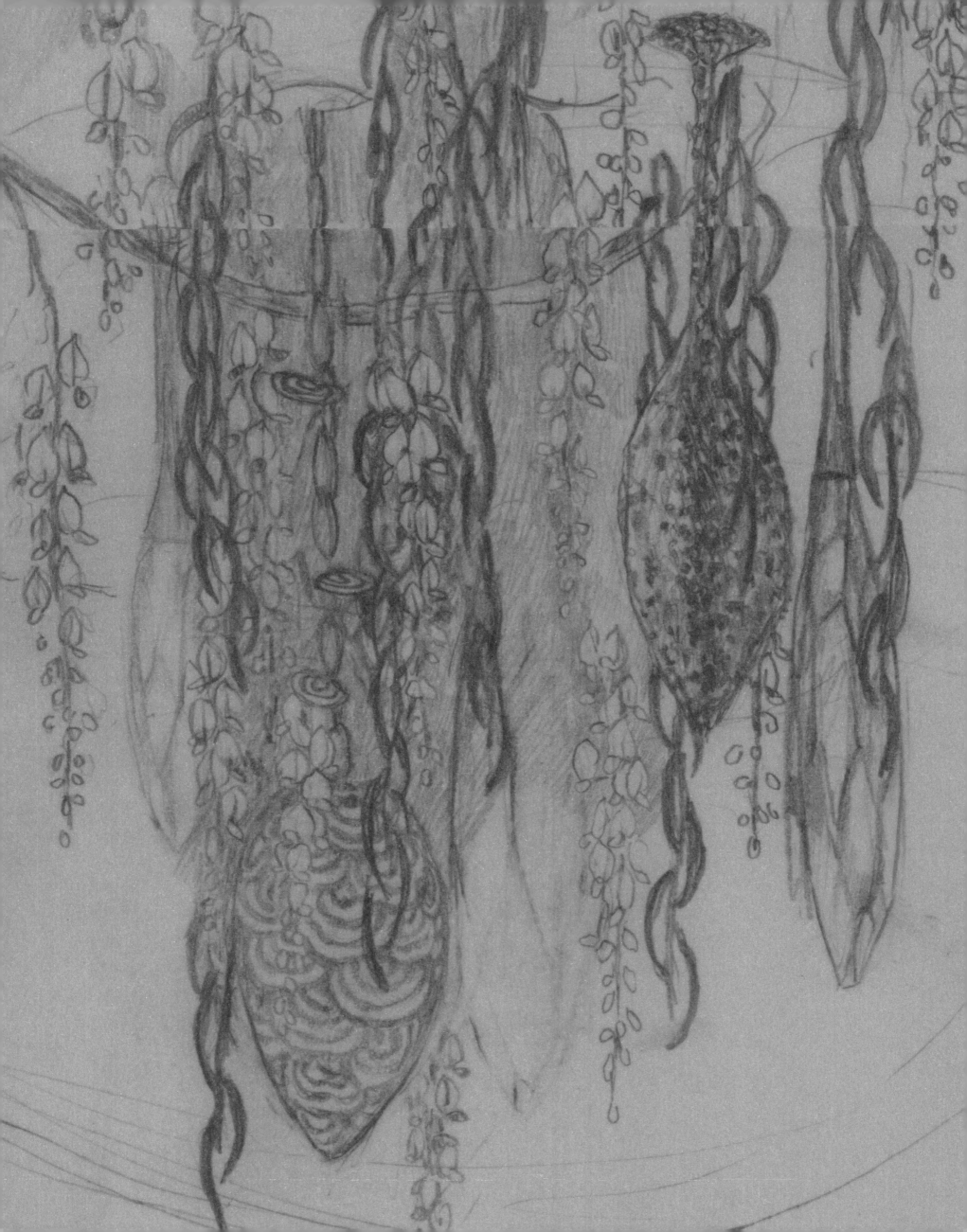

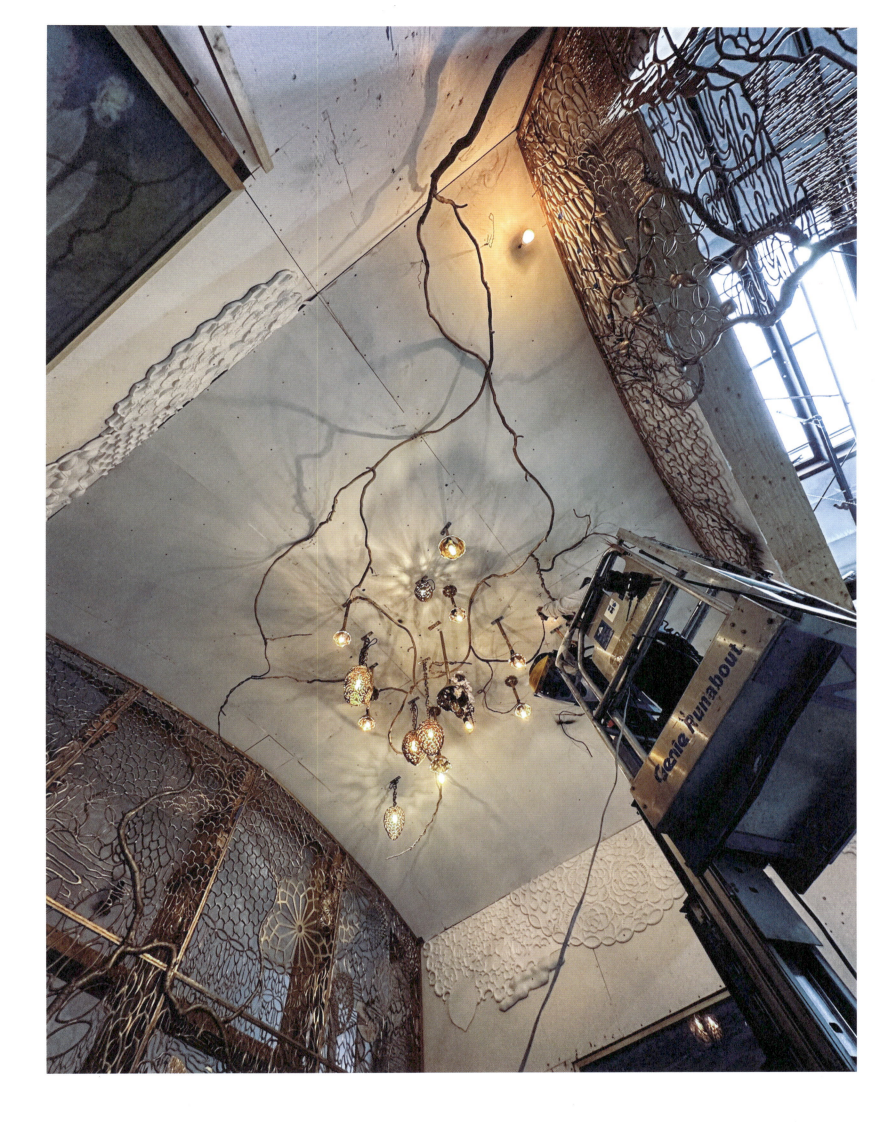

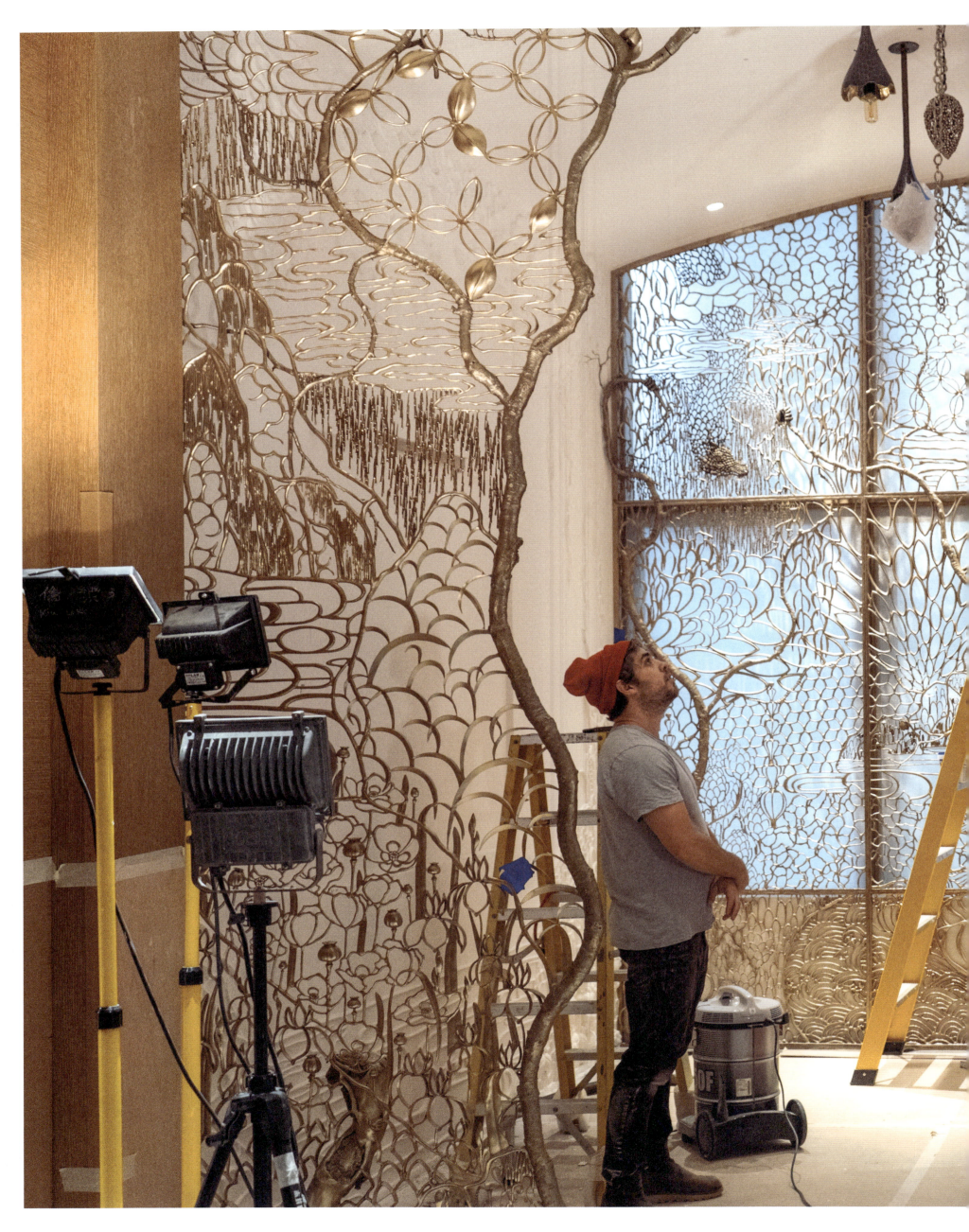

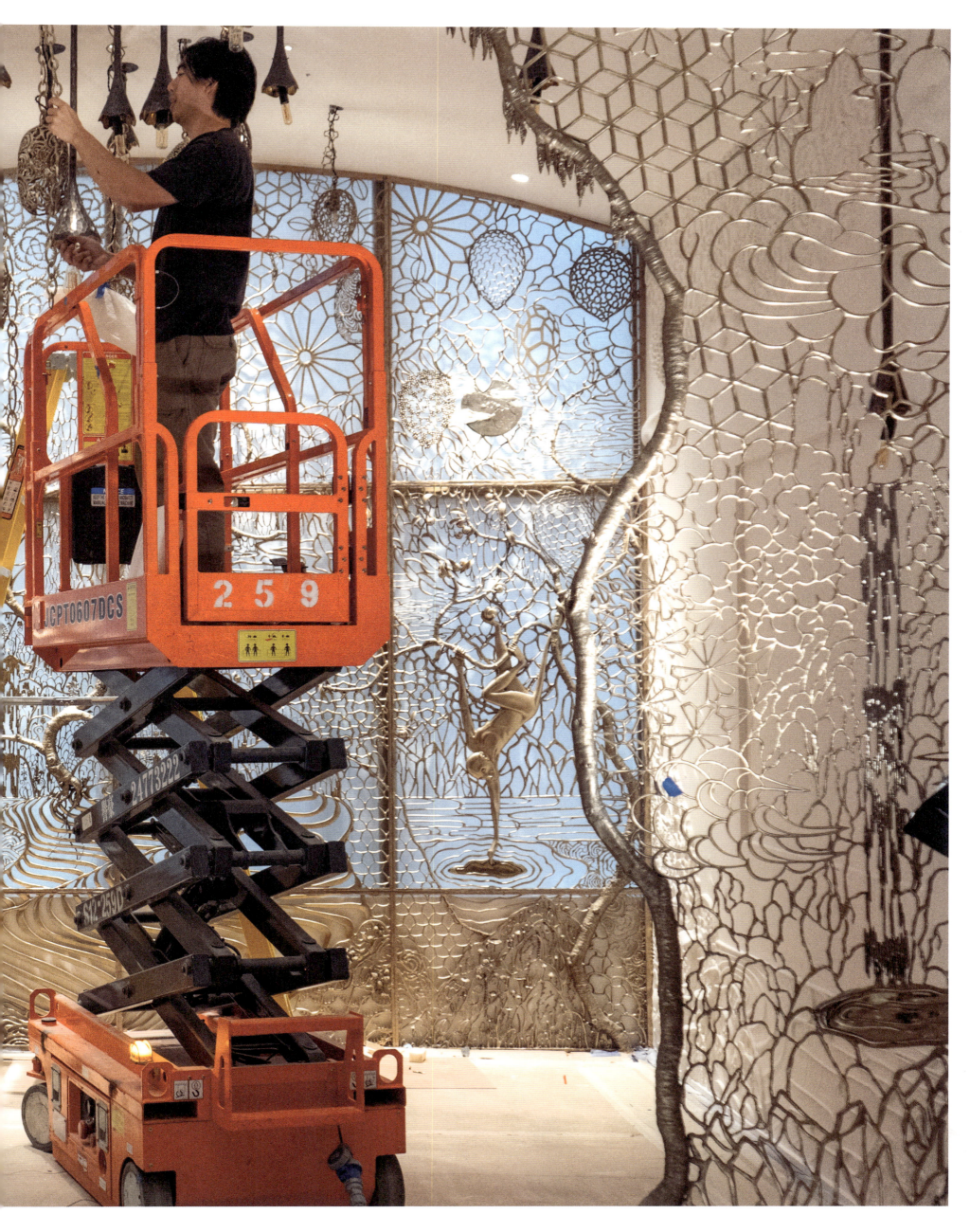

A CONVERSATION BETWEEN ARI AND DAVID WISEMAN

Ever since David became interested in drawing around the age of 16, we have been in an ongoing dialogue about his work and ideas. Our collaboration has been constant. Seven years ago, David and I realized that I could bring both my academic training and experience in the museum world to his studio, helping to build and manage an independent art studio, while allowing him a new level of artistic and personal freedom. It has been tremendously rewarding for us, as brothers, to develop our own organization that supports the creation of new work and shares our creative process with a larger audience. At the culmination of his most significant commission to date—The Four Seasons of Flower Fruit Mountain—we took the opportunity to sit down and have a discussion about his art, his evolution as an artist, and the studio.

—Ari Wiseman, Cofounder, Wiseman Studio

ARI WISEMAN *Do you remember when you first discovered that you were on a path to becoming an artist and designer?*

DAVID WISEMAN I can't pin down the precise moment, but at a certain point I just acknowledged that my love for creating, drawing, and sculpture, admiring craft traditions, and observing the natural world, meant that I was on such a path. I felt pulled to make—to do something tangible with all those passions. All the while, I was becoming aware of current thinking in art and architecture. I have always been drawn to nature-based design, and felt I could contribute some ideas.

AW *As your practice has developed and you have become more informed about the worlds of art, decorative arts, and design history, which other artists, projects, or movements do you draw inspiration from?*

DW There are so many traditions and movements that I admire and that have influenced me, from the Flemish school to Studio Ghibli, to Jugendstil, to ancient Mayan art and architecture.

I love seeing how arts and craft movements affect architecture and the built environment around them; for example, how nature and patterns are integrated in the Jali screens of South Asia, or how the region's woodblock prints, embroidery, and tapestries are applied to the ceilings, walls, and window treatments.

AW *Are you inspired by the Western canon? When people see porcelain and plaster ceilings or walls, the quick reference is to Baroque or Neoclassical interiors—whether it's Italian plasterwork from the seventeenth and eighteenth centuries or English ceilings of that period and later. You don't seem to be terribly drawn to those worlds or that type of work.*

DW These are such big categories, and there are examples I love, but I have always felt compelled to allow nature to chart its own course. I'd prefer natural references to be primary and free rather than constrained to a decorative frieze, lion's paw, or bound sheath of wheat. There are many other Western traditions that I am also drawn to, such as chinoiserie and the Secession, Nouveau, Deco, Der Blaue Reiter, and Arts and Crafts movements.

AW *Can you describe your studio and how this particular arrangement of the studio fuels or serves your creative process?*

DW For 13 years, I was working in a cinder block bunker with an enclosed patio space. It was a big garage with a wall to separate the metal shop from the ceramic studio. Now, we're in a much larger studio that is similarly divided—one side for the fragile process of ceramics and the other for the louder, more industrial processes of grinding and welding metal. Our new studio has a separate building dedicated to pouring bronze and another for viewing and exhibiting finished work. Outside, our studio garden features many of

the species that have made their way into my work: ginkgoes, daturas, magnolias, irises, water lilies, pomegranates, wisteria, and many kinds of succulents.

It's a joy when working on a piece—a canopy of wisteria, for example—to be able to take a break and study the real thing growing in the garden. When you're responsible for a plant's health and cultivation, you really get to see it throughout its life cycle, which I find very inspiring. We use our garden as a nature laboratory.

AW *You began your design practice working with plaster and porcelain. How and when did you begin to integrate the bronze which now accounts for the majority of your work?*

DW When we were still in the old studio, we made the commitment to cast all of our bronze in-house. This decision was born out of a close relationship with my colleague, Jóse Luis, whom I met 15 years ago at a local art bronze foundry. As a master of the lost-wax casting process, he was open to sharing his years of experience with me and helped me to understand how I could improve my results from beginning to end, from the mold-making stage to the final patina.

Little by little, he began helping; advising at first, then lending a hand, until we eventually began working together to create editions of tabletop sculptural objects, chandeliers, and other furnishings. Soon after, we brought in members of Jóse Luis's extremely talented network of bronze fabricators and craftspeople, many of whom were his own family members. I see our process as akin to a guild system—skills are passed on from master to apprentice. This infrastructure and team has allowed me to cast in real time, turning drawings into castings in a matter of days as opposed to waiting months for an outside foundry.

AW *How did you first encounter the process of lost-wax casting and what did you learn from that experience?*

DW I never set out to create bronze works. It was a natural extension of my object-making. I was interested in sculpting and the idea of molding to create multiple iterations. My first castings were of wall pieces: anime-inspired deer heads and castings of fallen tree trunks in plaster. I then began sculpting vases, which led me to the process of making plaster molds in order to slip-cast them in stoneware and porcelain. I looked to bronze when I wanted to understand how a simple material change of those early forms, from porcelain to a metal, could impact the design. I wanted to understand what that material brought to the form. What were its intrinsic characteristics—its mass, texture, surface and patina, even its cultural connotation, since bronze has been a part of the human story since the Bronze Age. It was a slow start, but as I began to explore its potential, more and more objects were conceived. It has been a fun and totally unexpected journey and I'm still so excited by every pour; by watching the mesmerizing, glowing, lava-like bronze flow into a mold. There's still so much to uncover and explore from this ancient, beautiful material and process.

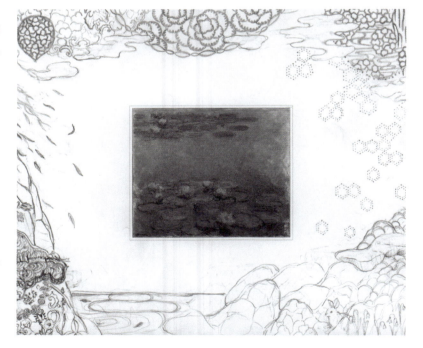

AW *The example of the branch introduces the concept of scale. Works like your branch chandeliers or screens consider human-scaled environments. But within them, you also dive into near-microscopic detail. Can you speak to the experience of traversing between these perspectives?*

DW It's what I know and stems from years of thinking about and creating objects. When I've taken on larger, more environmental work, I still think and design in terms of the object, sculpting one part at a time. One handmade object becomes another, and another, and eventually a quadrant of a room is created by pieces as detailed as handheld sculpture.

AW *This is certainly the case in* The Four Seasons of Flower Fruit Mountain. *As your largest and most comprehensive project to date, can you speak to the creative journey undertaken to create this space?*

DW The original project scope was near total and complete freedom, save for a couple of key details: a large, wall-to-wall, floor-to-ceiling, bronze screen to obscure a bay of windows, console tables, a dining table, a chandelier, and plaster wall motifs, which, as it happens, would frame and surround two Monet *Water Lilies* paintings.

A daunting task, to say the least.

Beyond that, I was on my own in terms of concept, scale, material, color, and finish. How and what could I do to the space that could possibly live up to these iconic paintings? This was a question I had never pondered before. But, I was being asked to bring a whole world to surround and complement, and maybe even be in dialogue with, the paintings.

Before arriving at any motif or sketch, I decided I needed to learn more about Monet, his life, and his interests. I read his letters to close friends, studied photographs of his studio spaces, and reviewed his carefully-planned landscape designs for Giverny, where he painted his storied *Nymphéas*. I learned how he thoughtfully designed every pond, bridge, and bed of flowers. His interest in caring for and cultivating a garden for each season captivated my interest and reminded me a bit of our humble first foray into a studio garden. That's how my design for the room began.

In my research, I chanced upon a photograph of Monet standing upon an arched and trellised Japanese bridge that spanned across a pond of water lilies. The bridge structure was almost entirely subsumed by the dense growth of blooming wisteria, his impressive beard seeming to echo the cascading vertical blooms. It was in this photograph that I could see his interest in nature's unbridled beauty charting its own course—growing upon, almost eclipsing, the structure of the bridge itself. I found a parallel to my own interests in the primacy of nature and in my work. So that became my first decision for the room: I would plant a bronze and porcelain wisteria vine, and arch the roof of the space to echo the arch of his bridges at Giverny. That was my entry point. That is what started the story.

As I dug deeper into the world of Giverny and wisteria, which also plays a prominent role in our studio garden, I learned that Monet obsessively planted for each season so that he could paint throughout the year. I then decided that each of the four corners of the room would represent a different season, with a blooming wisteria planted firmly in spring, among other favorite plant species: hollyhock, poppy, Japanese iris, nasturtium. This format provided me with an overall framework to explore. I then decided to travel outside of Giverny into other realms and traditions.

Since the work was to be installed in Hong Kong, I began to read about the local flora that blooms in each season there, as well as the ancient holiday celebrations marking the Chinese seasonal calendar. As an avid monkey fan,

> I dove into the sixteenth-century epic poem titled Journey to the West, which features the protagonist—a troublemaker monkey—as well as many other fantastical characters living in the realm of Flower Fruit Mountain.
>
> —David Wiseman

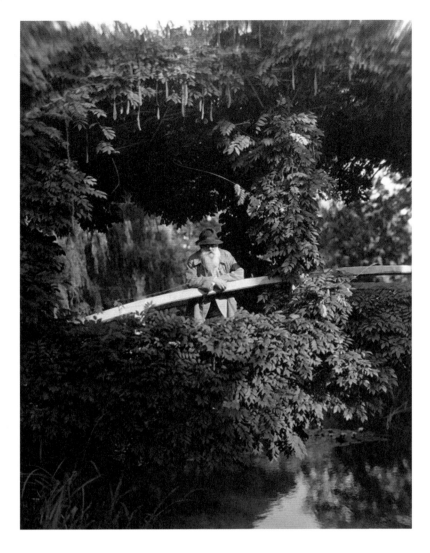

I was drawn to a tale about an autumnal holiday celebrating the beloved character Sun WuKong, or, the Monkey King. I dove into the sixteenth-century epic poem titled Journey to the West, which features the protagonist—a troublemaker monkey—as well as many other fantastical characters living in the realm of Flower Fruit Mountain. I began integrating his story into my sketches for the autumn corner, along with motifs from the Mid-Autumn festival, an ancient harvest celebration of the full moon, including lanterns and mooncakes.

As I continued to uncover these wonderful tales, I integrated their narratives within the themes of Giverny blooms and seasonal celebrations.

AW *And that process took over three years. Can you speak to your creative thinking along this journey?*

DW I had to write the story of the room. That took a lot of time. It was quite a challenge because I had committed to a production timeline that involved coordinating with an industrious crew of 20. They wanted to get going and make progress, but the process couldn't be rushed. I learned this the hard way after having to scrap much of the first draft of a very large, bronze screen that didn't speak to what I was trying to say about Giverny, the seasons, and Flower Fruit Mountain. I had to create the room one object at a time, inch by inch, season by season.

A facet of the Monkey King's fascinating story deals with his invitation and subsequent expulsion from heaven for the crime of stealing the coveted peaches of immortality—fruits reserved for the gods. I drew various different frolicking monkeys, but I wanted to weave into the work the particular part of the myth of Sun WuKong's fall from grace and subsequent longing for atonement. I decided to portray him hanging on a limb, captivated by the full moon's reflection on the surface of water below during Mid-Autumn festival, reaching out, attempting to make contact with the eternal celestial realm, yet unable to attain his goal, still clutching the ill-gotten peach in his other limb. The image evokes a popular theme in Chinese parables of monkeys fascinated by the moon's reflection, sometimes diving in to attempt to save it from drowning, and others grazing a finger on the surface of the water to attempt to make contact with the chimera. Translating these ideas into clay and then bronze took time, many iterations, months and months of development to get it right and to weave all the stories together.

AW *This is a remarkable window into your creative process. Would you say that this is how you approach all your work?*

DW Yes. When something needs to be made, I just know it; I feel it. It defies explanation.

THE FOUR SEASONS OF FLOWER FRUIT MOUNTAIN

David Wiseman's Total Work of Art In Bloom

THE FOUR SEASONS OF FLOWER FRUIT MOUNTAIN

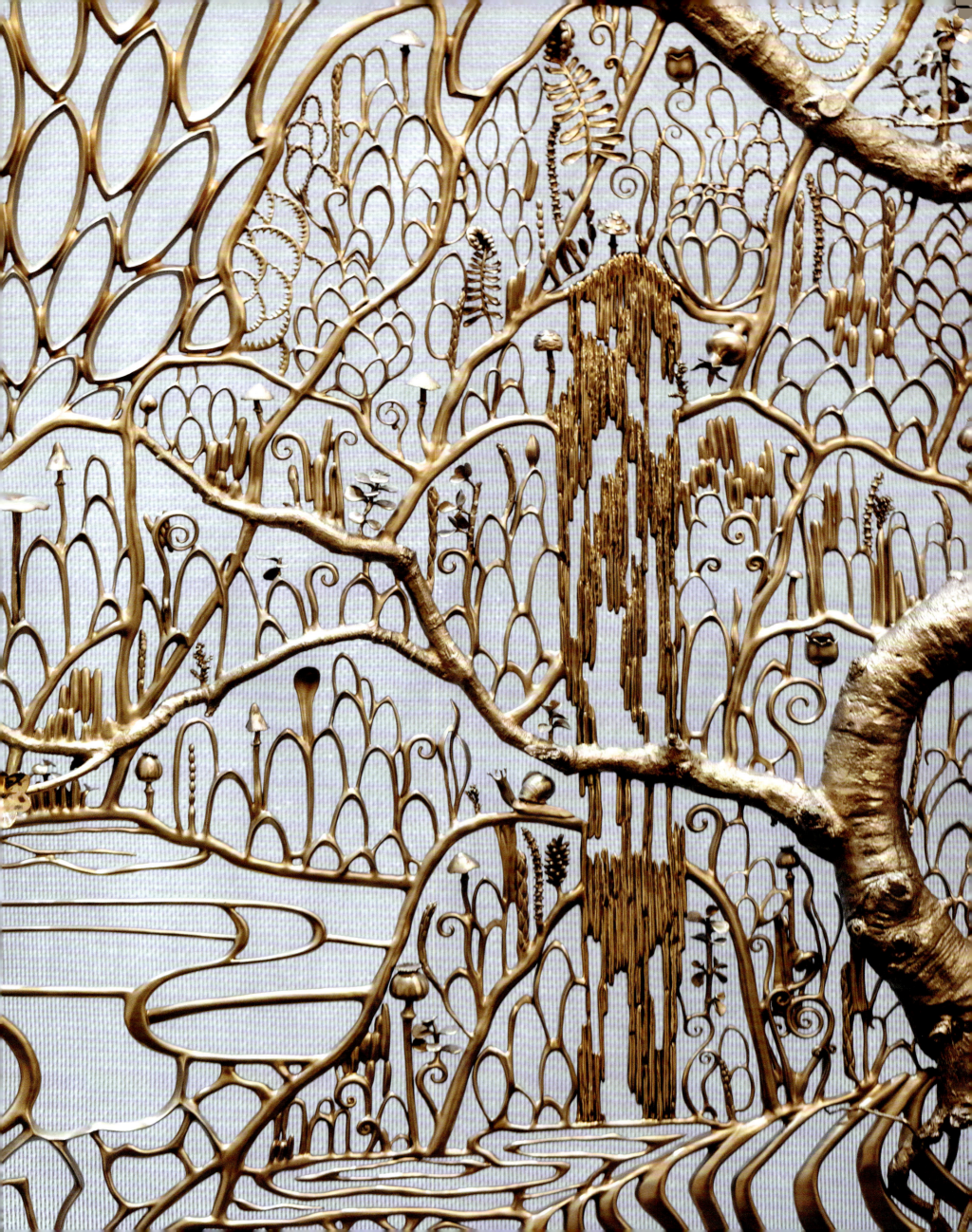

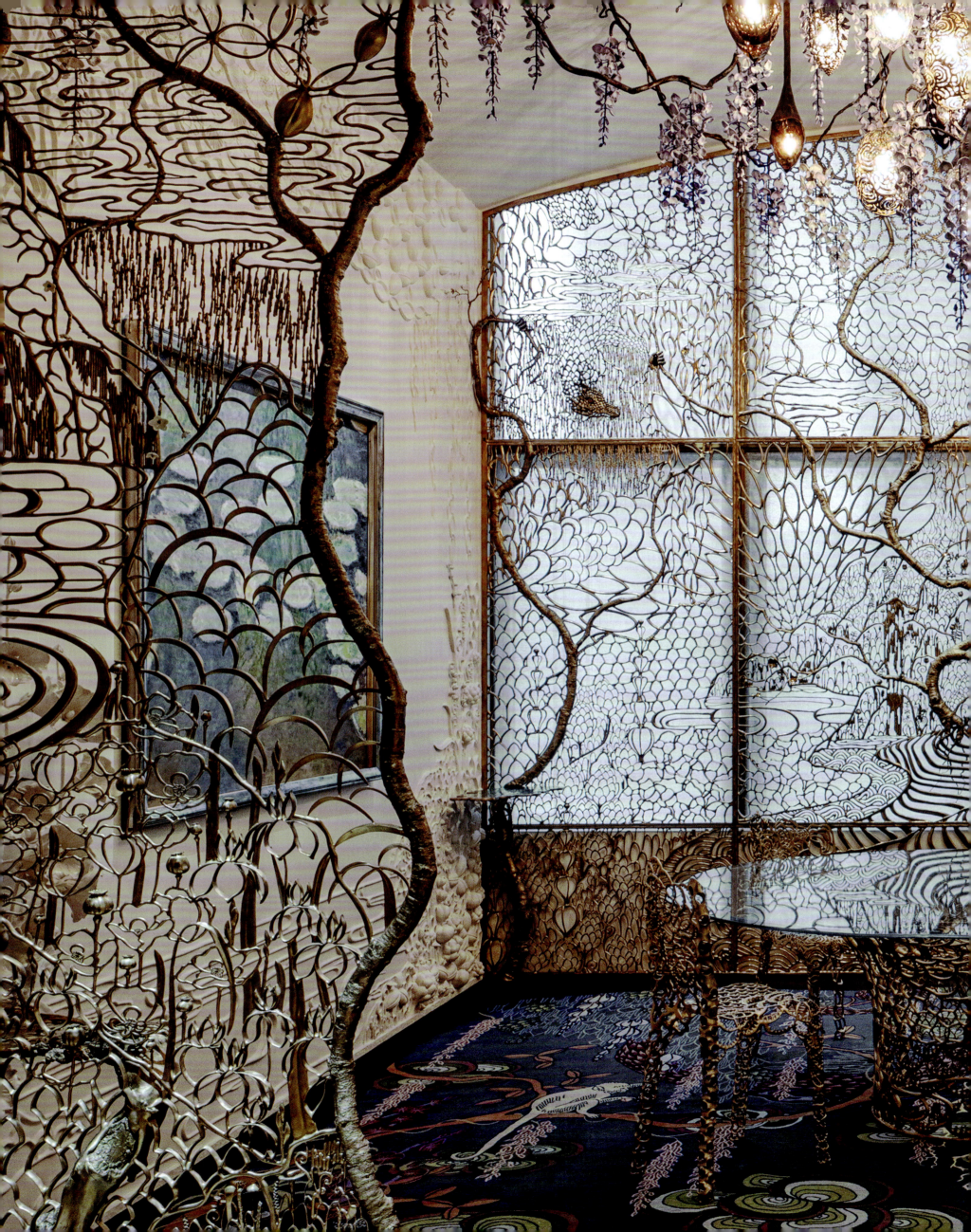

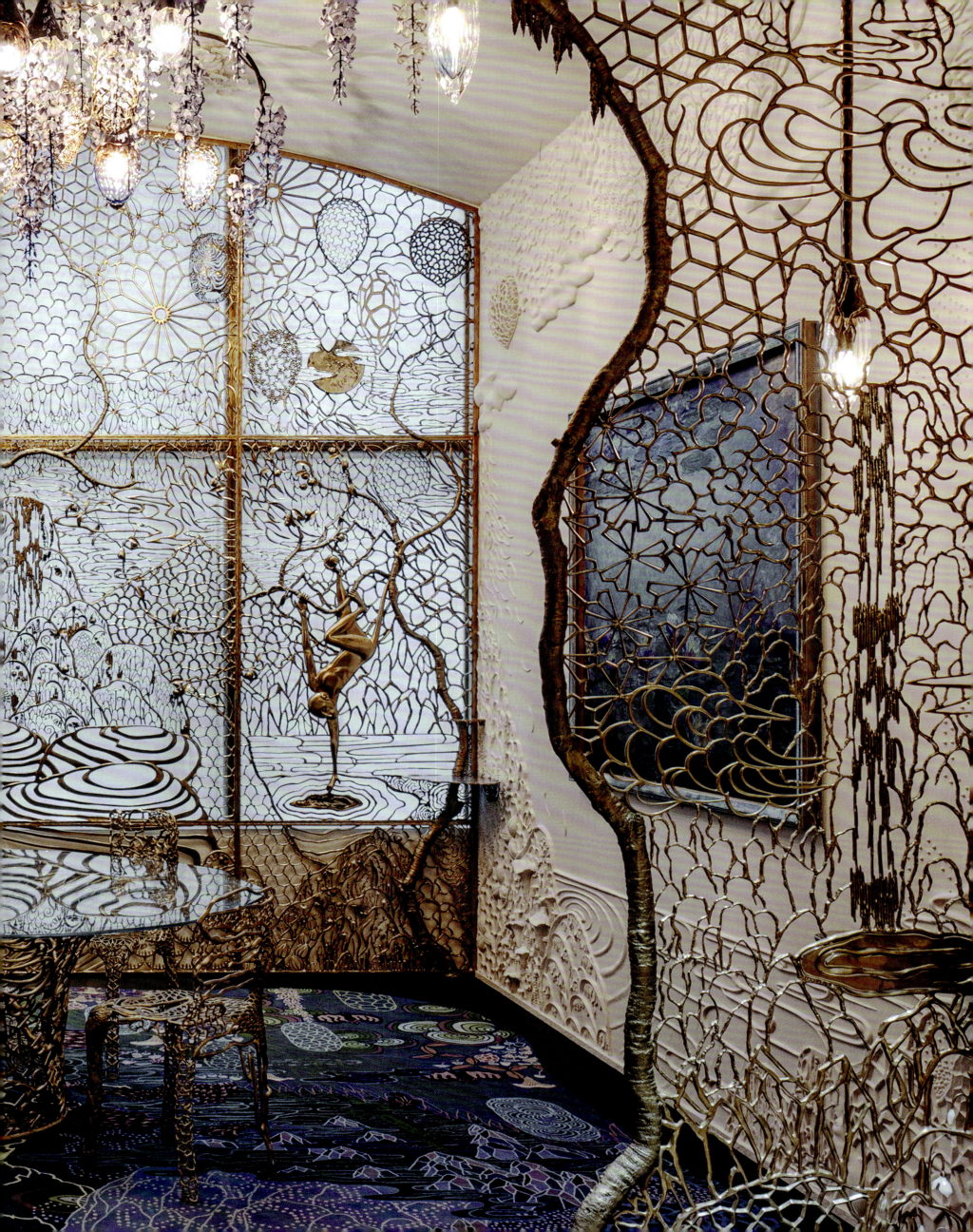

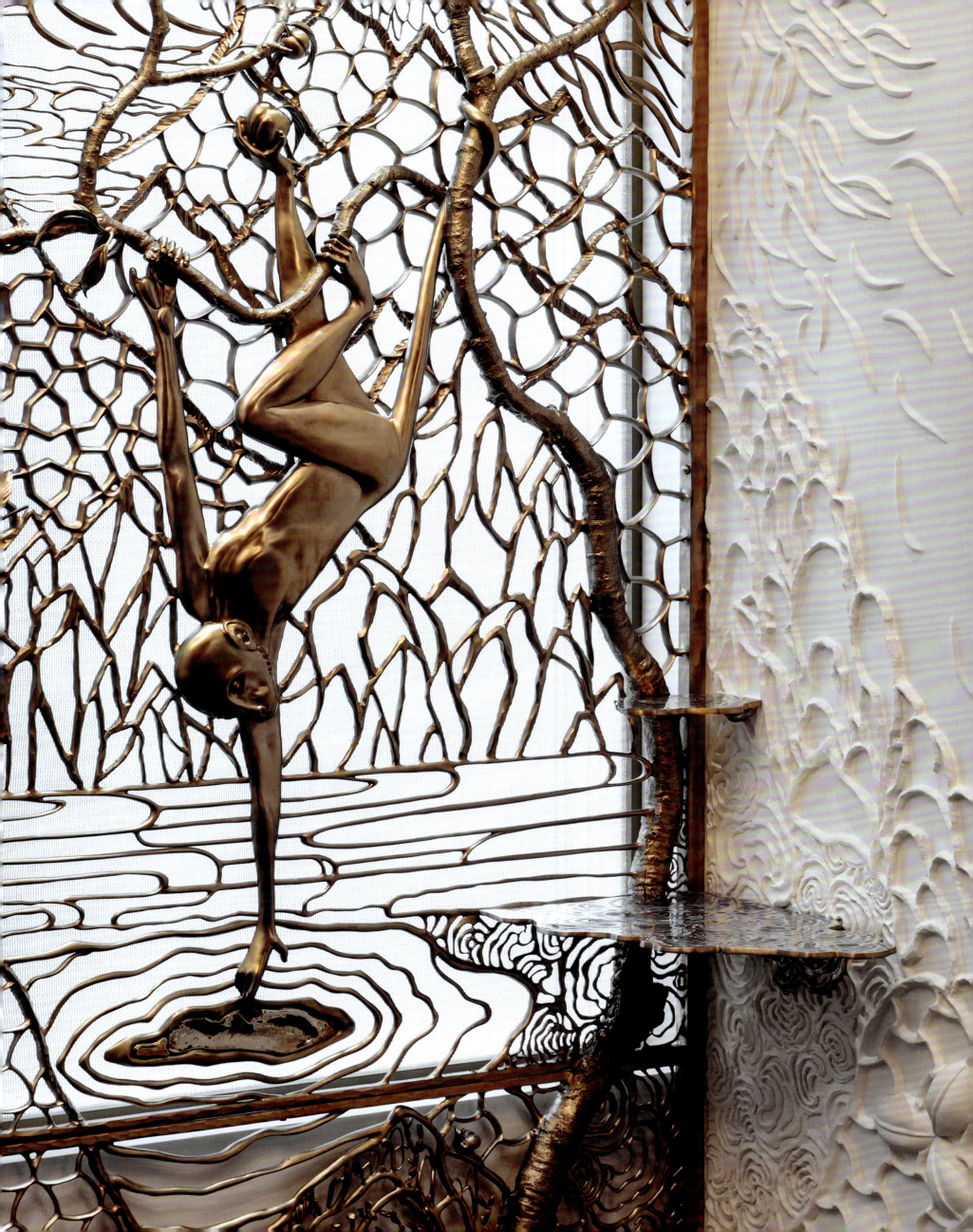

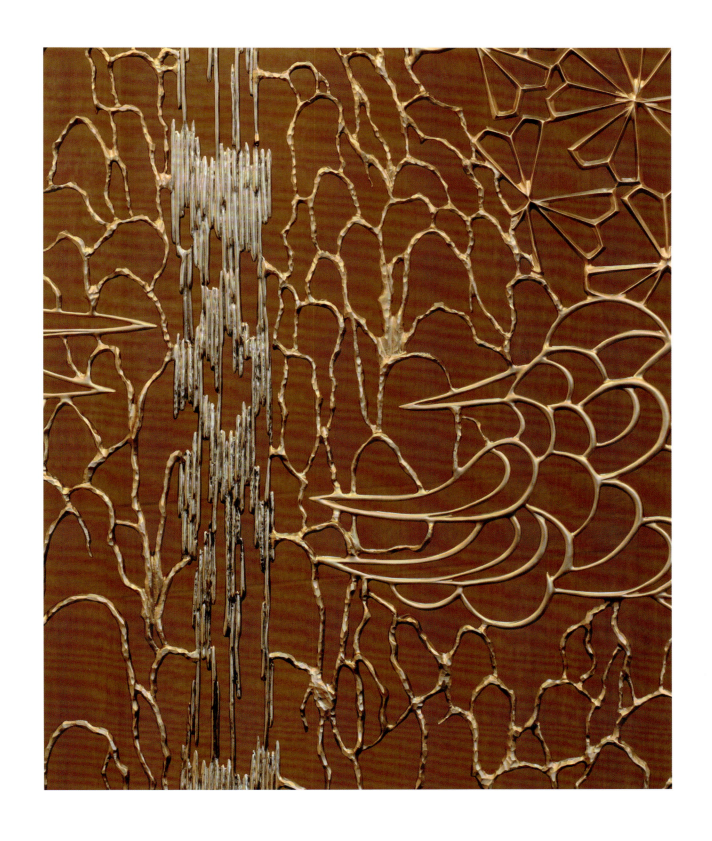

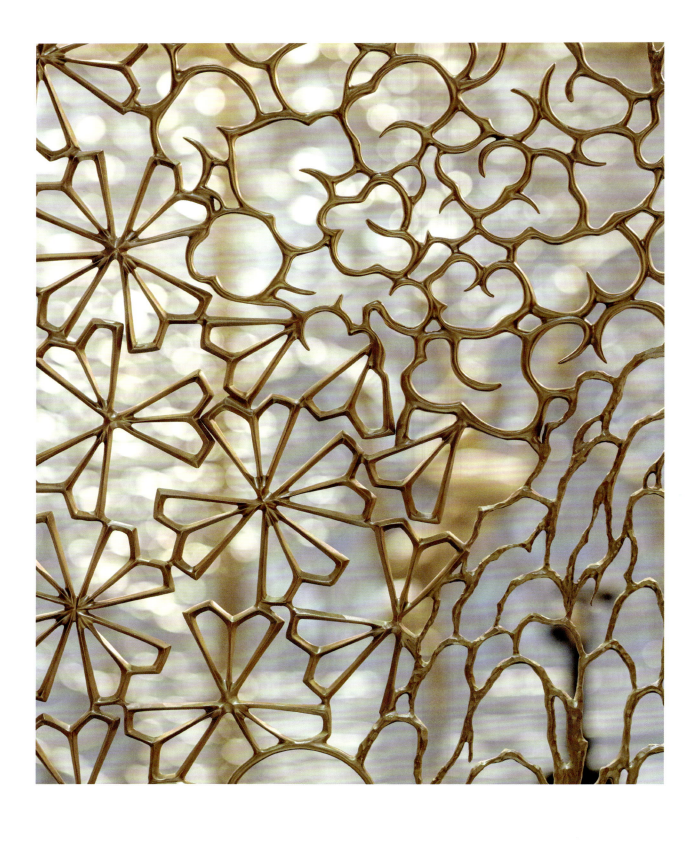

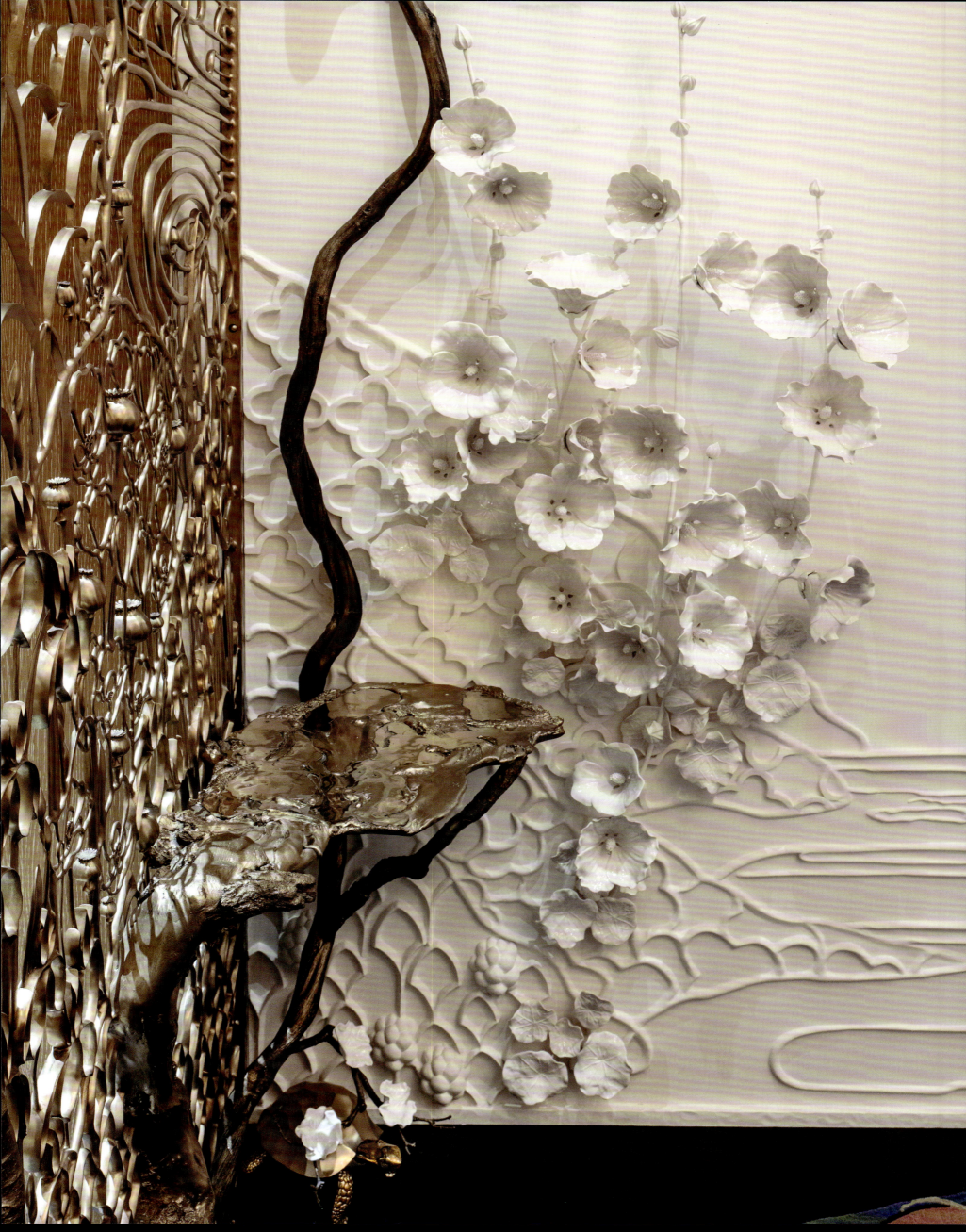

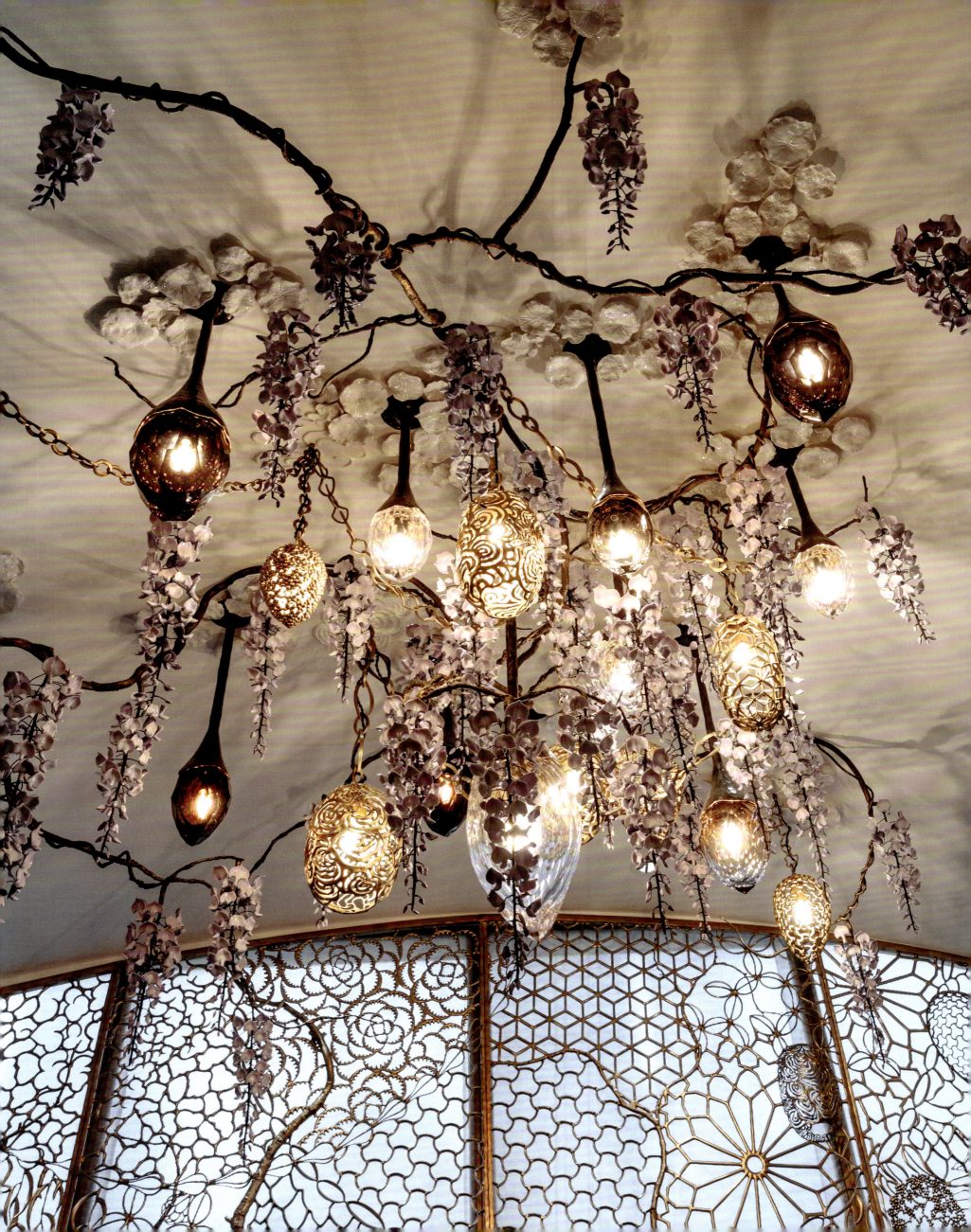

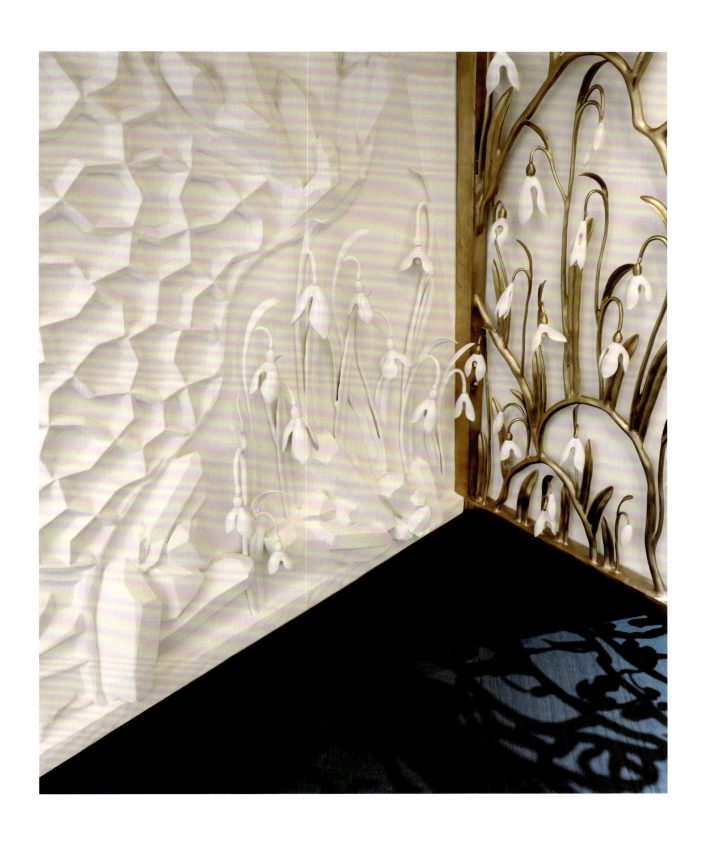

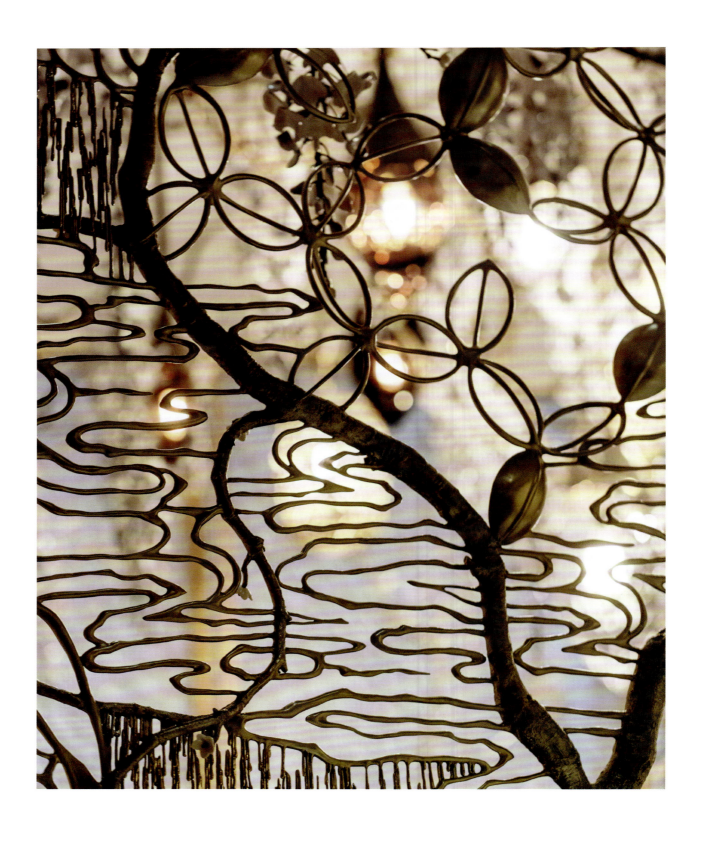

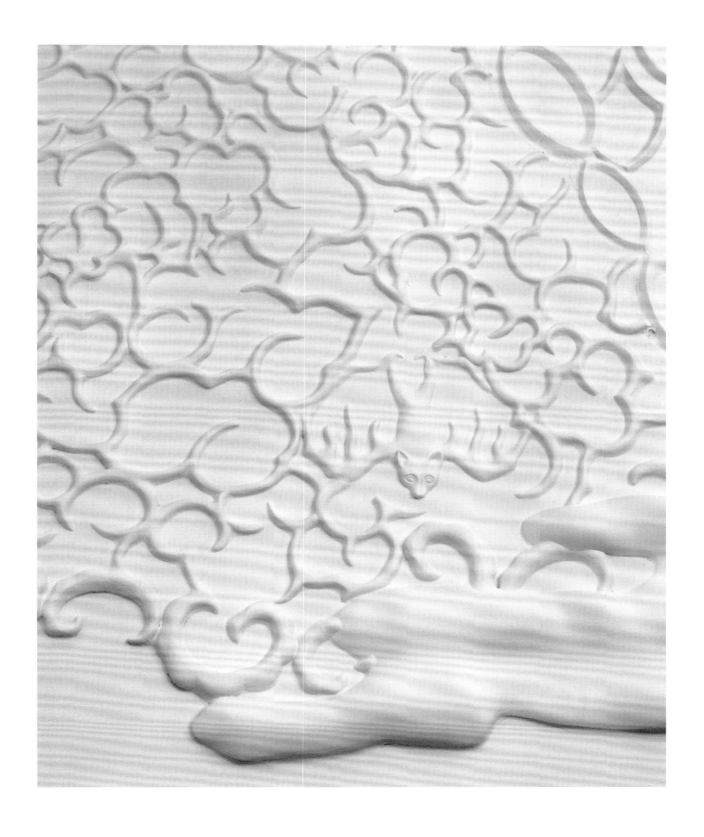

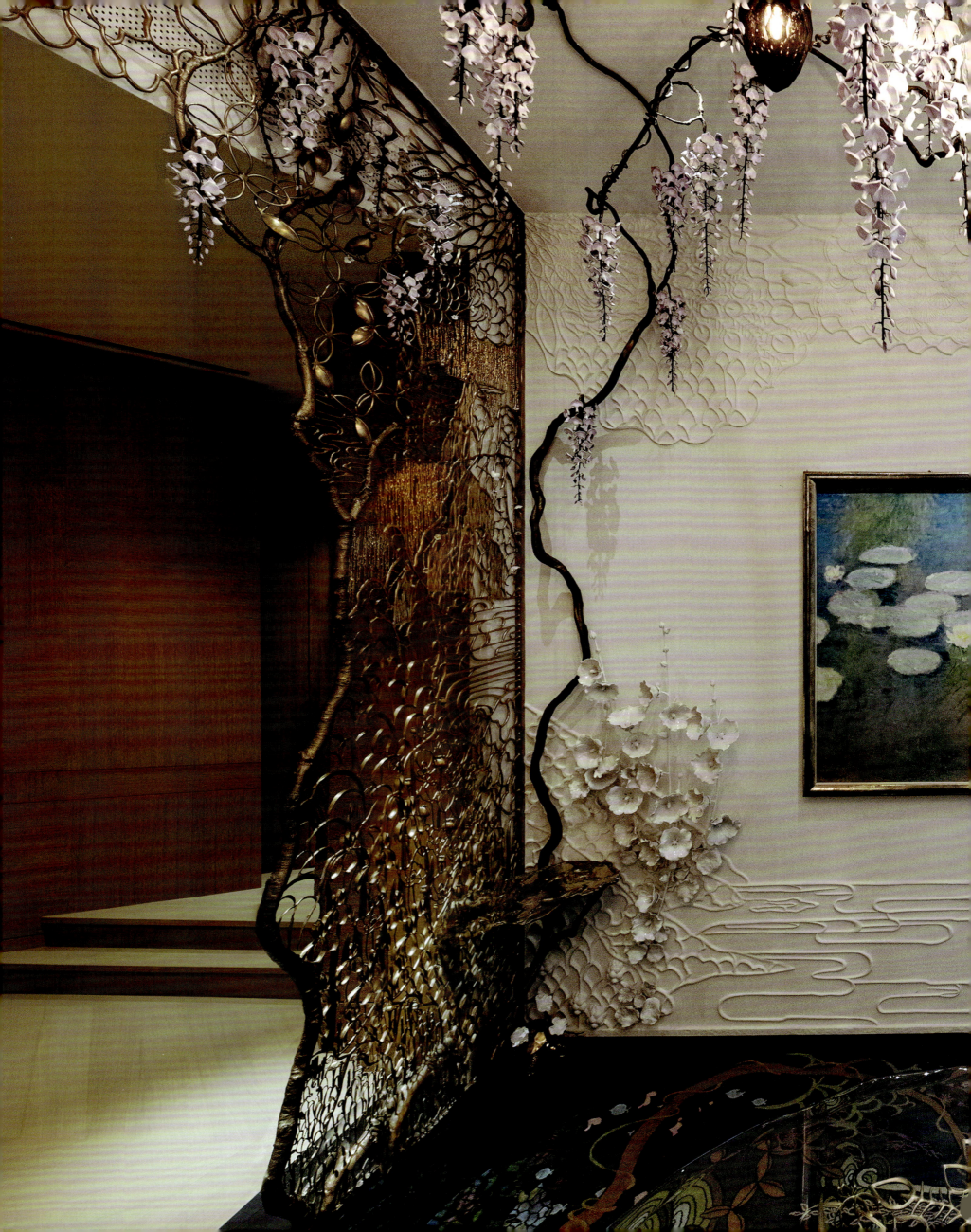

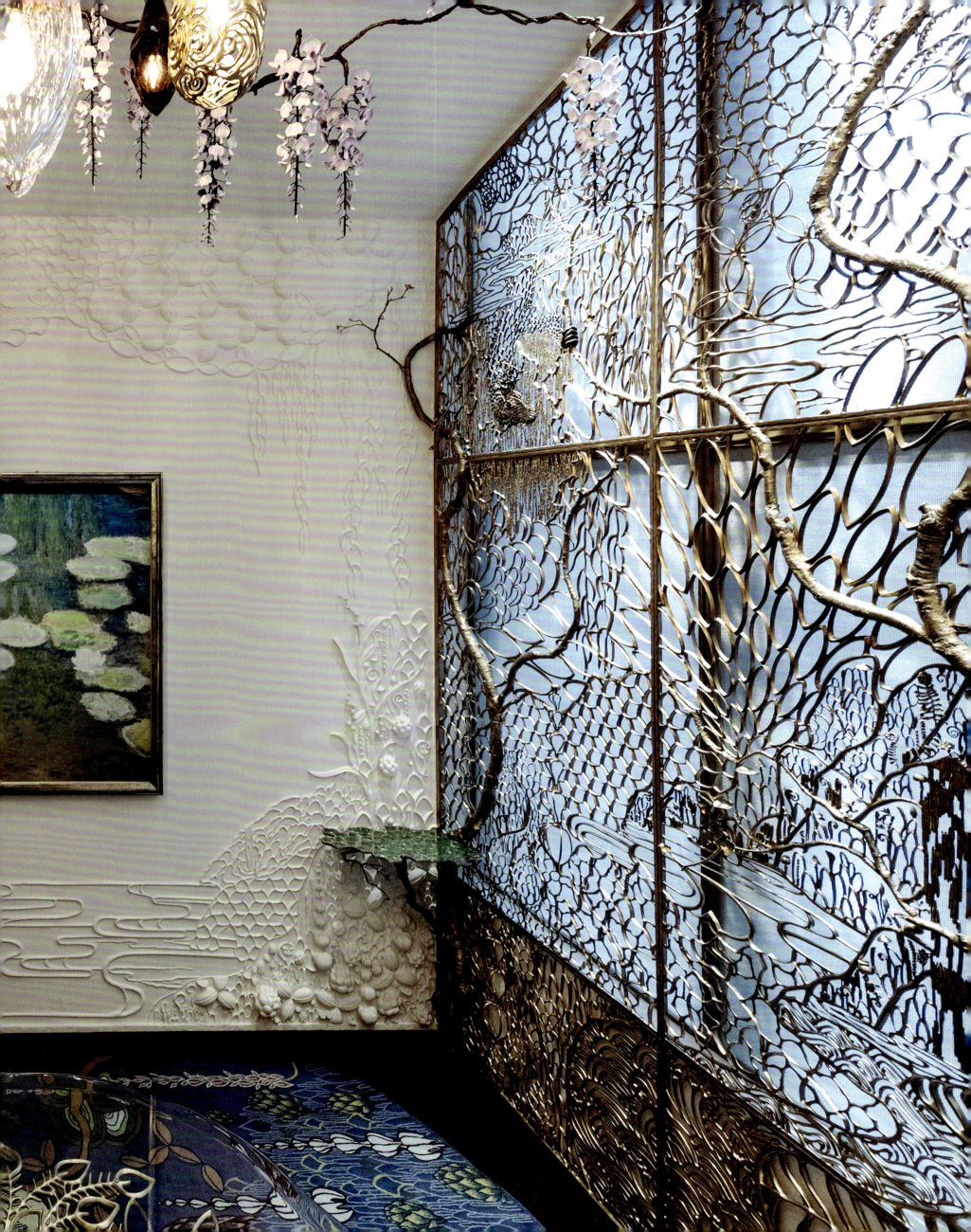

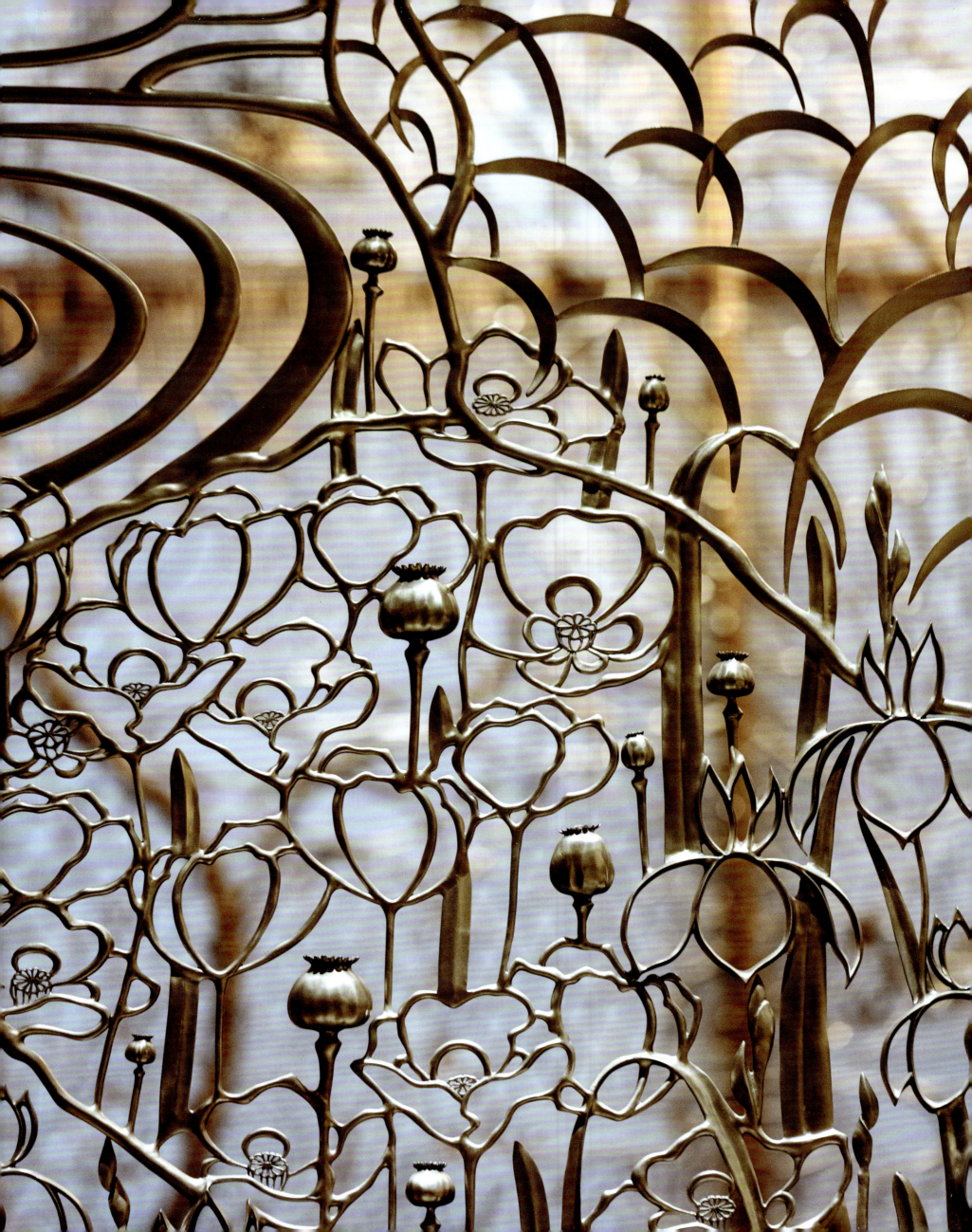

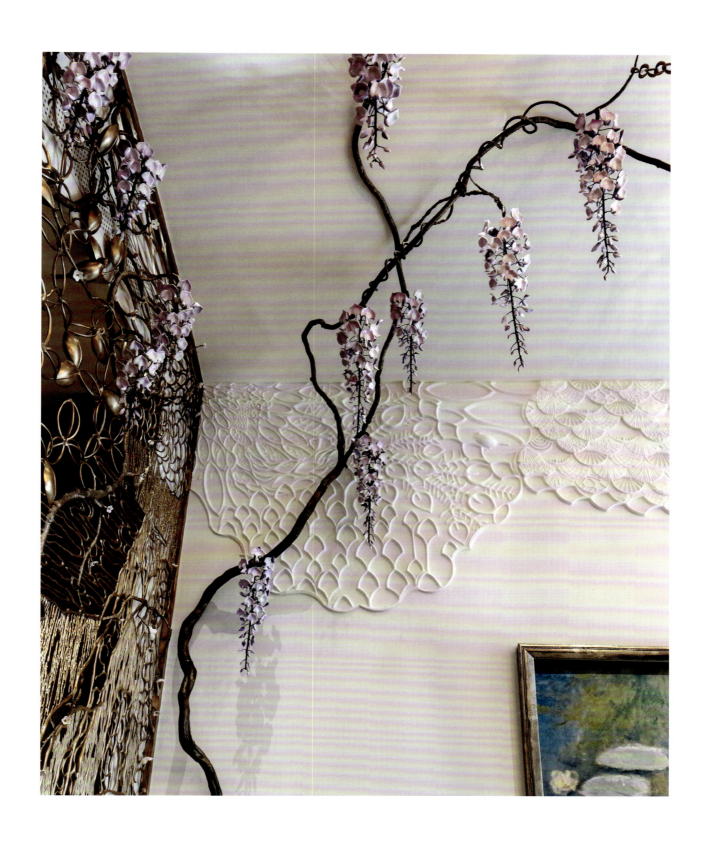

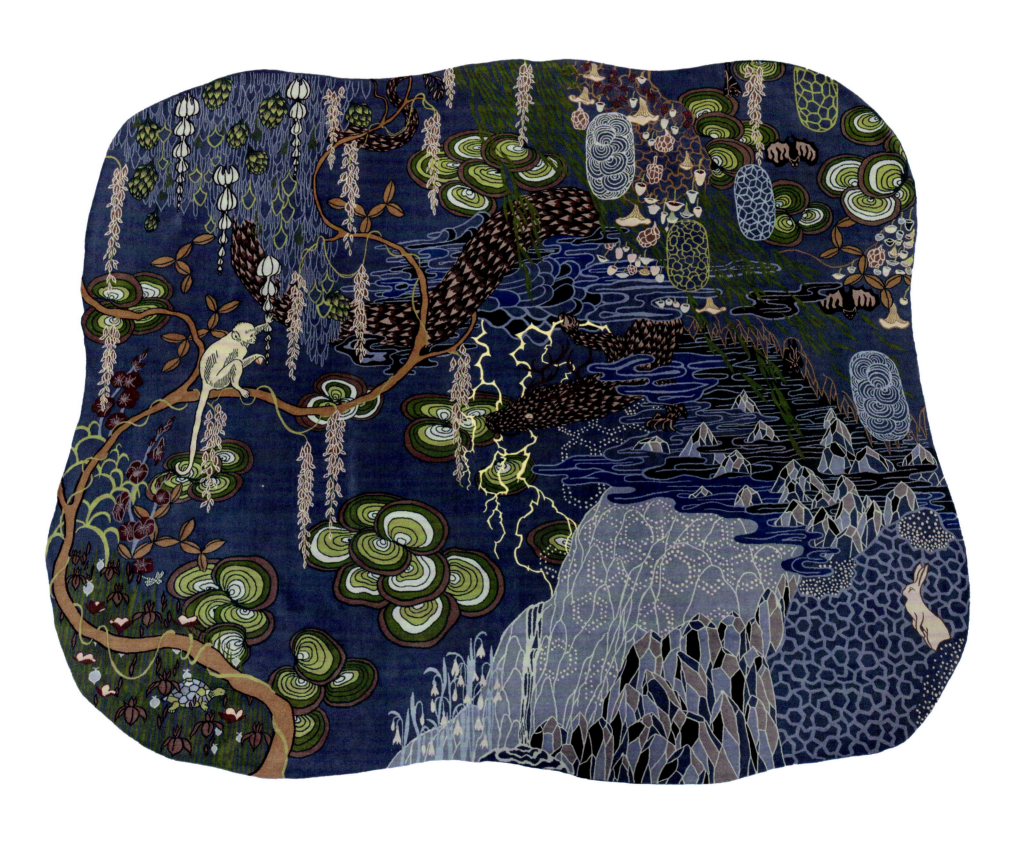

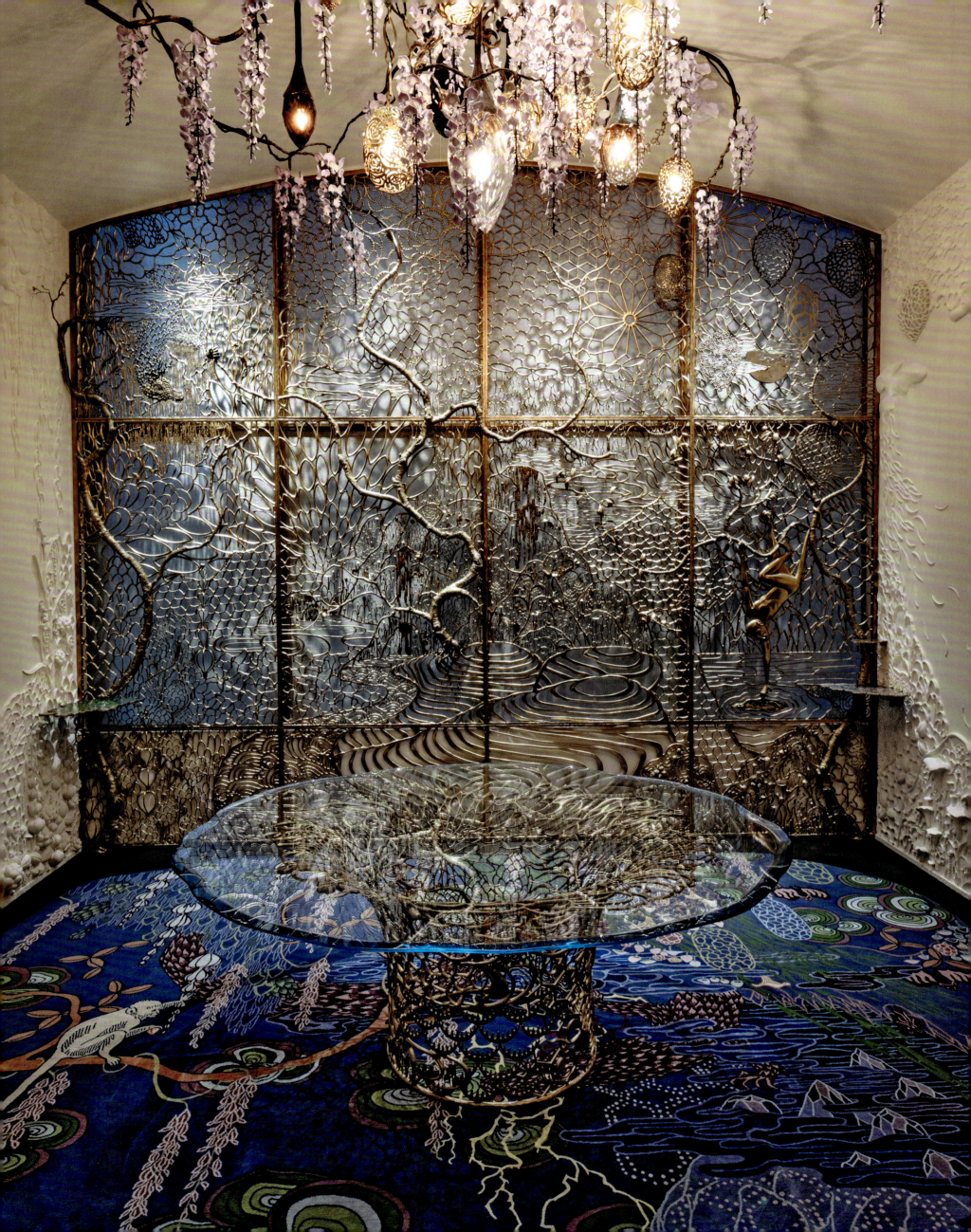

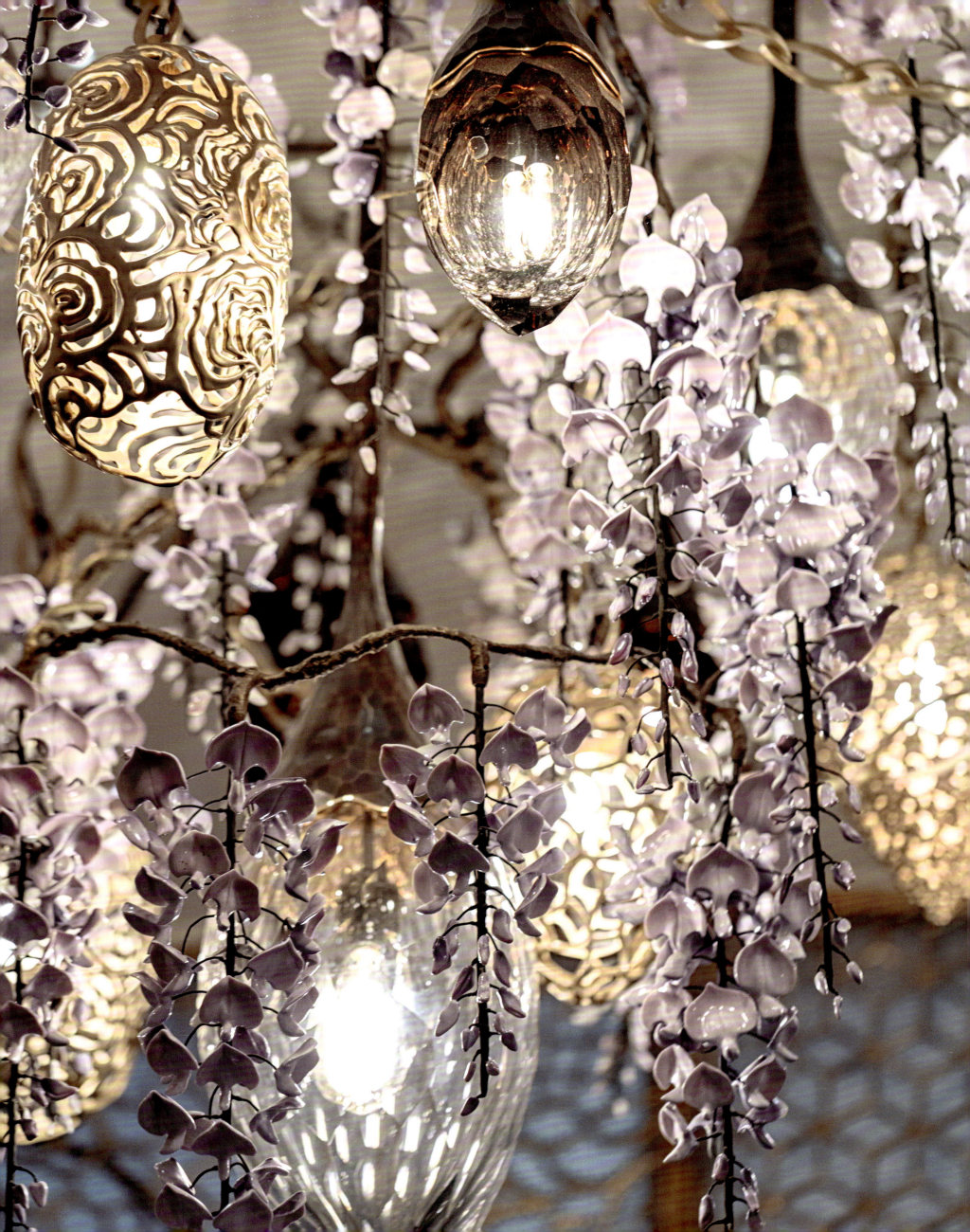

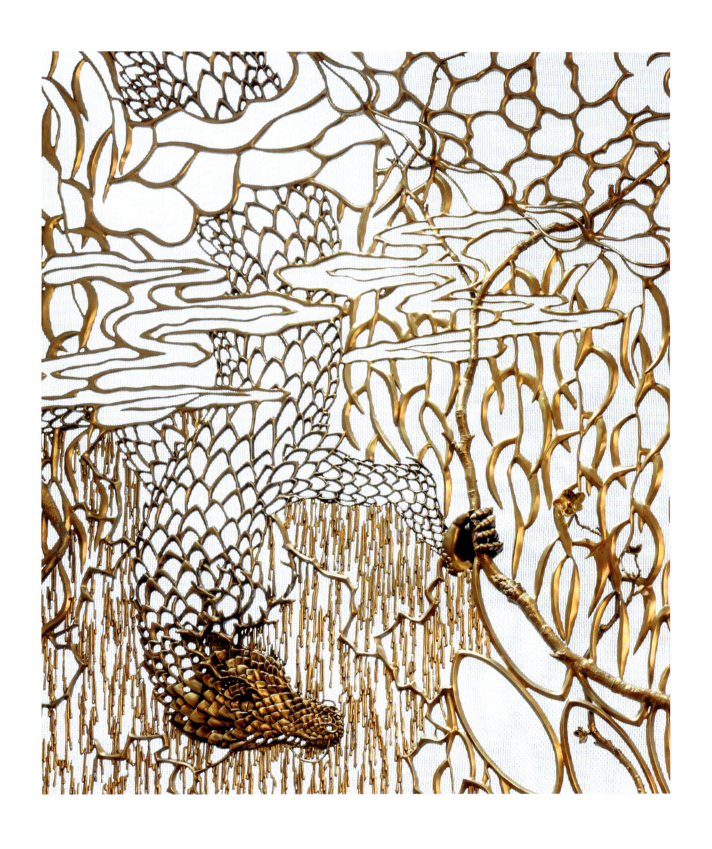

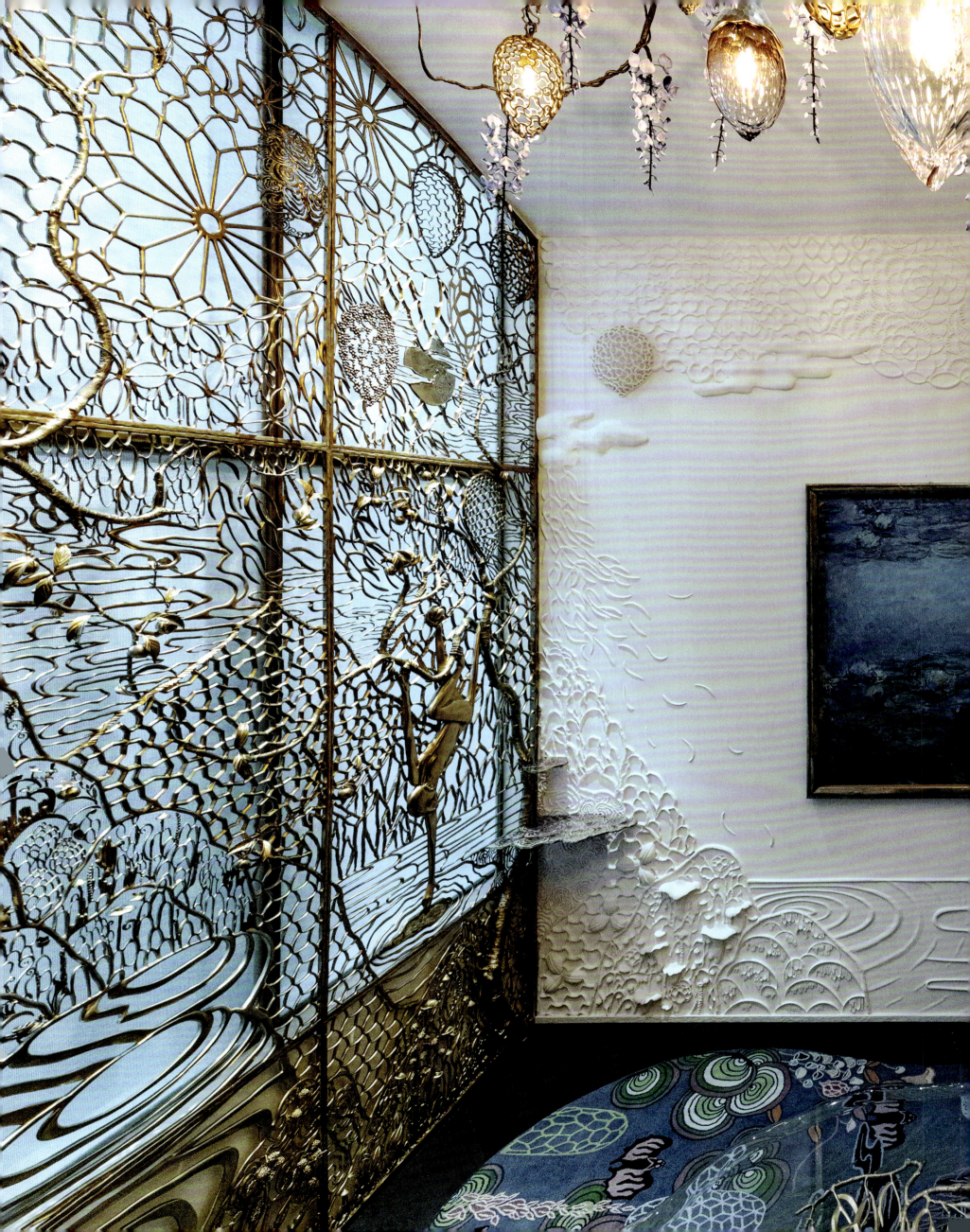

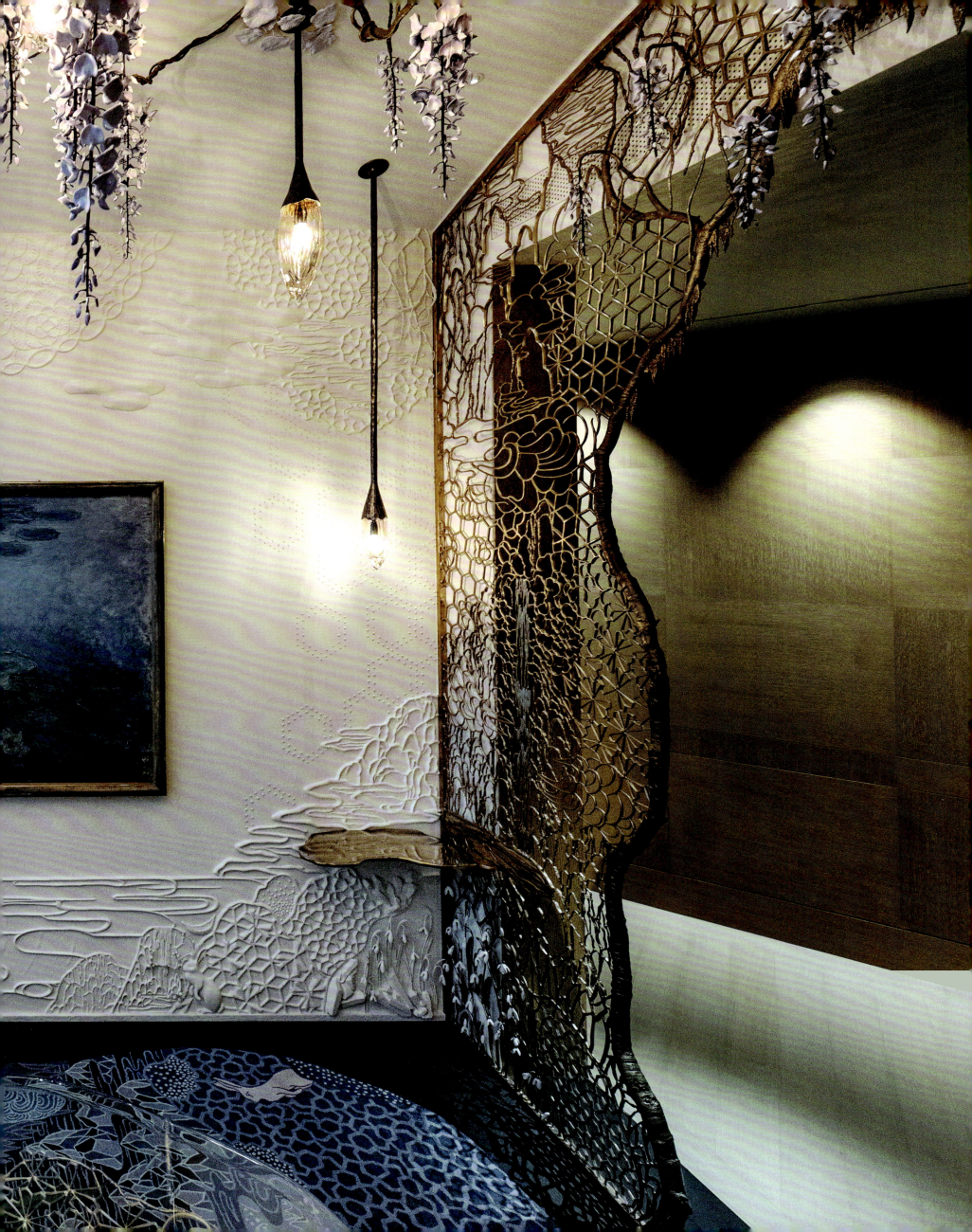

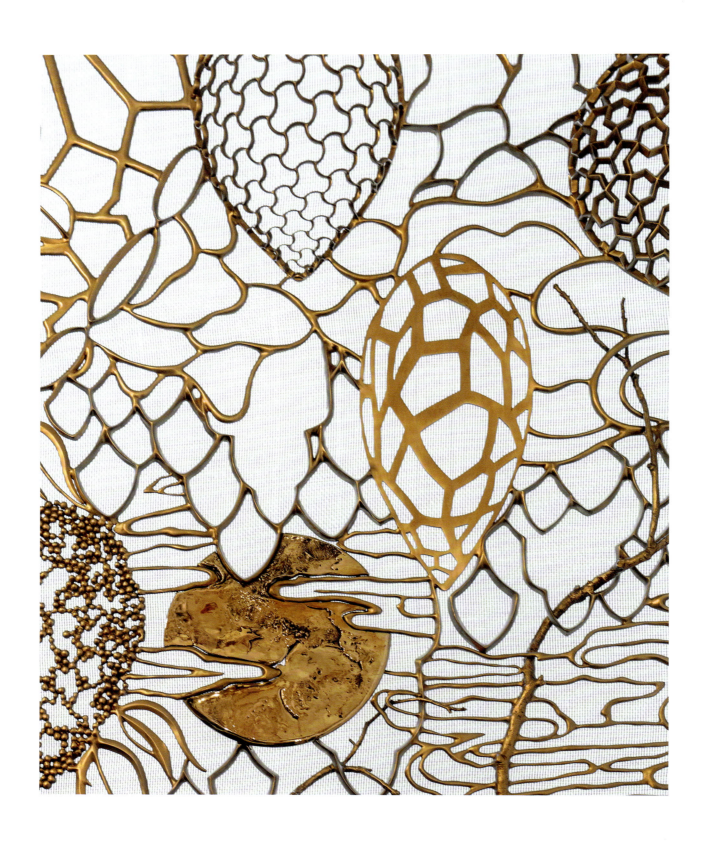

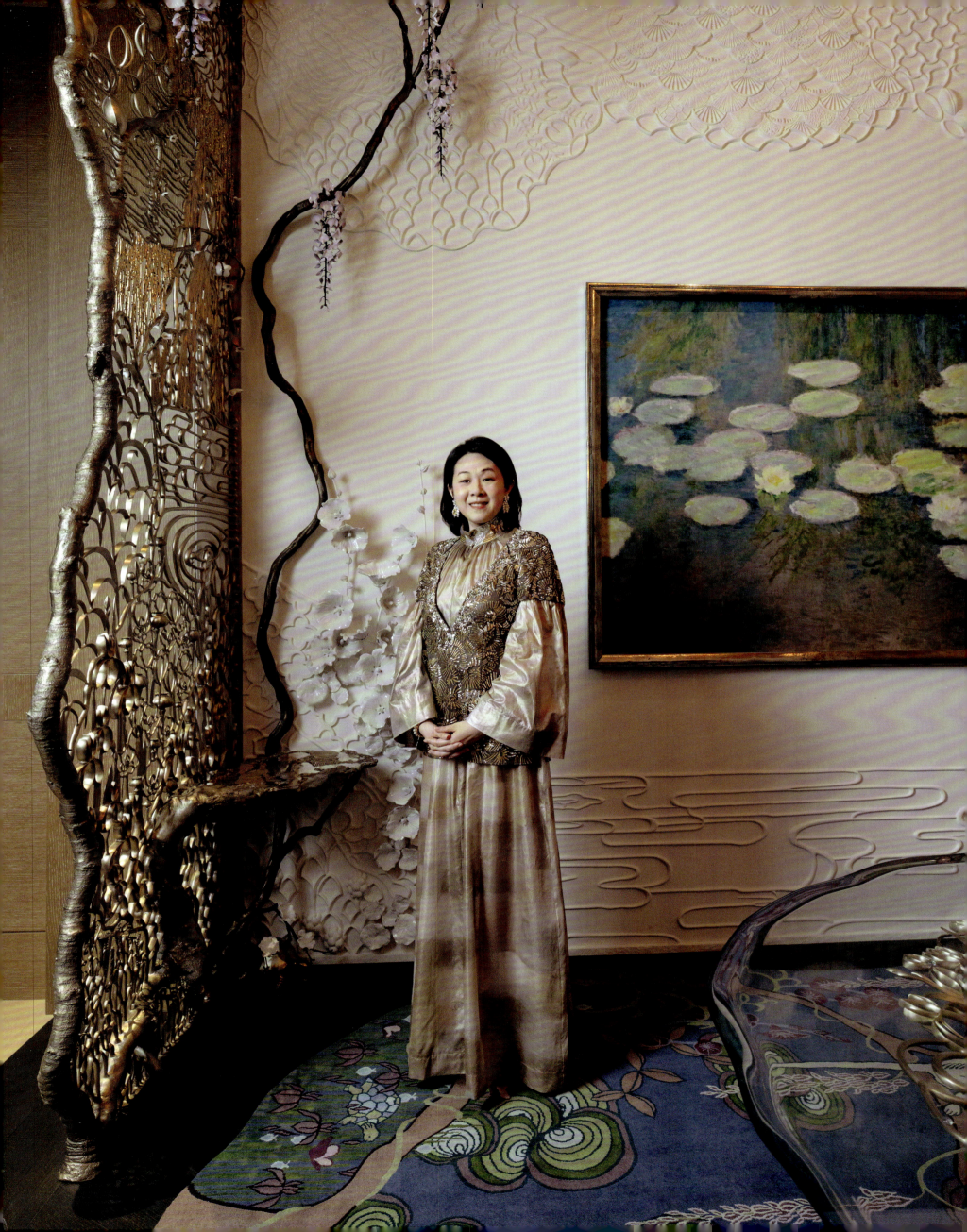

First published in the United States of America in 2024 by August Editions

ISBN: 978-1-947359-12-3

Copyright © 2024 August Editions and Wiseman Studio
Texts © 2024 their respective authors
Photos © 2024 their respective authors

All photographs Mark Hanauer except the following:
Wiseman Studio 13, 18 (bottom), 28 (top), 38, 40, 45, 51, 53 (bottom), 55, 60 (top)
Hugo Lau 54, 64 (bottom), 66-67
George Rinhart 72

Design: Asad Pervaiz / Work by Index

All rights reserved. No part of this publication may be reproduced, stored in a retrieval system, or transmitted in any form or by any means, electronic, mechanical, photocopying, recording, or otherwise, without prior consent of the publisher.

First edition
Printed in China

Acknowledgements

First and foremost, I would like to thank our client and friend, Rosaline Wong, whose deep belief in our studio was a profound gift and source of inspiration. Throughout the entirety of this, at times slow, but steady, unfolding process, I felt her total support and trust. I am so grateful to her for the opportunity, honor, and vision to create such a work in the presence of Monet's masterpieces. Next, I would like to thank my brother, Ari, whose refined palate, gentle and patient style, and keen eye (which he happily shared in our daily tête-à-têtes) helped to shape every aspect of the work.

I want to thank our staff. To José Luis, who I am so grateful to have met many years ago, when I first wandered into an art foundry and began asking my questions. He brings a lifetime of experience, wisdom, and good humor to the work, which has been one of the singular greatest gifts to the studio, and to my life. To Juliana Wisdom, who tirelessly worked with me, not only helping to sculpt forms, but also encouraging and generously lending insights, as well as organizing and keeping track of so many of the logistics. To John Yu, who, in addition to his skilled craftsmanship, contributed so many ideas to the work. Thank you to both Juliana and John for flying across the world to install this project with me.

To Jorge Islas, who, in the midst of becoming a father, and despite all the sleepless nights and new responsibilities, was always on pace with production at a very high level of artistry. To Florencio Badillo, whose experience and knowledge helped us solve so many crucial elements of the piece. To Craig Matola, who brought so many technological breakthroughs to the studio and contributed to many elegant solutions throughout this project and others. To Omar Vigueras, I know of no one as driven and hard-working; I feel so fortunate and privileged for the energy he devoted to this work. To Jorge Barreda, whose total commitment to the studio is a daily reminder of how lucky I am to work with such an amazing crew.

To Franklin Cordova, Robert Cisneros, and Pepe Elias Alarcon, whose countless hours of finishing brought this work to life. To Isabel Ordaz, whose mold-making expertise allowed this work to be created in its time, and not three additional years. To Sesar Islas, whose support of the studio was so essential and so valued. To Roan Florez, Nessie McCabe, Sarah Smiley, Sofia Arreguin, and Alex Kerr, who steadily crafted so many finely detailed glazed porcelain and plaster details, including the several thousand strong individually sculpted and glazed wisteria canopy. To Cristina, whose indefatigable support of the studio and delicious cooking helped us get across the finish line. To Sarah Giang, whose deep belief in the studio and our "studio life" help to make being here such a joy.

To my parents, whose rock solid support, encouraging presence, and integrity are my north stars. To my uncle, Mark Hanauer, whose discerning and perceptive camera eye adds so much feeling and refinement to the images of this book. To Kelly Dix Van, whose unbridled support and love was the greatest gift and privilege to experience. To Karen Feldman and Artel, I am so grateful for the many years of collaboration and for their exquisitely crafted crystal pendants. To my friends, Spencer Nikosey, Scott Goldberg, Jared Purrington, and David Kopp, you were there from beginning to end, throughout all the ups—the bonfires, the jacuzzi summits, the endless questioning and searching—and the inevitable downs, picking me up when they came along. To Jeanne and Jackie Greenberg and Salon 94 for presenting a new body of work that developed from this project. And, finally, to Dung Ngo, Asad Pervaiz, and Sophie Aliece Hollis, who made this book a beautiful reality.

D.W.